The culture of fashion

D0223267

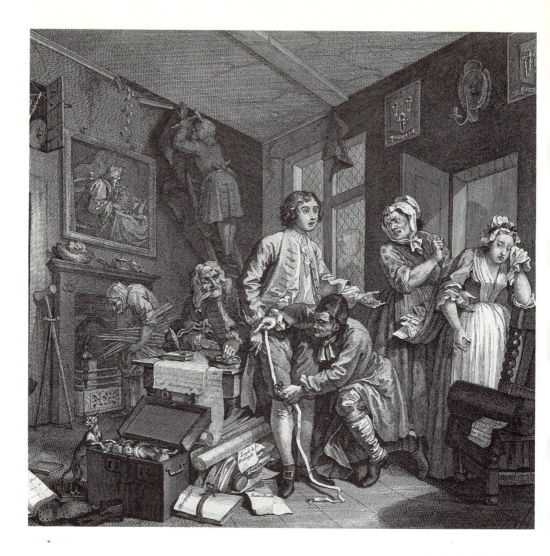

frontispiece] *The Rake's Progress,* Plate I, by William Hogarth, 1735. The central figure Tom Rakewell is being measured for a suit of mourning following the death of his benefactor, an old miser. The wealth of incidental detail provides a record both of contemporary clothing styles and of the ambivalent attitude social commentators took towards material luxury and its corrupting power in the eighteenth century, an approach which has compromised the fashionable throughout the history of fashion.

The culture of fashion

A new history of fashionable dress

picture research
Jane Audas

Christopher Breward

distributed exclusively
in the USA and Canada
by St. Martin's Press

Manchester University Press

Manchester and New York

Published by Manchester University Press
Oxford Road, Manchester M13 9NR, UK
and Room 400, 175 Fifth Avenue, New York, NY 10010, USA

Distributed exclusively in the USA and Canada
by St Martin's Press, Inc., 175 Fifth Avenue, New York, NY 10010, USA

British Library Cataloguing-in-Publication Data
A catalogue record is available from the British Library

Library of Congress Cataloging-in-Publication Data
Breward, Christopher. 1965–
 The culture of fashion: a new history of fashionable dress /
Christopher Breward: picture research, Jane Audas.
 p. cm. – (Studies in design and material culture)
 ISBN 0-7190-4124-4 (hardback). – ISBN 0-7190-4125-2 (pbk.)
 1. Costume – History. 2. Fashion – History. I. Title.
 II. Series.
GT511, B74 1994
391 – dc20 94-5415

ISBN 0 7190 4125 2 *paperback*
Reprinted 1995

Printed in Great Britain
by Bell & Bain Ltd, Glasgow

Contents

Illustrations

Colour

Acknowledgements

I would like to thank the following for their help, advice and encour-
agement in the completion of this book: firstly my colleagues in the
Department of Art and Design History at Manchester Metropolitan
University who offered much practical and intellectual support during
the research and writing stage, particularly Dr Elizabeth Coatsworth,
Professor Diana Donald, John Hewitt, Dr David Peters Corbett, Louise
Purbrick and Richard Tilston. Also the students on the History of Art and
Design BA course and the Fashion and Textile course at Manchester,
whose participation in seminar discussions broadened the debate. I am
grateful for similar encouragement and comments from Dr Lesley Miller
and the students on the MA course in the History of Fashion and Textiles
at Winchester College of Art, and from John Styles and Katrina Royall at
the Victoria and Albert Museum. Individual thanks should go to Jane
Audas for dedicated picture research and to Radha Burgess and Katrina
Rolley for readings and further suggestions.

General editor's foreword

This series of books is principally about the history of objects. When put so bluntly, there seems to be a certain absurdity in the suggestion that there might be a need for such an enterprise. After all, is that not what various other disciplines are providing? The answer to this question is no. The History of Design, Material Culture or Decorative Arts, as it is variously understood, usually begins where others end. Many disciplines have objects of one kind or another at their core, but the history we are concerned with here stands alone in its analysis of the wide range of genres which fill people's lives. The furnishings, utensils, adornments, decorations, graphic materials, vessels, mechanised products and clothing give form and meaning to the cultures within which they reside.

Of all these genres, clothes are perhaps the most potent and prominent. They fulfil the relatively straightforward function of providing the body with a protective layer. But they are also the basic material of fashion, and it is through the mediating power of fashion that they have become one of the most important elements of the designed world. Fashion is simultaneously an intensely personal and a mass phenomenon, particular styles having the ability to generate deep resonances in the lives of individuals, and to become movements on a global scale. By analysing the symbolic meaning of the clothing of others, it is possible to extract an extraordinary range of information: educational background, political allegiance, religion, sexual preference, sporting interests and, perhaps most emphatically, class background. Much of this information is surrendered unwittingly.

In this pioneering study, Christopher Breward moves through six centuries of fashion with the explicit aim of exposing the meanings behind the garments which people wore. He reveals the extent to which clothing moves beyond its role as a screen for the body to become a gathering of information and symbols for communal consumption.

To James

Introduction

Adornment, especially clothing, has, like the applied arts, the advantage of touching on a wide range of quotidian functions and of embodying a relatively uncomplicated partnership of function and style that permits the isolation and study of style. The potency of this material as cultural evidence can be tested by the simple act of criticising someone's clothes; the reaction is much more intense than that aroused by comparable criticism of a house, a car, or a television set. Criticism of clothing is taken more personally, suggesting a high correlation between clothing and personal identity and values. Although personal adornment promises to be a particularly rich vein for material culture studies, to date little significant work has been done with it.[1]

The history of fashion has become a rich area of research and interpretation within the past thirty years (possibly longer, if the discipline is traced back to the publication of antiquarian studies of medieval and classical dress from the 1830s). Formerly the province of museum curators and theatrical designers, the subject has been opened up by a variety of disciplines, each using the source material of clothing and its wider representation in paint, print and film, from academic and practical positions that generally have some sort of vested interest in the very wide possibilities that the study of dress can offer. The first serious use to which research in historical costume was applied lay in the area of art historical studies. The careful dating of clothing in paintings was seen as a useful tool in processes of authentication and general connoisseurship. The emphasis on the creation of chronologies and a rational progression of styles that art historical directions dictated at the time has to some extent influenced the nature of much fashion history writing. The discipline has often been criticised for producing hemline histories that neglect considerations of context and meaning for the seemingly less enlightened concerns of provenance and influence. This is perhaps unfair and denies the worth of a huge body of very useful empirical and descriptive work which traces a history of cut and decoration, and is helpful in

providing a base against which more critical methods can be applied.

Various approaches have subsequently been adopted in an effort to rectify those accusations of elitism and dilettantism that have been thrown in the direction of traditional fashion history. Moves towards a self-conscious 'new art history' in the late 1970s, in which social and political contexts were prioritised over older concerns of authorship and appreciation, challenged those assumptions which had underpinned the serious study of fashion in the first place. Indeed many of the defining aspects of new art historical approaches, which drew on ideas from Marxism, feminism, psychoanalysis and structuralism, encouraged a fresh prominence for debates incorporating problems of identity, the body, gender and appearance, central to any definition of 'fashion'. Rees and Borzello use examples which have broad implications for the status of fashion history itself in their definition of the scope of new art historical approaches: 'When an article analyzes the images of women in paintings rather than the qualities of the brushwork, or when a gallery lecturer ignores the sheen of the Virgin Mary's robe for the Church's use of religious art in the Counter-Reformation, the new art history is casting its shadow.'[2] Design history, a relatively young discipline, compared to the history of art, has been able to take on board the complexities of social considerations, economic implications and cultural problems, in a less self-conscious manner. The relationship between production, consumption and the designed object, which has always been central to any definition of the discipline, demands an investigation of context, and is well suited to the study of historical and contemporary clothing. As Josephine Miller states:

> This is a multi-faceted subject and in some ways can be seen to relate to almost every area of design and many aspects of the fine arts. It needs to be placed firmly within a cultural context, against a background of technological and industrial change, literary and aesthetic ideas. In the post-industrial period, the marketing and retail outlets, together with developments in advertising and publishing techniques, have brought a new set of considerations with them. Moreover, the study of dress and its production cannot be separated from women's history.[3]

However, despite its fitness for design history methods of approach, the study of dress and fashion remains marginal to wider design history concerns. The most recent encyclopaedia of design and designers, for example, does not include any

significant mention of fashion or fashion designers.[4] This perhaps reflects the discipline's roots in Modernist design practice. A theoretical and inspirational aid to students of industrial and graphic design, design history as originally taught in art and design colleges has tended to prioritise production in the professional 'masculine' sphere, re-enforcing notions of a subordinate 'feminine' area of interest into which fashion is generally relegated. Related disciplines, including cultural studies and media studies, have taken the politics of identity and appearance closer to their core, but tend to concentrate on contemporary issues and confine themselves mainly to the study of representation and promotion, using social anthropology and semiotics as tools to define meaning.[5] Broader historical contexts remain beyond their concern.

It is perhaps not surprising then, in the face of a potentially confusing and contradictory conflict of interests, that this book has aimed to incorporate the positive elements of all three approaches, art historical, design historical and cultural in its attempt to present a coherent introduction to the history and interpretation of fashionable form. Rather than prioritise the benefits of one direction over another, it would seem to be more helpful if they could be used together to provide a more rigorous but essentially fluid framework for the study of fashion in its own right. These differing methods can also be set within a broader debate concerning the nature of cultural history generally that has occurred over the past ten years, which has fostered concepts of diversity rather than prescriptive or narrowly defined readings of historical phenomena. Roger Chartier outlines the problems in his discussion of the concepts of 'popular' and 'high' culture, an area especially pertinent to the history of fashionable clothing:

> First and foremost, it no longer seems tenable to try and establish strict correspondences between cultural cleavages and social hierarchies, creating simplistic relationships between particular cultural objects or forms and specific social groups. On the contrary, it is necessary to recognise the fluid circulation and shared practices that cross social boundaries . . . Second, it does not seem possible to identify the absolute difference and the radical specificity of popular culture on the basis of its own texts, beliefs or codes. The materials that convey the practices and thoughts of ordinary people are always mixed, blending forms and themes, invention and tradition, literate culture and folklore. Finally, the macroscopic opposition between 'popular' and 'high' culture has lost its pertinence. An inventory of the multiple divisions that fragment the social body is preferable to

this massive partition . . . Their ordering follows several princi-
ples that make manifest the divergences or oppositions between
men and women, townspeople and rural folk, Protestants and
Catholics, but also between generations, occupations and
neighbourhoods.[6]

It is the central contention of this book that fashion has
played a defining but largely uncredited role in the formula-
tion of such differences, and therefore requires a method of
analysis that takes account of multiple meanings and inter-
pretations. Reductive connections between social influences
and fashionable appearance have dogged much fashion
history; the new cultural history presents a more questioning
framework which allows for explanations which are multi-
layered and open-ended. Melling and Barry have also pre-
sented a model which acknowledges difference and tensions
between new historical approaches, suggesting a more posi-
tive use for the harnessing of divergent directions:

> It would be misleading to present all these changes as moving
> in harmony and in a single intellectual direction. For example,
> there is a clear tension between the emphasis laid by some,
> notably literary critics, on the autonomous power of the text
> and language, compared to the interest of others in recovering
> the intentions of historical actors. Put crudely, the former are
> seeking to deconstruct the identity and rationality of historical
> actors, while the latter strive to reconstruct them. To some
> extent we are seeing, within the concept of 'culture' as a basis of
> historical explanation, a revival of the standard sociological
> debate between 'structure' and 'action'. Should culture be con-
> ceived of as a given system or structure within which past actors
> are predestined to operate? Or does the emphasis on culture
> place higher priority on human creativity, on self-conscious
> action by the individual or society to change their condition? It
> would be ironic should this false dichotomy become too well
> entrenched, since the notion of culture has in many ways been
> invoked precisely to avoid the need to choose between structure
> and action, but the danger remains, if concealed by the inher-
> ent ambiguity of 'culture' as an explanation.[7]

In essence, then, I hope to present an introductory guide
to the cultural significance of fashion, from its emergence in
the mid-fourteenth century to its final explosion in the mid-
twentieth century that locates itself within these broader
historical debates. In terms of method, each chapter incorpo-
rates a chronological narrative of changing form, using the
analytical approaches pioneered by traditional art historical
fashion history. This narrative is then both problematised
and substantiated by an engagement with critical debates

drawn mainly from recent cultural histories, but also including comment from economic, design and art history and literary theory. As the main purpose of the book is to broaden the parameters of fashion history by engaging with other disciplines, the text uses direct quotations as a way of exposing the student to the possibilities and uses of a wide variety of historical discourses. In constructing such a huge historical range it is impossible to make any claims for comprehensive coverage. As the title suggests, the cultural and social significance of fashionable clothing and its representation is prioritised. A description of the construction and production of dress and textiles is generally left for others, and geographically study is confined mainly to England, though the influence of continental and transatlantic interpretations of style in formulating notions of Englishness is also taken into account. Fashion is taken to mean clothing designed primarily for its expressive and decorative qualities, related closely to the current short-term dictates of the market, rather than for work or ceremonial functions. This does not presuppose that fashionable dressing is the preserve of a social elite, and much of the work focuses on constructions of fashionability across social divides.

Chapters are arranged so that each concentrates on a specific historical problem or debate. Thus the medieval chapter concerns itself with the problems of archaeological approaches and their implications for a reconstruction of the beginnings of an organised fashion system that takes into account the whole spectrum of medieval society. The Renaissance chapter isolates the use of fashion as a symbol of status and wealth and its potential for undermining such structures, whilst the chapter on the seventeenth century places the concept of sartorial display in the context of cultural conflict and moral uncertainty. The chapters on the eighteenth and nineteenth centuries both deal with the emergence of revitalised production and consumption systems, the earlier chapter concentrating on the problems of 'revolution' as a defining historical construct, and the later chapter examining the implications of new technology in clothing production for attitudes towards gender and class. The early twentieth-century chapter places the increased or 'mass' consumption of fashionable dress within the sphere of fashion promotion and advertising, tracing a path towards unlimited and potentially unquantifiable diversification. In this way the book can be used in two ways, as a chronological unfolding of changing forms, and as a critique or

analysis of wider cultural and social influences and their historical interpretation.

Notes

1 R. B. St George, *Material Life in America 1600–1860*, Boston, 1988, p. 30.

2 A. L. Rees and F. Borzello, *The New Art History*, London, 1986, p. 2.

3 J. Miller, 'The Study of Dress and Textiles' in H. Conway, ed., *Design History – a students' handbook*, London, 1987, p. 15.

4 G. Julier, *Encyclopaedia of Twentieth Century Design and Designers*, London, 1993.

5 D. Miller, *Material, Culture and Mass Consumption*, Oxford, 1987.

6 R. Chartier, 'Texts, Printings, Readings' in L. Hunt, ed., *The New Cultural History*, Los Angeles, 1989, p. 168.

7 J. Melling and J. Barry, *Culture in History: Production, Consumption and Values in historical perspective*, Exeter, 1992, p. 5.

1 Medieval period: fashioning the body

1] In this illustration of scenes from courtly life, the new figure-hugging cut, trailing tappets and contrasting colours that so annoyed the clerics and chroniclers are clearly discernible in both male and female dress.

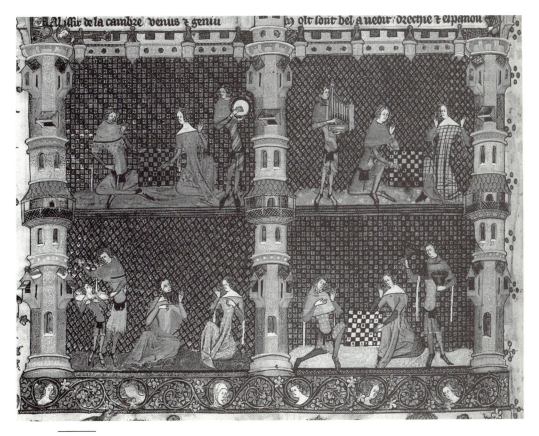

Sometimes their clothes are long and wide, at others they are short, tight, dagged, and cut about and boned all round. The sleeves of their surcoats like their hoods have tapets, long and wide which hang down too far. They look, to tell the truth, more like tormentors and devils in their clothing than like normal men. And the women surpass the men in their clothing, which is so tight that they hang fox tails under their dresses at the back to hide their arses, a kind of behaviour which may well have provoked many of the evils and misfortunes that have beset the kingdom of England.[1]

It was in these critical and derisory terms that John of Reading described the results of a shift in fashionable dress away from the simple, functional style previously popular amongst the European nobility, towards a French-inspired emphasis on contour and cut. This was a change perceived by contemporaries to have occurred in England during the 1340s, as a result of the political and stylistic influence wielded by Philippa of Hainault at the London Court. The chronicler isolated several elements of the new style that seemed designed to cause offence: the lack of a consistent fashionable form, the implied economic waste of long, wide sleeves and tappets, the bestial, indeed supernatural shape which clothing now gave to the human body, and the heightened sense of differentiation afforded to gender roles, with its attendant implications of lasciviousness and sexual misdemeanour. Using such descriptions as central sources for their research, costume historians have identified the middle years of the fourteenth century as the first period of significant fashion change, generally linking it with the rise of mercantile capitalism in European cities. In common with contemporary

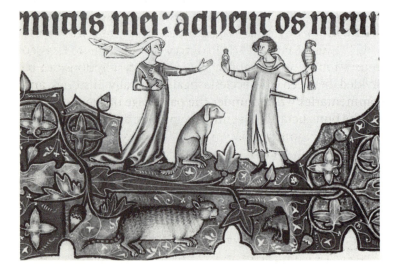

2] The loose, simple 'T'-shaped cut of the early-fourteenth-century 'cotte' is adopted by this aristocratic couple.

commentators they have also isolated a sudden sense of widened choice and a concurrent speeding up of succeeding styles replacing the uniformity of appearance common to earlier periods. They have noted a drastic stylistic upheaval which 'transformed human beings from soft rounded creatures with a mobile surface into harsh, spare, attenuated insect-like things'.[2] But they have concentrated specifically on the effects such a shift might have had on the physical form or construction of textiles and dress and their representation in art historical and architectural sources. Little attention has been given to the wider implications of what might be termed 'the birth of modern fashion' for structures of class and gender within society, or the broader cultural and economic implications of such a 'naissance'. This chapter, whilst tracing the basic shifts in style, their causes and effects, will suggest those areas of historical investigation outside the immediate concerns of Costume History which might provide a framework for a more comprehensive analysis of the beginnings of the 'fashioned body'.

Sources for historical enquiry

Until recently costume historians were restricted to two major fields of historical evidence in their attempts to reconstruct a sense of medieval fashion: the visual representation and the literary description. Visual sources have been divided into the sculptural or architectural, including funerary monuments, brasses and ecclesiastical carvings or misericords, and the two-dimensional, incorporating panel paintings, tapestries, stained glass, frescos and book illuminations. In terms of regional difference, sculptural sources have been used more profitably to give a history of costume change within the British Isles, whilst pictorial sources provide a more focused impression of continental style.[3] Literary descriptions can be divided between the ecclesiastical, generally histories and commentaries written under the patronage of the monasteries; the bureaucratic, covering inventories, accounts, and personal correspondence (letters and diaries), and the romantic, including poetry, literature and drama.

Sources based on secondary interpretation inevitably carry with them the dangers of biased or misrepresentation. The inherent moralism and censure of monastic sources, for example, constructs a history of dress based on exaggeration and outrage; whilst literary sources such as the widely-used Chaucer can tend towards caricature for comic effect, or a

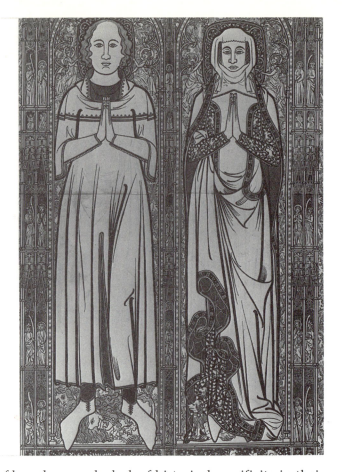

3] Experimentation with the combined effects of looseness and tightness is evident by the middle of the fourteenth century. Tight sleeves and undergarments contrast with the elaborately draped and folded 'houppelande' or overgown.

sense of broadness and a lack of historical specificity in their appropriation of folk traditions and earlier literary forms. Visual sources can be equally suspect in their tendency to depict an impression rather than a focused analysis, failing to provide those details of cut and construction essential for the reconstructive priorities of the dress historian. What they do provide, however, is a fairly reliable guide for dating purposes, used as one step in a more comprehensive archaeological process.[4] Despite accusations of bias and inconsistency, some historians have identified the subjectivity of secondary evidence as a useful source of contextual information in itself, revealing valuable information regarding both the material and spiritual status of clothing and textiles within medieval society:

> Artists were no dispassionate eyewitnesses . . . they had other aspirations than documenting what people were wont to wear when feasting or fighting. The prime function of art was to be prop and pillar for the meditating mind . . . scenes and objects from everyday life were not depicted for their own sake but as

4] The growth of the houppelande reaches extremes by the mid fifteenth century: wide sleeves and trailing skirts allow for the display of richly woven textiles, whilst the bulky, distorted shape of the body is echoed in extravagantly padded and horned headdresses.

symbols of the supernatural . . . The Madonna on the Buxtehude Altar is not knitting a nice warm sweater for her babe, but the seamless robe for which in time the saviour's executioners were going to toss.'[5]

It would seem that the most useful approach to source material, if a comprehensive view of medieval dress is to be produced, is to use combinations of evidence which support, rather than contradict, the widest possible reading of historical material culture. Recent archaeological finds of medieval textiles and clothing preserved by the anaerobic conditions of river mud in London have thrown into sharp relief the problematic and reductionist approach of traditional dress historians towards the status of evidence. Rather than use the 'small brown scraps of cloth' to extend and broaden the debate, there has been a tendency for the discipline to polarise the implications of surviving fragments, using them either to refute or corroborate existing secondary evidence. The very concrete and tactile nature of a leather belt, or the visible intricacy of a dagged or serrated tunic edge, obviously carries great weight in any consideration of sewing technique or production processes, but such observations tend towards description rather than explanation. Archaeological evidence thus becomes prioritised, and the status of surviving artefacts misinterpreted as somehow floating above the pressures of social construction and historical manipulation that dress

historians have identified as coming to bear on literary and pictorial sources: 'The most important body of evidence for the shaping of medieval garments is to be found in neither visual nor literary sources . . . The most reliable evidence for medieval cut and construction is to be found in the surviving garments themselves.'[6]

A system of enquiry that attempts to make an objective analysis of archaeological 'fragments' without placing them both in the wider context of contemporary interpretation and in the shifting processes of reinterpretation that take place over time and space, can only hope to tell a 'fragmentary' history. Craig Clunas, in his work on early modern China, suggests an approach based in material culture studies and anthropology that welds together such apparent disparity:

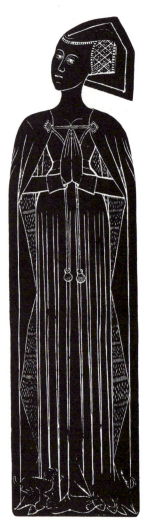

5] By the 1470s, softness and rotundity in form has been replaced by spiky angular forms, accentuated here by the mannered linearity of a brass memorial engraving.

the ideas of Arjun Appadurai and Igor Kopytoff have seemed to offer a solution to the historically divorced discourses of material culture (the province of the curator or archeologist) and its 'context' (the province of the historian). Arjun Appadurai has written: 'even though from a *theoretical* point of view human actors encode things with significance, from a *methodological* point of view it is the things in motion that illuminate their social and human context.'[7]

It would seem that it is the task of the historian to combine both skills in studying sources for a history of medieval dress. A closer deconstruction of contemporary interpretations of dress, textiles and their symbolic value, expressed through writing, drawing and sculpture might offer a fuller sense of 'significance' for surviving artefacts than dress historians and archaeologists have formerly allowed. The literature of Costume History is notorious for its obsession with creating an evolutionary narrative of costume change; the discipline's myopic attention to the rise and fall of hemlines has come under perhaps justified criticism from connected areas of study such as Design History or Critical Theory. However, to deny that traditional Costume History has not provided essential work, especially in terms of dating and style for the dress of earlier periods would be shortsighted in itself. Before attempting to provide a much-needed wider context for the interpretation of the Medieval fashionable image, it seems sensible to construct just such a chronology of change.

Tracing change – presenting the body, 1300–1500

Simplicity and looseness typify the appearance of all classes and both sexes in representations of the human body at the turn of the fourteenth century. Costume form for men and women was based on a simple 'T' shaped shift with cylindrical sleeves, the 'cotte'. This might be elaborated with an overgarment, the 'surcot', or a mantle when temperature or occasion demanded. For ease of movement worker's dress, especially masculine forms, rarely fell below the knee, whereas court dress and overtly feminine styles fell to the ankle or beyond. Gender differentiation was echoed in the treatment of the head. Women concealed everything but the face in layers of linen veiling, whilst men are depicted bareheaded with thick soft curls growing over the ears.

By 1320 clothing appears to constrict, pulling in around the arms and across the chest.[8] The new tightness necessitated the addition of buttons, allowing ease of access to the cuff

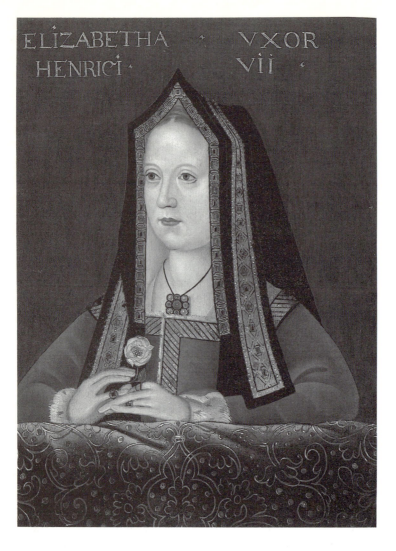

ELIZABETHA · VXOR
HENRICI · VII ·

6] The retaining of a natural shoulder-line and the adoption of comfort in terms of tactile velvets and furs, produces the sombre, serious feel of clothing at the turn of the sixteenth century.

and lower sleeve, and causing 'a sunburst of pleats at the inset of the sleeves' to erupt whenever the arm was moved.[9] Stella Mary Newton has attributed eyewitness condemnation of the new styles to claims that dressing now demanded the assistance of a partner to fit and fasten clothing, shared robing rituals implying greater and forbidden proximity to the naked figure[10] (though this doesn't really complement unproblematised contemporary descriptions of mixed bathhouses). The habit of combining over- and undergarments, now in bright contrasting colours or 'mi-parti', continued with the tighter cotte covered by a loose, sleeveless surcot. A preoccupation with the qualities of contrasting or even clashing textures and effects has been identified by cultural historians such as Le Goff as a central tenet of medieval aesthetic

sensibilities; he quotes William of Auvergne, who states: 'Visible beauty is defined either by the appearance and the position of the parts within the whole, or else by the colour, or else by these two characteristics put together, whether one juxtaposes them or one considers the harmonic relation which relates the one to the other.'[11]

Experimentation with the combined effects of tightness and free-flowing looseness perhaps found some expression in the widening of cuffs at wrist or elbow to form trailing pendants, echoed by 1340 in the lengthening peaks of men's hoods. Archaeological evidence has shown how excess material cut away from sleeves to fit them to the arm could be added at hems and cuffs in this way, pre-empting those critics who accused tailors of waste in their adherence to the new styles of cutting and fitting. The sophistication of much tailoring at this time has been lost in pictorial depictions, though here the surviving object can help in a reconstruction of the sense of movement and fit embodied in the fashionable shapes of the 1330s and 1340s:

> The shaping of tunics in the middle ages was more developed and complex than pictorial sources have so far suggested . . . tunics were made up of up to eight shaped sections, with some seams on the straight grain of the fabric and others on a partial bias. The juxtaposition of bias and straight edges would give an elegant movement to the garment in wear, which is evident even in the rather coarse twill cloths.[12]

Women's headgear also witnessed a shift from the enveloping concealment of veils towards a more revealing wide neckline and a preference for exposed and elaborately plaited hair, sometimes treated with egg-white and sculpted into curls, or 'exposed to sun and frost in order to attain the coveted blonde colour'.[13] Married women, expected to maintain a modest covering, could adopt the barbette, 'a stiffened circle of white linen, with a broad band passing under the chin'.[14] An emphasis on the sweep of the neck flowing down into the body as an attribute of femininity was countered in the masculine dress by longer hair and the reintroduction of closely groomed beards. Concurrent with such differentiation in the arrangement of headwear was a gradual move towards more obvious distinctions between the male and female clothed body. Male garments rose up the thigh, their hemlines decorated with dagging (deliberate slashing of the edges of textiles to form a serrated or undulating border, made possible thanks to the dense, heavily fulled quality of medieval cloth which prohibited fraying). By 1360 the sense

7] The dagged or serrated edges of late-fourteenth-century clothing is evident in both pictorial sources and in archaeological finds as here.

that the male body was bursting out of attire several inches too small was compromised by the introduction of the houppelande, a loose-bodied floor-length coat with narrow sleeves. Criticised for its similarities to female dress, the houppelande came to represent those problems attached to gendered definitions of dress in the late fourteenth and early fifteenth centuries. In the period between 1360 and 1480 masculine appearance never really stabilised, veering either towards the exaggerated phallic pronouncements of the short tight tunic, or the effeminate swaying luxury of the long gown.

Exaggeration which relied on cut and trimming to distort the figure was superseded in the early 1360s by the adoption of the paltok, a hip-length tunic that emphasised a broad, rounded chest through use of liberal padding, Margaret Scott has typified the resulting silhouette as 'egg-shaped' and testifies to its popularity as the standard masculine form until 1420.[15] An emphasis on bulk also changed the general cut and decoration of the houppelande, its widening sleeves and

caillete

·I·8·9·X·

8] Whilst this woodcut, entitled 'Of newe fashions and disguised garmentes', aims to ridicule the excessive vanity associated with aristocratic dressing, it also provides a template for the ideal appearance of the ambitious young man.

lengthening, trained hemline offering broadened opportunities for elaborate dagging and inventive systems for fastening and manipulating the fabric into a myriad of folds and creases. Colour remained intensely vibrant; cloth of scarlet derived from madder or cochineal competed from the thirteenth century on with perse, blues and greens which relied on the growing profitability of the woad trade. The ferocity of competition resulted in German madder dealers painting devils in blue as an attack on the new trend.[16] Intensity of colour symbolised both material value and the inward 'brightness' of the wearer. Chrétien of Troyes typifies the contemporary connections drawn between notions of nobility and the emotional resonance of colour: 'The day outside was somewhat dark, but he and the maidens were both so fair that a ray shone forth from their beauty which illumined the palace, just as the morning sun shines clear and red.'[17]

The emphasis in female dress until 1380 centred on tightness and length, accentuated by a conscious revealing of laced fastenings down the front of the dress which empha-

sised the breast and waist. In tandem with the growing mass of the houppelande, a gradual lengthening and broadening of the cut of women's gowns accelerated until the mid-fifteenth century, necessitating the gathering up of reams of skirt into a belt, which itself had moved above the natural waistline to just underneath the bust. The strongest focus of differentiation again fell on the head with the erection of elaborate horned, boxed and veiled coronets for English noblewomen, constructed from finely wrought metalwork (padded heart shapes in Flanders and France) and a high cropped bowl cut for men's hair.

By 1460 the dominant shape recalled the tightness and brevity of dress in the previous century, the skirt and sleeve of the houppelande receding significantly, though distorted and augmented by padding at the shoulders and chest and pleating and gathering at the waist. Margaret Scott encapsulates the resulting, dehumanising effect : 'By about 1450 men had become very wide-shouldered, narrow-waisted creatures walking around on long slim legs which ended in the tapering toes of pointed shoes or boots.'[18] The top-heavy bombasted effect was accentuated by the adoption of padded, turban-like hoods, complemented by a growing tendency towards verticality in the wired butterfly and steeple head-

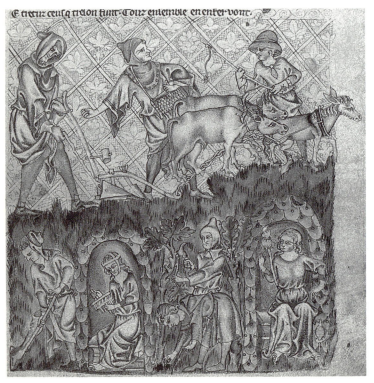

9] In this early-fourteenth-century manuscript illumination, peasants are depicted in clothing which corresponds to contemporary fashionable forms such as pointed sleeves and hoods, whilst also retaining distinctive decorative features seemingly unconnected to more metropolitan styles.

dresses chosen by women up to the 1480s. Details of textiles in the altarpieces and miniatures of the Flemish and Burgundian courts reveal an ostentatious display of richly woven cloth of gold and Venetian silks with huge floral designs, occasionally replicated in rarer English two-dimensional representations.

A final shift towards the square, loose simplicity associated with the turn of the sixteenth century was anticipated in the 1470s by a rejection of superfluous bulk in favour of an attenuated minimalism. In men's dress this was signified by seams that did not fasten at the shoulders or down the front of the robe. The body appeared in a state of undress, with underlinen showing through at the joins; a manipulation of the contrasting effects of layered clothing that would continue via an obsession with looseness and a toned-down sobriety in the colours, textures and shapes of both masculine and feminine garments in the 1490s. If cycles in fashion are anything more than a historian's conceit, the end of the fifteenth century brings us back, at least in a superficial stylistic analysis, to the beginning of the fourteenth, with simple, square-necked 'T' shaped garments, waists and shoulders approximating to the natural human contour, and the rejection of elaborations such as dagging or vivid colouring for the restrained sumptuousness of fur trimming, teamed with deep black, brown and purple dyes. In many ways, perhaps, a shift in focus back to the body corresponds with the claims made by historians for a wider shift in values and perceptions at the end of the fifteenth century:

> From now on the eye halted at the physical appearance, and the perceptible world, instead of being merely a symbol of the hidden reality, acquired value in itself and was an object of immediate delight . . . The withering away of symbolism, or at any rate the fading away of symbolism before perceptible reality, shows a deep change in sensibility. Man, reassured, contemplates the world as God did after creation, and finds that it is good.'[19]

Whilst the progress and development of fashionable style from c.1350 onwards is in obvious and marked contrast to fashion systems in earlier periods, it is inadequate merely to describe its shifting forms and broader cultural meanings without grounding that change in some sort of economic and industrial context. Before going on to relate its implications for new formations of identity in Western society, it may be useful briefly to examine the underpinning of medieval fashion change by technological and organisational

innovation. Jean Gimpel in his influential, though admit-
tedly hyperbolic book on early industrial processes, *The
Medieval Machine*, dismisses all previous notions of pre-
industrial primitivism in his claims for a medieval 'industrial
revolution':

> The middle ages was one of the great inventive eras of mankind.
> It should be known as the first industrial revolution in Europe.
> The scientists and engineers of that time were searching for
> alternative sources of energy to hydraulic power, wind power
> and tidal energy. Between the tenth century and the thirteenth
> century, Western Europe experienced a technological boom . . .
> There was a great increase in population, which led to massive
> movements of people . . . they emigrated . . . they founded and
> built new towns. Conditions favoured free enterprise . . .
> Capitalist companies were formed and their shares were bought
> and sold. Entrepreneurs were fully prepared to use ruthless busi-
> ness methods to stifle competition. They introduced extensive
> division of labour to increase efficiency . . . Energy consumption
> increased considerably . . . Many of the tasks formerly done by
> hand were now carried out by machine . . . The period was
> characterised by a sense of optimism, a rationalist attitude and
> a firm belief in progress.[20]

Despite his imprudent use of twentieth-century termi-
nology, Gimpel successfully conveys the sense of general and
rapid advancement in which a discussion of medieval cloth-
ing should be placed. Textile production, almost anticipating
its later role in the reorganisation of industrial processes in
the eighteenth century, had a central place within the
medieval economy. Up until the second half of the thirteenth
century, the major centres of woollen cloth production were
located in the thriving cities of Flanders – Ypres, Ghent,
Bruges, Arras, Saint Omer and Douai. Raw materials were
imported from English farmers who had so far failed to
exploit the commercial possibilities of weaving, finishing and
marketing wool through their concentration on sheep-
rearing. Political interference and manipulation by the
English Government, characterised by successive rises in
excise duties and periodic trade embargoes gradually starved
the Flemish of their only source of wool and eventually many
of their workers, attracted by English offers of jobs and low
taxes. As early as 1271 Henry III decreed that 'All workers of
woollen cloths, male and female, as well of Flanders as of
other lands, may safely come into our realm, there to make
cloths'[21] and John Lydgate's tract 'Horse, Goose and Sheep' of
*c.*1436–40 makes explicit the growing superiority of English
wool:

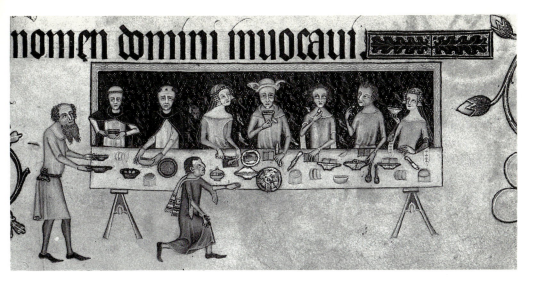

nomen domini inuocaui.

10] The aristocratic household enabled a rudimentary dialogue between the clothing habits and consumption choices of those from differing ranks. In this illustration of a banquet scene, servants, clerics, a minstrel, and the lord's family and guests, come together around the table.

Of Brutus Albion his wool is his chief richesse
In price surmounting any other thing
Even grain and corn. Merchants all express
Wool is the chief treasure in this land growing.

All nations affirm up to the full
In all the world there is no better wool.

The sheep is came and has been full long
Of new strife and of mortal war
The wool was cause and great occasion
Why that proud forsworn Duke of Burgundy
Came before Calais with Flemmings not a few.[22]

The expansion of the English textile industry was also encouraged by the introduction of innovations such as the spinning-wheel and fulling mill, which improved production without demanding a commensurate increase in labour. However, as Gimpel points out, mechanisation demanded a tighter organisation of the work-force. Thirty stages of production in the completion of finished cloth implied almost as many specialised jobs. Workers were divided into three specialised guilds, dyers, fullers and shearers, in descending order of earning capacity and importance. Weavers formed the main body of the textile profession, but their prosperity relied on long hours and good health. On the bottom rung were the manual workers, the combers and carders who at least possessed equipment, and the unskilled threshers, washers and spinners. The guild of drapers held control over all stages of operation, from the purchase of raw wool to the final stages of marketing. It was no coincidence that the

drapers filled positions of power in town bureaucracies and were able to regulate output and prices, honing their entre-preneurial skills. Further intervention in the economic organ-isation of a widening English wool trade arose through the involvement of cross-continental merchants' associations such as the Hanseatic League in the co-ordination of exports, and the financial backing of Florentine bankers who saw the production of fashionable textiles as a basis for sound invest-ment. The highly developed and international complexion of the medieval fashion business, in which merchants were able to trade across the continent with samples of English broad-cloth[23] or fine Italian silk, gives some credence to arguments which rely on foreign influences as an explanation for fashion change. The dramatic evolution of fashionable form in the mid-fourteenth century is certainly resonant with the heightened language of commerce and a new material worth that arguably takes clothing into the sphere of a 'modern' fashion system. Van Uytven outlines the arising disparities caused by an ongoing emphasis on inherent value and status, and the ironies that this caused for developing trade, distrib-ution and marketing strategies; a note of caution that fortu-itously leads the historian towards a closer evaluation of the consequences and contexts of 'modern fashion' for new markets and consumers:

> A fine Brussels cloth was worth about 800 grams of gold, equiv-alent to one diamond, five rubies and five emeralds or thirty kilos of pepper, a proverbially high-priced spice. As a craftsman had to spend between a third and a half of his earnings on food for his family, it is clear that his purchases of clothing would be limited in volume and value. Only an exclusive upper-class person could afford to wear quality cloths and therefore even a modest production of luxury woollens called for distribution over a very wide area.[24]

Poverty and luxury – medieval clothing and social hierarchies

A descriptive history such as the one just given, especially one relying to such a great extent on the evidence of portraits, tomb effigies and manuscripts commissioned by the wealthy, or ecclesiastical archaeological remnants that owe their sur-vival to their inherent quality and expert workmanship, present a view of medieval dress that necessarily focuses on the status of the wearer. Much of what survives in terms of source material for a history of fashion reflects the viewpoint

of the rich (though the recent finds in the Thames mud provide useful comparative evidence of non-elite dress). Indeed, it is perhaps arguable that if it is possible to identify a moment from the mid-fourteenth century to the late fifteenth century in which the historian can justify evidence for the beginnings of a fashion system, then the moment described concerns only the rich. In a society arranged around rigid strata, duties and expectations, dictated by such considerations as gender, wealth, age, land and ancestry, personal appearance carried immense importance as an indicator of social position and role. Luxurious textiles, inventive cutting and rapidly changing style all attested to a heightened, civilised position, and conceivably, from a twentieth-century viewpoint, make for the most romantic and colourful history. But what is missing from such a narrative is any explanation or description either of variety within such a system of prioritised 'fashion', or of systems which while not dominant in terms of wealth and status, must have presented similar shifting codes and styles. What is required, and what costume history neglects, is an evaluation of both the typicality and the social meanings of the butterfly head-dress or the houppelande, and in their absence an evaluation of the alternatives.

The advice offered by the God of Love to the Lover in the *Roman de la Rose* presented specific guide-lines relating to the politics of personal appearance which went beyond descriptive analysis to offer indications of the cultural role of aristocratic display:

> First one must show no vilanie, which means having nothing to do with people who are vilain, those who are unkind, unhelpful, and without friends . . . Be friendly, greet people, important or unimportant, in the streets as you pass along . . . Do not display vain pride. Above all, be attractive, show cointerie! Dress well and buy good footwear, as your pocket book permits. You should have a good tailor who knows how to sew fine stitches and make your sleeves well fitting. Wear fresh, new shoes quite frequently, so closely fitting that lower-class people will wonder how you got into them and how you will take them off. When you go out, carry gloves, a silk purse, and wear an attractive belt. If you cannot afford this, do the best you can. At Pentecost, a young man can wear a chaplet of roses around his head, which is cheap enough. Do not allow any dirt to be on you. Wash your hands, polish your teeth, and have no sign of dirt on your fingernails. Sew on your sleeves, comb your hair, but do not make use of any face make-up, which is for women only, or for sodomites.[25]

The writer betrayed many of those characteristics that identify the period under study as one of realignment in terms of fashion; the new emphasis on tightness and fit, for example. More importantly there is also a betrayal of social uncertainty, evidence that fashion was fulfilling a role wider than that of decoration. Apart from the warnings against effeminacy, pertinent in a passage that seemingly comes close to its advocation in its espousal of fine textiles and floral embellishments, the writer was also concerned enough to highlight the manner in which dress might differentiate the wearer from 'lower-class people'. Status was seen to be achieved through a combination of natural nobility and pecuniary advantage, though there is an inference that fashionable grace was achievable in degrees, according to pocket.

The reliance of fashion on the economic power of the spender, whilst often discussed in work on the relationship between dress and class in the eighteenth and nineteenth centuries, has been overlooked in studies of medieval dress. Disciplines other than dress history offer no remedy; consumption as an issue is as conspicuously absent from social and economic histories of the later Middle Ages. Christopher Dyer in his pioneering work on medieval standards of living identifies the gaps:

> The emphasis in historical writing has always been on the forces of production. Medieval historians have enquired into such subjects as field systems, the efficiency of corn growing, the organization of cloth-making and the techniques of trade . . . All too often agriculture is seen as a matter of cultivation and productivity, and the end products of bread, porridge, ale and fodder are forgotten. Trade is seen in terms of sellers rather than buyers. Market places and towns were indeed inhabited by merchants, shopkeepers and hucksters, but their presence would have been futile without customers. Weavers, cutlers and potters could only make their living if their cloth, knifes and jugs were bought and used.[26]

As a result of such neglect, a simplistic reading of the relationship between wealth, status and appearance has evolved. Most evident in descriptions of peasant costume are those explanations that use literary and visual representations as descriptions rather than constructions. In a rather deterministic manner the appearance and attire of the serf in low-relief grotesque carvings or manuscript border illuminations has been attributed almost entirely to conditions of work.[27] Working dress is typified by historians as consisting of the knee-length 'gonne', a loose-sleeved tunic of undyed wool

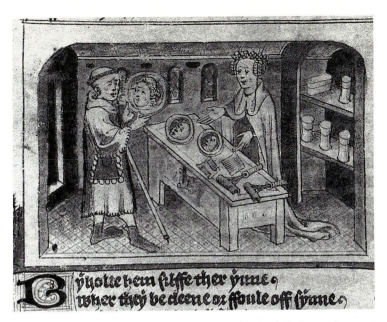

ꝓnotie bem filfe ther ynne ҫ
wher they be cleene oꝛ ffoule off ꝼame ҫ

11] The expansion of mercantile activity in urban areas encouraged a growing use of fashionable suppliers by tradesmen and those in the lower ranks of public life.

fastened by a basic leather thong, tied around the waist and secured by knots passed through a slit in the leather. A loose hood provided warmth and protection in the winter, whilst a wide-brimmed straw hat shielded from the summer sun. Legs might be covered by basic loose wool trousers secured with a cross-gaitered leather or twine strip to the knee. Functional aspects have been prioritised at the expense of any consideration of the symbolic attributes of clothing, or the variety of textiles and styles available within a narrow and limited spending bracket. Using the evidence of maintenance agreements drawn up for the local provision of clothing and food allowances to old people, Christopher Dyer has presented a rather more sophisticated and less deterministic picture of fourteenth-century peasant appearance:

> Peasant clothes were not made from the cheapest materials available. The textiles used for tunics cost 8d to 1s 3d per yard, not very different from the cloth bought by some gentry households . . . Peasants evidently economised on the dyeing of their clothes, because they often wore 'white', the natural colour of the fleece . . . Wealthy peasants like Robert Oldman, the reeve of Cuxham, with his robe of Murrey (dark brown) worth 6s 4d, his red robe worth 5s 3d and cheaper blue garment, must have stood out among his drably-clad neighbours.[28]

An obvious interest in fashionable colour and quality of finish implies that peasant clothing should not be read merely in terms of the provision of warmth and modesty. Indeed the wider changes in fashion of the 1350s can to some

extent be identified through maintenance records for peasant consumers as early as the 1380s. John Herfney of Framlingham in Suffolk was promised an allowance on his retirement in 1389 that included a doublet of russet lined with blanket and two pairs of hose. The reference to doublet and hose suggests an acquaintance with the new style of cutting the tunic closer to the body and much shorter, but lined to give the requisite padded effect and matched with stockings to complete a more streamlined fashionable appearance. Peasant comprehension and adoption of fashionable style can be accounted for in several different ways. Certainly a concurrent expansion in the English woollen textile industry provided both the home market and foreign buyers with cheaper and wider choice, even extending to those on lower incomes. Also the proximity of servants and estate workers to the lives of their employers, demanded by a working society arranged in a feudal system to rotate around the lord's household, offered more opportunity for first-hand observation and imitation or adaptation of aristocratic lifestyles and dress. A transcription of ballads by the troubadour Marcabru describes a sense of confusion arising from the similarities between peasant and lord, or more specifically shepherdess and lady: 'The other day beside a hedge I found a shepherdess, half peasant and half upperclass, full of gaiety and sense. She was the daughter of a peasant mother. She wore a head covering, a gown and a fur lined garment, and she had a well woven shirt, shoes and stockings of wool.[29]

But more useful in an exploration of the uses and meanings of fashionable style across social groups is an explanation provided by contemporary debates on the ethics of the new luxury. Conveniently dated to the early 1350s,[30] the poem 'Wynnere and Wastoure' presents an open debate between Winner, the respectable urban proto-capitalist who represents the Church, trade and business, and Waster, the voluptuary and champion of knights, landed gentry and the aristocracy. Winner is critical of Waster's extravagance and wilful neglect, advocating hard work and prudence. Waster accuses Winner of undermining traditional hierarchies in which lords are distinguishable from servants through lifestyle and supports magnanimity and overspending as a means of stimulating the economy for the good of all. Coinciding with a growing taste for overt fashionable display at most levels of society, the poem anticipated attempts by Parliament to interfere with the consumer choices of society at large. The sumptuary

law of 1365 attempted to dictate that grooms, servants and the employees of urban craftsmen should only wear cheap woollen cloth costing no more than 1s 1d per yard. At the other end of the scale, merchants worth £1000 were permitted to dress no better than gentlemen receiving £200 a year rent (silk and some fur), whilst knights worth £1000 could dress at their pleasure with the exception of ermine.[31] Following the social upheavals caused by the Black Death, the debates encapsulated by Wynnere and Wastoure and the sumptuary laws, however ineffective they were in their material effects, illustrate a recognition within medieval society of the power of dress as a communicator of rank and a longing for that power to be manifested through a clearly defined system of priorities based on social position rather than wealth.

Implicit in the demands of the 1350s and 1360s for more suitable lower-class dress was an expectation that the aristocracy should cement their position at the heights of the feudal system through ostentatious display, a sentiment echoing the justifications of Waster for his prodigality. Christopher Dyer has shown that the purchase of textiles formed a high proportion of the expenditure of aristocratic households, but was made necessary by the very visible role that textiles played in the communication of status. Such a purchase would cover clothing for the immediate family, liveries for servants and retainers, upholstery for beds, hangings and tables, and cloth for hygiene, storage and wrapping. The quality of such textiles might vary considerably according to the standing of the family. Using household inventories and accounts Dyer presents a comprehensive picture:

> The Eyres of Hassop [Derbyshire] in the 1470s . . . obtained most of their woollens by contract with local weavers, fullers and dyers, as much as 100 yards in one year. They also bought ready-made a wide range of cheap woollens, cottons, canvas and linens . . . The very luxurious silks were bought in very small amounts . . . Most gentry families must, like the Eyres, have bought silks very sparingly, and more woollens than linens. The higher aristocracy wore silks in greater quantity . . . and also large quantities of linens . . . imported from the low countries, Flanders and Germany. Their clothes were more likely than those of the gentry to be lined with fur. They bought squirrel skins in the thirteenth and fourteenth centuries, changing to marten, sable and budge (black lamb) in the fifteenth. Such linings could add £2 or £3 to the cost of a garment, reflecting both the value of the materials, and the amount of skilled labour needed to match and stitch the skins.[32]

However, if one single group were singled out as the focus of critical attention in the discussions on dress from the mid-fourteenth century on, it was the merchant and business classes in the growing urban trade centres. Provincial tailors in Northampton, for example, capitalised on metropolitan patronage of 'full many gentilmen and other people of our lorde the Kynge for the shayping of their clothying and of their servauntes and of theire lyvereys' during the fifteenth century.[33] A familiarity with the wide range and value of textiles on offer, together with an understanding of their potentiality in terms of prestige, conspired to cause little differentiation between the opulence of the aristocrats and the showiness of the tradesmen who supplied them. A.R. Bridbury describes the resulting patterns of fashionable emulation:

> the new affluence brought lesser men, minor landlords, successful lawyers, civil servants and clergymen, prosperous provincial merchants perhaps, and even those who were not in the leading ranks of membership of the great households, within the charmed circle of those who were able to wear cloth which proclaimed their discrimination and paid suitable tribute to the importance of their status.[34]

Certainly by the end of the fifteenth century some artisans were able to bequeath remarkably rich clothing in their wills. Heather Swanson quotes the case of John Chesman, a barber and chandler who died in 1508 leaving four gowns, two of them furred, three doublets, two jackets and a 'little shert with red silk going through it'. A 'cremsyn gown' left by the pewterer Richard Wynder was valued at 38s 4d.[35] Of course these men were the exception, most townsmen contented themselves with the relative comfort of three-shilling russet gowns, but Chandler and Wynder, alongside the rural workers Herfney and Oldham, illustrate the wide varieties of style, cut and colour available to ordinary men of reasonable means after the 1350s and give the lie to histories of dress which conveniently compartmentalise medieval costume according to social caste. The power of clothing to transform and transgress perceived social barriers was perhaps stronger than its supposed ability to define them. The *chanson de geste* by Houn de Bordeaux perfectly presented the paradox in the story of Hue who has lost all his clothing in a river. The minstrel 'minister of the devil' gave carefully described aristocratic clothing to Hue, a naked wild man in appearance, but a 'gentle' knight in character:

Underneath a tree he found a man who was as we shall describe him. He had a harp on which he could play, and a viele. There was not another minstrel so good in all the pagan land. He had spread a cloth before him and on this he had four loaves of fine bread and a skin of claret wine . . . When he saw Hue, naked as the day he was born, he was frightened. He called out 'Wild Man, don't hurt me.' 'By my faith, I am quite wild', said Hue, 'but I won't touch you. Please give me some of your bread.' 'You shall have it. I am sorry for you. Find in my pack an ermine-sleeved garment and a mantle of scarlet, with lining. Cover your flesh. You have good need for this . . .' Hue went forward, found the pack, took out the ermine, put it on, and wore a mantle on top. He found plenty of braies and shirts, and he took what he needed.[36]

Defining gender through dress – femininity and fashion

If the stylistic changes of the 1350s initiated problems for the recognition and characterisation of social status, then to an even greater degree they threw into sharp relief, both physically and metaphorically, the roles and appearance of men and women. The economic and political position of women within Western society was well defined by the thirteenth century, particularly in relation to the organisation of the home and the textile and fashion industry itself. Erika Uitz claims that:

> Until relatively recent times, the reputation of an honourable woman in western and central Europe depended to a large extent on whether she could provide her family and her home with textiles, clothes and other necessities. Thus we can safely assume that . . . noblewomen and many others learned to work with silk not in order to make their living from the trade but to enhance their reputation as lady of the home or as potential marriage candidates.[37]

Uitz's view is perhaps a little simplistic, prematurely prescribing later constructions of domesticity for the role of women. What she does identify, though, is the existence of a strong relationship between perceptions of fashion and social expectations of femininity, as though the two were complementary components of the same model. Mary Wiesner charts a more exact history of the process whereby women became excluded from participation in trade, industry and public affairs in favour of a role that prioritised women's status as keepers of the household and visible symbols of patriarchal wealth and standing.[38] Exclusive female involvement in the fashion and textile industry is seen by Wiesner to

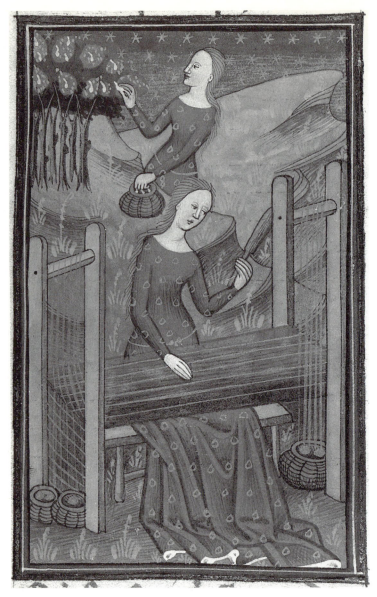

12] Concepts of femininity and fashion were closely intertwined for most of the medieval period, from the production of textiles and clothing accessories, through responsibilities for the maintenance of household linens, to the display of family wealth on the body.

have remained unchallenged until the late Middle Ages. All stages of manufacture from preparation of the raw material to final alterations on the garments themselves took place in the home, organised by the women of the household. In the first half of the thirteenth century, especially in towns and cities, this monopoly was broken by the emergence of male-dominated guilds and systems of apprenticeships for weavers, cloth cutters and tailors. It is no coincidence that this process of proto-capitalist organisation, moving the production of clothing from the home to the public sphere, with its reliance on successful marketing and retailing strategies, preceded a

perceived speeding up of fashion change in the following century. Unorganised female labour was restricted to the unskilled early stages of preparation and cleaning, and the production of cheaper, small-scale fabrics such as veils, ribbons, bindings, scarves and feather work. Using the *Livre des Métiers*, containing the regulations of the Paris Guilds, Shulamith Shahar builds a vivid picture of the role of women workers in the Paris fashion industries of the thirteenth century before their eventual marginalisation:

> The occupations which were exclusively female were: spinning on a broad loom, production of elegant head coverings, decorated with jewels and gold thread, and production of decorated purses . . . Spinning on broad and narrow looms was done at home, and the women received the materials from the merchants. They were under the supervision of two male supervisors . . . who enforced regulations as to quality, wage rates, conditions for the acceptance of apprentices, fines for violations, acceptance of new workers and rest days. The purse-makers, like the women who wove silk for head coverings, were organised in women's guilds whose regulations were determined by the guild members.[39]

Whilst the exclusion of women from skilled production has usually been seen, especially in Marxist readings, in the context of later developments leading to the growth of capitalism and the separation of home and workplace, recent feminist approaches have chosen to interpret the formation of female domestic roles in the medieval and early modern periods in the light of social rather than economic determinants, the rise of an aggressive patriarchal mode of masculinity emphasising the family as the preferred sphere for feminine intervention and responsibility. Such interpretations, using admittedly prescriptive sources such as sermons, etiquette books and misogynistic political pamphlets have focused on the role of ideology in formations of gender stereotypes. Dress and appearance, read as ideological constructs alongside their status as material evidence of technological and aesthetic circumstance, seem to reflect those same early changes and definitions, clearly illustrating similar tendencies towards well defined gender roles, but so far this area has not been sufficiently explored by either fashion historians or women's history.

To characterise masculinity or femininity as separate and definable states within medieval culture would be misconceived; more appropriate would be a discussion of masculinities and femininities, as variations obviously

existed according to class, age, wealth and nationality. But in physical terms notions of a formulaic ideal for male and female beauty were ingrained in visual and literary interpretations of the human body. Descriptions of the ideal male body prioritised proportion, strength, nobility and grace: 'Aucassin . . . was attractive and large and well-cut in legs, feet, body and arms. He had blond hair, finely curled, and his eyes were grey-blue and laughing, and his face was bright and shapely, and his nose was high and well-placed.'[40] And, 'He had a broad back and a body in proportion. Broad shoulders and a wide chest, he was strongly built. Big powerful arms and huge wrists. A long and graceful neck.'[41]

Heightened colour, diminutive size and delicacy formed the recurring standards for female beauty, which in some way was seen to mirror or complement the male ideal. In both cases, the shifting emphasis in fashionable cut and style towards a more overt display of the body and its sexual characteristics seems to have accentuated difference in a very deliberate manner:

> She had blond hair finely curled. The eyes were gay and laughing, the face shapely, the nose high and well-placed. The lips were more red than a cherry or a rose in the summer season, and her teeth were white and fine. She had breasts, hard, which lifted up her gown just as if they were nuts, she was slender about the waist so that one could enclose it in two hands. The daisies lying under the instep of her feet, which she crushed with her toes, were outright black compared to her feet and legs, so very white was the little girl.[42]

Chivalric or courtly literature formed the main source for such descriptions and was responsible for circulating the most dominating models of gendered fashionability. This was a discourse which presented the noblewoman as a romantic paragon, relieved of temporal responsibilities such as the management of households and territories in favour of a leisured lifestyle revolving around the playing of games, chess and falconry, the production of decorative textiles on lightweight looms, and the pursuit of courtly love in which the ideal lady became the focus of knightly missions. This was of course an ideal; in the words of Eileen Power 'The lady of chivalry was indeed a beautiful, artificial figure, but never perhaps, save in the idolence of courts and great Lords' castles, the figure of a real person. It is significant that her image has been drawn from romances, and the romantic poem of the middle ages often represented not reality, but an escape from reality.'[43]

Despite the shortcomings of such sources as historical evidence for the realities of dress and appearance, here was an escape that helped to shape the self-perception of high-ranking women in the real world, and to some extent moulded and reflected attitudes towards them. Thus through the propagation of an ideal, the medieval woman became entwined with concepts of weaving, textile work and fashion as 'feminine' pursuits. This association was simultaneously constricting and empowering. Christiane Klapisch-Zuber condemns expectations of needlecraft as a universal female skill as 'ways of immobilizing women's bodies and dulling their thoughts'[44] justified by liturgical promises of release from purgatory and fatherly assurances of outside earnings in the face of poverty or spinsterhood. The contemporary picture painted by Christine de Pisan in *Le Livre des Trois Vertus* of 1406 (see fig 4) is rather more positive. The noblewomen with whom her book was concerned found themselves in a position of tangible power, capable of deputising for their lords during absences from estates caused by war, diplomacy or business. Within the household the specific budgetary duties of the great lady were prioritised as covering almsgiving, household expenses, payment of officials and the purchase and maintenance of gifts, jewels and dresses.[45] The management of the wardrobe took on a special significance, with the presentation and position of women at court increasingly viewed as a feminine prerogative, specifically concerned with the display of power through a wealth of textiles and the cultivation of physical beauty. Shulamith Shahar cites the example of triumphant processions separate from those of the king, for queens and female fiefholders accompanied by their noblewomen when they entered their towns.[46] Petrarch has provided eyewitness evidence for such scenes in his description of a riverside ceremony held by women of the Cologne court in 1333: 'What shapes! What poses! Their heads garlanded with fragrant herbs, their sleeves raised above their elbow, they dipped their white hands and arms into the current, murmuring in their own language a sweet cantilena.'[47]

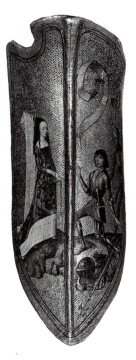

13] This decorative shield clearly illustrates the artificial roles prescribed for men and women in courtly chivalric literature, the delicate elegance of the lady protected by the warlike figure of her knight. To some extent the romantic associations of the model were reflected in the clothing choices of the elite.

A female sphere concerned with dress, its production and its political significance was not confined to the world of noblewomen alone. Its role within the structure of the family across social boundaries has been identified by social historians as an important location for the formation of more lasting constructions and concepts of femininity. The familiar modern ideal of companionate marriages based on ideals of romantic love was alien to medieval communities. The

usual wide difference in age between partners, and the dry business nature of marriage arrangements based on property prohibited any great sense of sentimental companionship, even though the ballads and romances suggested warmer kinds of courtship. David Herihy claims that the huge loss of population caused by plague in the later Middle Ages helped to inspire a more positive attitude towards marriage. Within a renewed atmosphere of mutual support and stronger familial ties, the maternal role took on the function of intermediary between generations of fathers and children and more importantly became a channel for the passing on of cultural values. 'Deeply involved in socializing the young, mothers were instrumental in preserving and enriching the cultural tradition.'[48] Dress might be characterised as one such tradition. Already practically involved in the domestic production of textiles and garments, as well as being responsible for their acquisition from a wider market, women became well versed in the rhetoric of clothing, its growing importance as a communicator of status, taste and gender roles.

Fashion and the individual – morality and cloth

As well as defining gender roles and status within family-based communities, the pervasiveness of fashion as a new concept from the 1350s had a more direct impact on the emergence of the individual – a sense of self-knowledge and an understanding of man's place in the wider structures of the world. Within medieval society the body was prioritised as the dwelling-place of the soul, inner character was displayed through outward signs and clothing could not avoid implication in such a problematic moral arena. Individuality and the communications of the soul were manifested through various strategies. Jacques Le Goff points to bodily gestures as a central support for an understanding of networks of behaviour and appearance:

> The body provided medieval society with one of its principal means of expression . . . Medieval civilization was one of gestures. All the essential contracts and oaths in medieval society were accompanied by gestures and were made manifest by them. The vassal put his hands between those of his lord and spread them on the bible; he broke a straw or threw down a glove as an act of defiance. Gesture had meaning and committed people.[49]

In liturgical circles the significance of corporeality was imbued with strict moral considerations. Gregory the Great

referred to it as 'this abominable garment of the soul' and at every opportunity the clergy would seek ways to chastise and mortify any evidence of physicality through self-flagellation, the wearing of uncomfortable textiles and a disregard for such effeminacies as bathing. Ascetic practices drew attention to the body and its imperfections in much the same way as revealing cut and bright dyes accentuated its new significance, but although the two extremes were undoubtedly antagonistic and critical of each other, the emphasis on the individual, whether positive or negative, was a central feature of medieval life. Aron Gurevitch identifies 'a tendency deeply inherent in medieval popular perception to translate the spiritual into the concretely sensible and the material 'so that a sense of individuality became a crucible through which moral and spiritual definitions of good and bad, rich and poor, male and female could be made. In other words individuality relied on symbolism of a sort that differentiated clothing, appearance and material possessions could easily supply. Gurevitch continues: 'Evidently, medieval popular culture created favourable conditions for an intimacy of the religious and artistic assimilations of the world. Symbols were transferred into artistic images without ceasing to be symbols.'[50]

The symbolic fashionable body was perhaps associated most closely with the growing importance of the city as a focus of social interaction and display and an allied sense of cosmopolitanism. Descriptions of metropolitan life might be condemnatory or laudatory according to the prejudices of the author, but they usually focused on the massed humanity of the inhabitants and used appearance as a classifying tool. Richard of Devizes, a Winchester monk of the late twelfth century, took a typically moralising view of a teeming London: 'every quarter of it abounds in grave obscenities . . . the number of parasites is infinite. Actors, jesters, smooth-skinned lads, moors, flatterers, pretty boys, effeminates, pederasts, singing and dancing girls, quacks, belly dancers, sorceresses, extortioners, night wanderers, magicians, mimes, beggars, buffoons, all this tribe fill all the houses.' In contrast William Fitzstephen concentrated on the positive values of display: 'The citizens of London are everywhere regarded as illustrious and renowned beyond those of all other cities for the elegance of their fine manners, raiment and table.'[51] Such inhabitants undoubtedly trod a fine line between the two extremes. Prostitutes, for example, though legislated against and denied the opportunity to wear the quilted or fur-lined

garments of the nobility, were officially identifiable through their bright contrasting clothing and excess of trimmings such as ribbons and mi-parti. Transgression of sartorial codes and laws by prostitutes could lead to confiscation of particularly rich textiles and decorations, furs, silver jewels, gemstone buttons, which according to Shulamith Shahar testified to 'an outward expression not only of feminine love of adornment but also of their desire to compensate themselves by lavish display for their inferior status'.[52]

The wearing of rich or fashionable clothing not only put the wearer at risk of identification with prostitution, but could also reveal the hidden sin of vanity:

14] The fashionable trod a precarious path between the sin of excessive vanity and a duty to present character and status through clothing. Here, in a woodcut entitled 'Of elevate pride and boasting', the burgher's wife neglects her domestic chores to admire her headdress, attracting the attention of the devil in the process.

One noblewoman, appearing in church decked out like a peacock, did not notice that on the long hem of her luxuriant dress a multitude of tiny demons was sitting. Black like Ethiopians, they clapped for joy and jumped like fish in a net, for the woman's inappropriate attire was nothing other than the devil's snare. Having fallen into vanity, people do not see the demons swarming around them like flies, but this mournful picture is distinctly visible to the righteous.[53]

In other words, interpretation was all, clothing was an outward grammar revealing the darker interior. Rossiand draws attention to the contradictions implicit in such a problematic reading of fashion: 'Not only was wealth legitimate, it facilitated self-realization, virtue, salvation. Popular preachers condemned only its excesses, burned women's tall conical headgear, and denounced luxurious clothing. However, they portrayed the apostles as honest craftsmen with a bourgeois lifestyle and the Virgin as a lady receiving her friends in an opulently furnished home.'[54] Such complicated codes, whilst shaping concepts of individuality, also had a role to play in the increased profile given to ideas of civility as a governing structure in the organization of 'modern' society. Using the pioneering work of the historical sociologist Norbert Elias, it should be possible for the fashion historian to link a growing awareness of fashion to those changes in manners that Elias identifies as the foundation of a 'court society' and by implication of the social formation of succeeding societies.[55] Using etiquette books alongside paintings, literature and court documents, Elias charts a history of the ways in which the most biological or 'animalistic' of human functions such as urinating, defecating, breaking wind and clearing the nostrils have undergone a process of control from a thirteenth-century frank acceptance to a gradual association after the Renaissance with shame and privacy. Through such changes 'a long-term trend becomes apparent towards greater demands on emotional management and more differentiated codes of behaviour'.[56] The parallels with shifting perceptions of fashion and its functions within society after 1350 are obviously strong:

The body as a whole was hardly involved, hidden away inside clothes which were all that people really saw. The nature of the clothes, therefore, becomes all-important to an understanding of what constituted propriety. Their precise role in a strategy of good manners reveals the extent to which attention never went beyond the visible . . . The focus of attention in clothes was their surface. It was this which not only caught the eye, but held it. Richness and respectability were the two dominant qualities.

The existence of the skin and the concrete conception of the body were largely forgotten in the presence of the coverings of wool and fur. It was as if everything should relate to the visible, as if material and form exhausted the potential qualities. The envelope assumed the role of the body.'[57]

Through such an interpretation as this we come full circle, arriving at an explanation which attempts to make sense of the apparent sudden shift towards both a revelation and a distortion of the body in those fashions of the 1340s condemned by John of Reading at the start of the chapter. If we can trust the chroniclers and the illuminators, the bureaucrats and the textile workers of the fourteenth century enough to deduce from whatever evidence they have left proof of change whose substantiality suggests the beginnings of a modern system of fashion then we are justified in moving beyond traditional fashion history explanations towards an investigation which highlights the potential of clothing as a creative medium for expressing social change and cultural value.

Notes

1 *Brut Chronicle* 1344, in S. A. Newton, *Fashion in the Age of the Black Prince*, Woodbridge, 1980, p. 9.

2 Newton, *Age of the Black Prince*, p. 2.

3 M. Scott, *A Visual History of Costume: The Fourteenth and Fifteenth Centuries*, London, 1986.

4 E. Crowfoot, F. Pritchard and K. Staniland, *Textiles and Clothing: Medieval Finds from excavatioons in London c.1150–1450*, London, 1992, p. 150.

5 H. M. Zylstra-Zweens, *Of his array telle I no lenger tale: Aspects of costume, arms and armour in Western Europe 1200–1400*, Amsterdam, 1988, pp. 7–8.

6 Crowfoot, *Medieval Finds*, p. 176.

7 C. Clunas, *Superfluous Things, Material Culture and Social Status in Early Modern China*, London, 1991, p. 2.

8 Scott, *A Visual History of Costume*, p. 16.

9 Zylstra-Zweens, *Of his array*, p. 19.

10 Newton, *Age of the Black Prince*, p. 3.

11 J. le Goff, *Medieval Civilization 400–1500*, Oxford, 1988, p. 339.

12 Crowfoot, *Medieval Finds*, p. 180.

13 E. Ennen, *The Medieval Woman*, Oxford, 1989, p. 218.

14 Zylstra-Zweens, *Of his array*, p. 22.

15 Scott, *A Visual History of Costume*, p. 17.

16 Le Goff, *Medieval Civilization*, p. 358.

17 Le Goff, *Medieval Civilization*, p. 338.

18 Scott, *A Visual History of Costume*, p. 17.

19 Le Goff, *Medieval Civilization*, p. 352.

20 J. Gimpel, *The Medieval Machine: The Industrial Revolution of the Middle Ages*, New York, 1977, p. viii.

21 Gimpel, *The Medieval Machine*, p. 99.

22 R. Van Uytven, 'Cloth in Medieval Literature of Western Europe' in N. Harte and C. Ponting, eds, *Cloth and Clothing in Medieval Europe*, London, 1983, p. 153.

23 P. Wolff, 'Three Samples of English Fifteenth-Century Cloth' in Harte and Ponting, eds, *Cloth and Clothing*, p. 121.

24 Van Uytven, 'Cloth in Medieval Literature, p. 151.

25 U. T. Holmes, *Medieval Man, his Understanding of Himself, his Society and the World*, North Carolina, 1980, pp. 43–4.

26 C. Dyer, *Standards of Living in the Middle Ages: Social Change in England 1200–1520*, Cambridge, 1989, p. 7.

27 Holmes, *Medieval Man*, p. 91.

28 Dyer, *Standards of Living*, p. 176.

29 Holmes, *Medieval Man*, p. 92.

30 Dyer, *Standards of Living*, p. 87.

31 N. B. Harte, 'State Control of Dress and Social Change in Pre-Industrial England' in D. C. Coleman and A. H. John, eds, *Trade, Government and Economy in Pre-Industrial England*, London, 1976, p. 135.

32 Dyer, *Standards of Living*, p. 79.

33 H. Swanson, *Medieval Artisans, An Urban Class in Late Medieval England*, Oxford, 1989, p. 46.

34 A. R. Bridbury, *Medieval English Clothmaking: An Economic Survey*, London, 1982, p. 43.

35 Swanson, *Medieval Artisans*, p. 47.

36 Holmes, *Medieval Man*, p. 173.

37 E. Uitz, *Women in the Medieval Town*, London, 1990, p. 53.

38 M. Wiesner, 'Spinsters and Seamstresses: Women in Cloth and Clothing Production' in M. Ferguson, M. Quilligan and N. Vickers, eds, *Rewriting the Renaissance: The Discourses of Sexual Difference in Early Modern Europe*, Chicago, 1986, pp. 191–2.

39 S. Shahar, *The Fourth Estate: A History of Women in the Middle Ages*, London, 1983, pp. 190–1.

40 Holmes, *Medieval Man*, p. 47.

41 Le Goff, *Medieval Civilization*, p. 355.

42 Holmes, *Medieval Man*, p. 48.

43 E. Power, *Medieval Woman*, Cambridge, 1975, p. 36.

44 C. Klapisch-Zuber, 'Women and the Family' in J. Le Goff, ed, *The Medieval World*, London, 1990, pp. 308–9.

45 Power, *Medieval Women*, p. 43.

46 Shahar, *The Fourth Estate*, p. 153.

47 P. Braunstein, 'Towards Intimacy: The Fourteenth and Fifteenth Centuries' in P. Aries and G. Duby, eds, *A History of Private Life:*

Revelations of the Medieval World, Cambridge, Mass., 1988, p. 575.

48 D. Herihy, *Medieval Households*, Cambridge, Mass., 1985, p. 158.

49 Le Goff, *Medieval Civilization*, p. 357.

50 A. Gurevich, *'Medieval Popular Culture: Problems of Belief and Perception'*, Cambridge, 1988, p. 194.

51 J. Rossiand, 'The City-Dweller and Life in Cities and Towns', in J. Le Goff, ed., *The Medieval World*, London, 1990, p. 139.

52 S. Shahar, *The Fourth Estate*, p. 209.

53 A. Gurevich, *Medieval Popular Culture*, p. 187.

54 J. Rossiand, 'The city dweller', in Le Goff, ed., *The Medieval World*, p. 170.

55 N. Elias, trans. E. Jephcott, *'The Court Society'*, Oxford, 1983.

56 S. Mennel, *'Norbert Elias – Civilization and the Human Self-Image'*, Oxford, 1989, p. 36.

57 G. Vigarello, *'Concepts of Cleanliness: Changing Attitudes in France since the Middle Ages'*, Cambridge, 1988, pp. 48–53.

2 Renaissance: the rhetoric of power

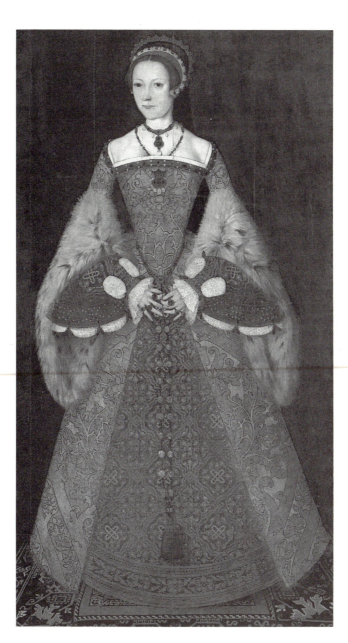

15] A severe, triangular aspect to the female outline was well established in court circles by the middle years of the sixteenth century, heightened here by the flat, decorative and heraldic techniques of English portrait painters. The constituent garments of kirtle, gown, sleeves and forepart are easily discernible here.

Five hours ago I set a dozen maids to attire a boy like a nice gentlewoman; but there is such doing with their looking glasses, pinning, unpinning, setting, unsetting, formings and conformings, painting blew veins and cheeks; such stir with sticks and combs, cascanets, dressings, purls, falls, squares, busks, bodies, scarfs, necklaces, carcanets, rebatoes, borders, tires, fans, palisades, puffs, ruffs, cuffs, muffs, pusles, fusles, partlets, frislets, bandlets, fillets, crosslets, pendulets, amulets, annulets, bracelets, and so many lets that yet she is scarce dressed to the girdle; and now there's such a calling for fardingales, kirtles, buskpoints, shoe ties, etc. that seven peddlers' shops – nay all Stourbridge Fair – will scarce furnish her: a ship is sooner rigged by far, than a gentlewoman made ready.[1]

Transformation, elaboration, and the cultivation of artifice begin to describe the nature of elite modes of dress at the end of the sixteenth century. They are neatly summarised, albeit in a satirical vein, by the above extract, published in 1607 but recalling more precisely the complicated profusion of fashionable styles available at the court of the recently deceased Elizabeth I. Firstly the writer alludes to the power of courtly dress as an agent of disguise, masking the realities of the body to make a symbolic statement. Simple 'boy' becomes 'nice gentlewoman', most obviously reflecting those transformations from masculinity to femininity that were common on the sixteenth-century stage and more subtly suggested in the fluidity between male and female styles of dressing from the 1580s onwards, but also illustrating the potential of appearance as a signifier of social rank. Then in conveying the laborious stages of the toilette, the painting, the pinning and the preparations, the writer re-creates a sense of the importance, the hierarchical connotations and the value or expense attached to the process of undergoing such a fashionable metamorphosis.

The mid-fourteenth century has already been identified as the moment when inventive cutting, new uses of colour and texture, and a deliberate manipulation of the social meanings attached to clothing can be said to have initiated a heightened significance for fashion as something more than the simple reflection of economic or technological trends and physical needs. The sixteenth century, particularly the latter half, shows the development of such a system taken to its extremes. Fashion historians have found evidence for this in their examination of the rich visual descriptions of dress offered by the panel portraits and vellum miniatures of the powerful and wealthy produced in England and Scotland from the 1540s on. The specific flat and schematic manner in

16] The preparation of the body for public display, illustrated in this Venetian woodcut by a woman in the process of bleaching her hair, typifies the ritualistic, transformative nature of sixteenth-century clothing practices.

17] The upholstered look of male clothing is accentuated here, especially in the onion-like hose, prominent codpiece and bulging doublet.

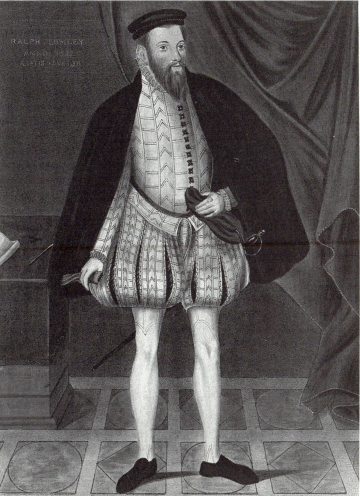

which figures were portrayed in such works offers ample opportunity for the detailed study of shifting style and ornamentation, and when combined with corroborative information garnered from journalistic reports and household inventories, it has been possible to produce heavily documented and useful descriptions of Elizabethan wardrobes.[2] The traditional approach, however, suffers from a sense of literalness in its reading of primary material. As the opening quote of this chapter suggests, late sixteenth-century aristocratic dress was nothing if not fantastical, and whilst costume historians, through painstaking detective work, have produced a framework which establishes the type of costume represented and its inherent symbolism, from widows' weeds to disguises for the masque, there is a reticence in taking such observations further. Through recourse to literary theory and recent art historical work on the body this chapter proposes an avenue through which the contrived and constructed nature of evidence for Elizabethan dress can be more fully acknowledged and used to illuminate the deeper cultural significance of court fashion.

Following the fashion – a survey of elite modes, 1540–1600

In the most general terms, the overriding stylistic principles for fashionable dress identified at the close of the fifteenth century continued to predominate until the middle years of the succeeding century. An emphasis on deeper colour and sumptuous texture at the expense of structural experimentation, expressed through heavy use of black, russet and burgundy velvets and brocades, trimmed or lined with sable and fox and cut to conform with the natural contours of the body, remained a basic staple until the 1550s. By the accession of Elizabeth I in 1558 the standard forms for male and female dress had polarised into an aggressive masculinity, accentuated at the shoulders and throwing emphasis on to narrow hips, muscular legs and padded codpiece, contrasted with a flattened angular femininity, exemplified through a balanced, symmetrical pairing of the bodice and skirt, pyramidical structures that met at the waist. The priority that both styles gave to outline necessitated the use of dark colour, enlivened by the contrast of white lawn frills at neck and wrists. Such a sombre appearance owed a great deal to the prevalence of Spanish court style as a fashionable model in London. From the arrival of Catherine of Aragon at the Court

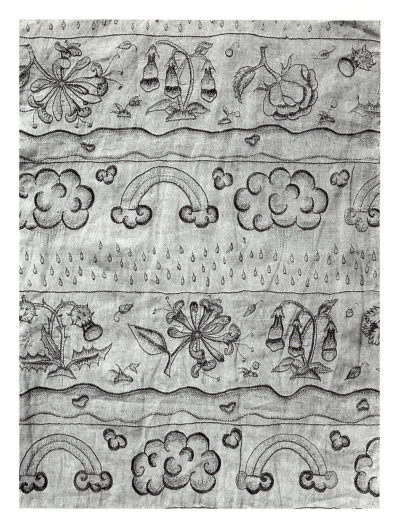

18] Embroiderers were able to translate the images from books of emblems or impresa to the fabric of clothing itself.

of Henry VII for her marriage to Prince Arthur in 1501, the exotic darkness, structural rigour and artificial stiffness of Habsburg modes of dressing provided an alternative to the predominance of Paris as fashion leader. Whilst Catherine preferred to adopt more informal English styles, her entourage was credited with introducing the first example of the far-thingale or hooped skirt support to England. Janet Arnold quotes contemporary observations that the foreign women wore 'benethe ther wast certayn rownde hopys, berynge owte ther gowns from ther bodies after their contray maner'.[3] Perhaps more pertinent to the fashionable silhouette in 1558 was the marriage of Mary I to Philip of Spain in 1554. Besides retaining the stiff cone-shaped farthingale with its concentric bands of whalebone, wire, or twisted rushes introduced by her mother, Mary in her portraits adopted the sombre, indeed rather forbidding demeanour demanded by the formalities of

the Catholic Counter-Reformation.[4] The imported stylised austerity of shape might however be offset by the addition of English decoration, particularly woven knotwork and trellis patterns incorporated into the weave of silks and velvets.

Both male and female dress at mid-century was distinguished by the elaborate variety of component garments, a shift from the relatively narrow choice of the preceding decades. The basic staples of women's dress included the kirtle, originally a floor-length one-piece gown, but from about 1545 a matching skirt and bodice with the skirt taking on the original name of kirtle. The kirtle might be divided by a forepart, a triangular piece of textile, generally stiffened and heavily decorated with applied embroidery and garnets, or a woven pattern and colour to contrast with the material of the

19] The concentric circular forms of women's dress during the 1580s are well displayed here in the ruff, sleeves, looped pearls and hair arrangement of Mary Cornwallis, a magnate's wife. Of particular note is the blackwork embroidery on the arms, shrouded in gossamer-thin over-sleeves.

kirtle and perhaps to match the design of the sleeves. The forepart was attached at the front of the kirtle where the skirt parted, generally tied into place with ribbons or aglets (metal or bone toggles). The bodice, or upper part of the costume, was usually a pair of bodices, boned and tied into place at either side of the trunk with sleeves of the same material attached at the shoulders. Throughout the 1550s sleeves incorporated a wide, long funnel-shaped outer sleeve, turned back on itself at the elbow and pinned to the upper arm, revealing both its own lining, either furred or finished to the same standard as the bodice, and the contrasting decoration of an embellished and slashed undersleeve. If through cold or modesty the shoulders and upper chest required covering, the partlet, a decorative yolk of embroidered fine linen, identical

20] An increasing sense of effeminacy dictates the styles worn by young aristocrats during the latter years of the sixteenth century. Elaborate embroidery, melancholy blackness and the attributes of hawking all conspire to produce an image of indolent power.

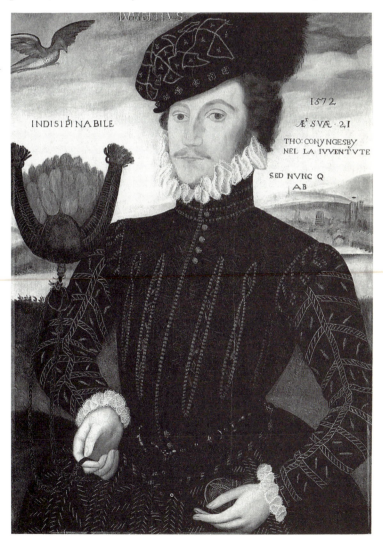

material to the bodice, or a semi-transparent gauze scarf could be attached to the top of the bodice and sleeves filling in the cleavage and neckline. Beneath all of this was worn a protective floor-length linen smock decorated at the exposed cuffs and neck with intricate black embroidery or fine cutwork resembling lace. The material of the smock could be pulled through cuts or slashes in the undersleeves and gaps between the ties at the shoulders or in the bodice to make decorative puffs. A formal gown, sometimes referred to as a Dutch or French gown, was designed to envelop the completed toilette like a voluminous coat. In the first half of the sixteenth century the gown had a square neck and fitted closely over the kirtle to the waist, falling in thick trained folds to the floor. From 1550 two major styles emerged incorporating the loose one-piece gown, perhaps closer to a sleeved cloak, and the two-piece gown, fitted to the bodice and cut round at the hem in the French style, rather than trained.

Male dress was equally elaborate. Like the smock, the foundation garment was usually a straight linen shirt with an exposed standing collar embroidered to match the visible cuffs. Embroidered shifts could be very expensive when ready-made, Henry Percy ninth Earl of Northumberland paying £7 5s for one in 1586[5] (almost twice the cost of the entire winter uniform for an officer serving in Ireland, valued at £4 0s 10d in 1599[6]). Over the shirt a padded doublet rising to the jawline at its highest extent was cut to fit closely, padded for extra emphasis at the front below the waist to form a 'peascod' which resembled the incipient bulk of a swelling beer-belly! The surface of the doublet might be closely worked with pinking and slashing so that the contrasting material of the doublet lining would be visible through the cuts. In cold weather and on ceremonial occasions a richly embroidered and scented jerkin could be fitted over the doublet, either sleeved or unsleeved. Over the top of all this, the most expensive and richest article of male clothing was the cloak, available in several styles and worn in a variety of fashions to suit the character and standing of the owner, as described by Stubbes:

> Cloaks of dyverse and sundry colors, white, red, tawnie, black, greene, yellowe, russet, purple, violet and infynite other colours: some of cloth, silk, velvet, taffetie and such like, whereof some be of the Spanish, French and Dutch fashion. These cloakes must be garded, laced and thorowly faced; and sometimes so

lyned as the inner side standeth almost in as much as the outer side; some have sleeves, other some have none; some have hoodes to pull over the head, some have none; some are hanged with points and tassels of gold, silver or silk, some without al this.[7]

Moving further down the body, hose or garments for the legs were available in a variety of styles, as attested to by a contemporary dandy: 'let me see what breeches wore I a Saturday? let me see: a Tuesday my callymanka; a Wednesday my peach collor satin; a Thursday my vellure; a Friday my callymanka again, a Satterday let me see my riding breeches'.[8]

From the 1550s until 1570 the most popular style, in keeping with the prominence of Iberian influence, was the Spanish kettledrum, thickly padded trunks reaching to mid-thigh, constructed from strips of embroidered material over a stuffed lining, shaped to resemble a pair of onions at the top of the legs. These would be attached to the doublet by means of points threaded through the eyelet holes at the waist edge of each garment. A girdle or scarf could be placed over the join to hold dagger, sword or purse. Silk stockings, either knitted or cut on the bias to cling to the contours of the leg completed the ensemble.

The basic components for male and female dress remained standard wear through to the end of the century, altering as styles changed according to cut and colour. From the 1560s an emphasis on dark-rich tones and textures shifted towards a brighter palette and unrestrained use of applied decoration, ornaments and jewellery. A central feature in both male and female dress was the treatment of the neckline. The previously exposed blackwork embroidery at the edges of the smock evolved into elaborate and separate ruffs, starched and pulled around the neck by the use of tasselled strings. Until 1570 the ruff was worn untied with the strings or ties hanging loosely at an open neck, but following the move to a fuller, more rounded French silhouette from the late seventies, the ruff deepened and thickened, forming a solid mass around the jawline. The emphasis on bulk was echoed in female dress by the abandonment of the conical Spanish farthingale for the padded French roll, a horseshoe-shaped bolster tied around the waist to form a supporting 'doughnut'. The resulting swollen appearance of the lower body was accentuated by fuller padding of the sleeves, which became the focus for displays of intricate blackwork embroidery, and the arrangement of hair into puffs at the side of the head kept

in place by a spangled caul or hairnet. The apparent ease and speed with which foreign trends were taken up by the English court has been well documented by Janet Arnold, who provides evidence of the circulation of fashion prints, portraits, dolls, and the manipulation of diplomatic channels for the exchange of sartorial information.[9] Contemporary commentators were also acutely aware of influences from across the Channel; Jane Ashelford quotes the case of George Gascoigne, who commented on the irony that we can 'mocke and scoffe at all contryes for theyr defects' and yet we 'doo not onlye reteyne them, but do so farre exceede them: that of a Spanish Codpeece we make an English football; of an Italyan wast, an English petycoate, of a French ruffe, an English Chytterling'.[10]

During the 1580s the female bodice grew longer and narrower, tapering down to an ever-widening expanse of skirt. The former symmetry of opposing triangular forms which typified the earlier part of Elizabeth's reign was replaced by the juxtaposition of the circular shapes lent by French farthingales and cartwheel ruffs, echoed in the adoption of massed strings of looped pearls, rather than the preference for ribbons and brooches asymmetrically placed over the bodice, prevalent during the seventies. The head was now completely encircled by starched and goffered linen or the increasingly popular cutwork standing ruffs. The impermanence of such structures, especially outside the measured pace of the court, was ridiculed by the moralist : 'they goe flip flap in the winde, like rags flying abroad, and lye upon their shoulders like the dishcloute of a slut!'[11] A sense of insubstantiality was also discernible in male dress, which had forsaken a stylised masculinity in favour of an attenuated and skimpy effeminacy. In tandem with the female bodice, the doublet stretched down towards the groin where the peascod curved into the body in an exaggerated overhanging point. The hose shrank around the hips whilst the upper thighs were encased in tight cannions finished in a contrasting textile. This was a courtly style designed precisely for the rituals of overt display, dances and audiences. Ashelford draws attention to the London arena of the middle aisle of St Pauls' Church:

> where the gallants would strut up and down in their new clothes between ten and twelve o'clock in the morning. Since their intention was to impress all present, the tailors, hiding behind the pillars, would treat the occasion as an impromptu fashion show and make notes on the latest cut, colour, trimmings and accessories. Thomas Decker in 'The Guls Hornebook' advises

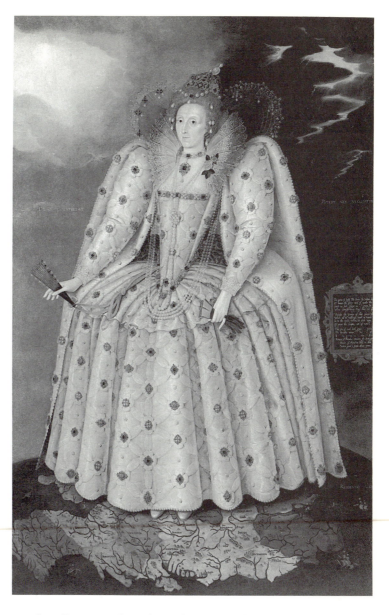

21] This iconic image of the aged Queen, successfully conveys the extreme and theatrical form taken by women's Court dress in the final decade of the century.

that 'four turns' in the walk were sufficient, as a fifth would mean that your outfit 'would be stale to the whole spectators'.[12]

The disintegration of both the body's natural contours and any sense of coherent harmony within the design of the components of fashionable dress and its colour and pattern as a whole continued into the final decade of the sixteenth century, typified by Francis Bacon's observation that 'there is no excellent beauty that hath not some strangeness in the proportion.'[13] Where previously male and female dress had tended to mimic and complement each other, gendered styles

now diverged into an increasingly stiff formality in the clothing of women and a relaxed romanticism in the appearance of men. The loosening of the male doublet, usually depicted worn unbuttoned over a shirt and sleeves embroidered with intricate flower motifs, together with the adoption of longer hair and a soft lawn falling collar edged with lace, presented a deliberately nostalgic, chivalrous and pastoral effect that coincided with whimsical trends in court music, literature and drama. Winged sleeves, angular tilted farthingales, a wealth of applied decoration in the form of rosettes and wired gauze veils, and a style of cut which prioritised tightness and length in the body and brevity with width in the skirt, gave to women, their hair scraped high from whitened mask-like faces into jewel-encrusted beehives, a brittle and unbalanced demeanour.

Brittle and unbalanced are descriptions that also convey the sense of strange incompleteness and masquerade that visual sources for a history of sixteenth-century court dress present to the late twentieth-century observer. The contrived rise and fall of hemlines and the ebbing and flowing of points of fashionable emphasis throughout the second half of the sixteenth century seem to take on their own self-contained momentum, and this is certainly brought into sharp focus by the type of chronological record just delivered. That such minute changes in detail and morbid attention to fashionable surfaces played a central role in the lives of the Elizabethan elite is supported by the wealth of visual and literary representations that survive as evidence for such a chronology. A preoccupation with dress and artifice was an issue that the Elizabethan ruling class seems to have left intentionally as its mark for posterity. But despite surface appearances the priority that fashionable dress took in deeper structures of political, sexual and cultural power remains to be addressed.

Town and country, court and gentry – the role of fashion in social relations

London was well established by the mid-sixteenth century as a centre for fashionable consumption and display. Its role as the major focus for the court during those moments in the year when it was not in progress ensured that it received the attentions of foreign visitors, traders and diplomats such as the German Thomas Platter who left a particularly vivid account of his impressions in 1599. The importance of the

city was seen by Platter as being disproportionate to its geographical size, so that its character came to represent the state and reputation of England as a whole:

> London is the capital of England and so superior to other English towns that London is not said to be in England, but rather England to be in London, for England's most resplendent objects may be seen in and around London; so that he who sightsees London and the Royal Courts in its immediate vicinity may assert without impertinence that he is properly acquainted with England.[14]

Within its precincts, inhabitants and visitors engaged in industries and trades reliant to a great extent on the constant display and exchange of fashionable clothing and materials. Platter continues:

> This city of London is so large and splendidly built, so populous and excellent in crafts and merchant citizens, and so prosperous, that it is not only the first in the whole realm of England, but is esteemed one of the most famous in all Christendom . . . Most of the inhabitants are employed in commerce; they buy, sell and trade in all corners of the globe . . . There are also many wealthy merchants and money changers in this city, some of whom sell costly wares while others only deal in money or wholesale transactions.[15]

Perhaps the overriding impression left by Platter's description is of a city in which men and women from competing and disparate social levels coexisted in a scenario of increased commercial and fashionable activity, in which one social group relied on another for the supply of essentials, luxuries and information. There is little of the preoccupation with strictly defined moral divisions of class, gender and wealth that typified records of the medieval city. If anything Platter highlights a sense of social easiness within which the outward signs of status or duty had become muddied. Women of the merchant and yeoman classes, for example, were classified by their tendencies towards a make-do approximation of high fashion style, juxtaposed with an adherence to older codes of hierarchical propriety:

> They lay great store by ruffs and starch them blue, so that their complexion shall appear the whiter, and some may well wear velvet for the street – quite common with them – who cannot afford a crust of bread at home I have been told. English burgher women wear high hats covered with velvet or silk for headgear, with cut away kirtles when they go out, in old fashioned style. Instead of whalebone they wear a broad circular piece of wood over the breast to keep the body straighter and more erect.[16]

In male dress the lack of any clear-cut connection between wealth or office and appearance is characterised by a description of actors, generally counted as belonging to the *demi-monde* or lower reaches of Elizabethan society, but in Platter's recollections symbolising both the nonchalance with which Londoners regarded the aspirational qualities of fashionable dress and its inability to transcend and subvert the usual barriers caused by the role of clothing as a signifier of status: 'The actors are most expensively and elaborately costumed; for it is the English usage for Lords or Knights at their decease to bequeath and leave almost the best of their clothes to their serving men, which it is unseemly for the latter to wear, so that they offer them for sale for a small sum to the actors.'[17]

It would be too simplistic to make any claims for a sudden and uncomplicated democratisation of metropolitan fashionable style from the highly subjective reports of journalists and travellers such as Platter. Indeed the sumptuary laws which had attempted to regulate the consumption of particular textiles and maintain a societal structure predicated on clothing choice in the fourteenth century continued to undergo modifications throughout the sixteenth century, responding to similar fears over the breakdown of the moral and economic status quo caused by over-zealous fashion consumption. Their wording suggests a continued denouncement by Government and ecclesiastical spokesmen of the state of affairs witnessed on the streets of London. The Act of 1533 encompassed most of the prevalent official insecurities in the action it took for

> the necessary repressing, avoiding and expelling of the inordinate excess daily more and more used in the sumptuous and costly array and apparel customarily worn in this realm, whereof hath ensued and daily do chance such sundry high and notable inconveniences as to be the great, manifest and notorious detriment of the common weal, the subversion of good and politic order in knowledge and distinction of people according to their estates, pre-eminences, dignities and degrees, and to the utter impoverishment and undoing of many inexpert and light persons inclined to pride, mother of all vices.[18]

By 1583 Philip Stubbes was reiterating earlier acts by suggesting that 'every man might be compelled to wear apparel according to his degree, estate and condition of life' in response to the fact that 'those who are neither of the nobility, gentility nor yeomanry, no, nor yet any magistrate, or officer in the commonwealth, go daily in silks, velvets, satins,

22] A mix of rural and metropolitan, merchant and aristocratic forms of dress and display is evident in images of Elizabethan London.

damasks, taffetas and such like, notwithstanding that they be both base by birth, mean by estate and servile by calling'.[19] Earlier in the 1560s there is evidence to suggest that the concerns of moralists, churchmen and bureaucrats were being taken seriously enough to instigate actual enforcement of the usually ignored sumptuary proclamations. In 1566 the city authorities in London 'appointed four "sad and discreet personages" to guard the gates between 7 a.m. and 11 a.m., and 1 p.m. and 6 p.m. every day to ensure that prohibited dress did not enter London unchecked'.[20] Perhaps the seemingly contradictory evidence of witnessed scenes of unbridled fashionable excess and restrictive sumptuary laws need not be read as incompatible. Harte has shown that such laws were generally unenforceable anyway, and the historian may use them more profitably to illustrate the prevalence of fashionable dress across the social spectrum, rather than trying to reveal through them the extent of its suppression. Indeed it is arguable that such laws encouraged an engagement with the luxury of dress by creating forbidden and therefore increasingly attractive categories of adornment. Critics of overt fashionable consumption, such as the poet George Gascoigne in 1576, were certainly quick to condemn a fascination for the strange and rare in the acquisition of apparel:

> Our bombast hose, Our treble double ruffes
> Our sutes of silke, our comely garded capes,
> Our Whit silke stockes, and Spanish lether shoes,

(Yea velvet serves, oftimes to trample in)
Our plumes, our spangs, and al our queint aray,
Are pricking spurres, provoking filthy pride,
And snares (unseen) which leade a man to hel.

And master merchant, he whose travaile ought
commodiously, to doe his countrie good,
And by his toyle, the same for to enrich,
Can find the meane to make monopolyes
Of every ware that is accompted strange.
And feeds the vaine of courtiers vaine desires
Until the Court have courtiers cast at heele
Quia non habent vestes Nuptiales[21]

Thomas Smith, in his 'Discourse of the Common Weal of this Realm of England', first published as early as 1549, was more systematic in his disapproval of the unbalancing of economic order and social relationships caused by imported luxuries. As Joan Thirsk shows, commentators like Smith saw England as a natural

> producer and exporter of sensible, durable goods such as wool, pewter vessels, beer and cheese. At the same time, England was importing from foreign countries a large range of goods not made at home . . . iron, salt, pitch, oil, hemp . . . Others arguably essential for civilized life . . . wines, spices, dyes, silks, carpets, oranges . . . Finally there were haberdasher's wares that might be clean spared . . . white paper, looking glasses, pins, pouches, hats, caps, brooches, silk and silver buttons, laces, perfumed gloves . . . the list descended from luxuries to frivolities.[22]

Smith particularly despised the foreign connotations of new luxury goods and the irrational value placed on specialist workmanship and fashionability, rather than the intrinsic worth and patriotic qualities of solid raw materials:

> I have seen within these twenty years, when there were not of these haberdashers that sell French or Milan caps, glasses, daggers, swords, girdles, and such things not a dozen in all London. And now from the Tower to Westminster along, every street is full of them . . . What grossness be we of, that we see it, and suffer such a continual spoil to be made of our goods and treasure by such means? And specially that will suffer our own commodities to go and set strangers on work, and then to buy them again at their hands; as of our wool, they make and dye kersies, frisadoes, broadcloths, and caps beyond the seas, and bring them hither to be sold again.[23]

A pamphlet of 1592 encapsulated just those uncertainties expressed by sumptuary law, and the earlier complaints of Smith over foreign imports and increased luxury, and recalled

23] The moral and economic conflict between the display of luxury and the virtues of work, or the city and the country, is manifested through clothing in this illustration to Robert Greene's influential pamphlet.

the popular medieval debate between Wynnere and Wastoure. 'A Quip for an Upstart Courtier' differed from its predecessor, however, in its more direct use of fashion as a conceit to illustrate the neglect of the country's economic and moral welfare in preference for foreign and effeminate luxury, which was seen to contaminate the wealth of the nation as represented by the ancient yeomanry. Spectators and moralists discerned a shift towards the expressive qualities of outward appearance, unfettered by considerations of class and duty. The enemy appeared to be external, resting on a new sense of individualism expressed through dress and possessions, based on the sins of vanity and ostentatious spending, and upsetting natural hierarchies. The protagonists of the pamphlet debate the relative virtues of the metropolitan life with its emphasis on display and artifice, and the provincial life defined through concepts of work, duty and common sense. Using contemporary styles of men's hose as a metaphor for differences in age, background and outlook, the debate evolves into one between velvet breeches and cloth breeches. Velvet breeches represents the subversive new dandyism of the urban youth and the descriptions employed to define his appearance are vivid:

> Mee thought I saw an uncouth headlesse thinge come pacing downe the hill stepping so proudly with such a geometricall grace as if some artificial braggart had resolved to measure the world with his paces. I could not deserye it to bee a man, although it had motion, for that it wanted a body, yet seeing legges and hose, I supposed it to bee some monster nurishte uppe in these desertes, at last as it drew more nigh unto mee, I might percive that it was a very passing costly paire of velvet

breeches, whose paines beeing made of the cheefest neapolitane stuffe, was drawn over with the best Spanish satine, and marvellous curiously over whipt with gold twist, intersemed with knots of pearle, the netherstocke was of the purest Granado silk, no cost was spared to lett out these costly breeches, who had girt unto them a Rapyer and Dagger gilt, point pendante, as quaintly as if some curious Florentine had trickte them up to square it up and downe the streetes before his mistresse. As these breeches were exceeding sumptuous to the eie, so were passing pompous in their gestures, for they strouted up and downe the valley as proudly as though they had there appointed to act some desperate combat.[24]

The constant references to foreign styles, rich fabrics and ornamentation contrast with the simple description of the more traditional cloth breeches:

Where upon looking about to se if that any more company would come I might perceive from the toppe of the other hill an other paire of Breeches more soberly marching and with a softer pace as if they were not too hasty, and yet would keepe promise nevertheless at the place appointed. As soon as they were come into the vallie, I sawe they were a plaine paire of Cloth-breeches, without either welt or garde, straight to the thigh of white kersie, without a stop, the nether stocke of the same, sewed too above the knee and only seamed with a little coventry blewe such as in *Diebus illis* our great Grandfathers soore, when neighbour hood and hospitality had banished pride out of England.

The confrontation between velvet breeches and cloth breeches draws to a conclusion with the latter asserting that the functional pragmatism of simple clothing outweighs the expense and waste of useless embellishment. The differences between the two modes of dressing are exposed as revealing the priorities, the history and the manners of the wearer, his character if not his social status. Underlying the conceits and metaphors was a growing realisation that appearances could be constructed rather than prescribed:

I pray you what difference is betweene you and mee but in the cost and the making, though you bee never so richly daubde with gold and poudred with Pearle, yet you are but a case for the buttocks, and a cover for the basest part of a mans body than I, the greatest preheminence is in the garnishing and therof you are proud, but come to the trouble we were appointed too, my honour is more than thine, for I belong to the old ancient yeomanry – the fathers, and thou to company of proud and unmannerly upstartes – the sonnes.

The parallels and contrasts that pamphleteers drew between the traditionalism of the shires and the modernity

of the city formed a convenient arena for the discussion of declining metropolitan standards in terms of dress, but their illustrations were of course constructs for political and religious ends. Some research into sixteenth-century shopping activities has uncovered evidence of provincial fashionability that actually competed with London trends and prices. Joan Thirsk quotes the 1578 probate inventory of a drapers in Kirby Lonsdale, Westmorland, that stocked

> a choice of three kinds of stitching silks – London, Spanish and Scottish . . . some silk hats . . . an impressive array of wool and linen cloth, both English and foreign, stockings of several different prices, hats not only of silk but of felt, lace of several kinds, including Norwich lace and Scottish lace, girdles and fringes, garters both English and French, Oxford gloves . . . plus all the other consumer goods that were so much deplored at the time because they mostly came from abroad: pins, needles, knives, daggers, silver and brass buttons, inkhorns, parchment, Turkey purses, playing cards and dice.[25]

An equally varied picture of the new role that clothing now played in the lives and self-fashioning of the sixteenth-century gentry and those they controlled outside London is provided through the work that Alice Friedman has carried out on the lifestyles of the Willoughby family, who were Nottinghamshire magnates and members of the Elizabethan Court.[26] In her research, as in the Kirby Lonsdale inventory, the divergence of old country and new town attitudes is not so explicit:

> Throughout the 1570s, Francis Willoughby maintained a large and powerful household at Wollaton in which the fashions of London and the Court were reflected in every aspect of daily life. Frequent notations in his household accounts record the purchase of books, fabrics or other luxury goods in London, and it is clear that many of the activities in which he participated drew their vitality and inspiration far less from the culture of the surrounding countryside than from that of a network of powerful gentry and aristocratic landowners linked by shared interests and ambitions.[27]

The importance of dress and self-presentation in the maintenance of power systems such as that just described, is betrayed through the portraits commissioned from the London painter George Gower by Willoughby in 1573. Their price was not a particularly significant drain on the household budget, costing less than the hire of a musician and no more than the wage of a private scholar. Along with a silver sugar box and the provision of books for the servants, the

images were a necessary but not extravagant display of world-liness and wealth. It is interesting that the portrait of Lady Elizabeth Willoughby, her bodice encrusted in pearls and loudly sporting an Italian triton pendant, cost twenty shillings, compared with Sir Francis's more austere ten-shilling portrayal. The value of elaborate dressing appears to have translated into the comparative cost of the images; indeed it could be said that image became the priority both in the arrangement of clothing on the living body and in its representation on panel.

Besides her role as visual communicator of family wealth, the Elizabethan noblewoman played a role in the household not so very different from the skills and duties expected from her medieval forebears, despite the heightened power enjoyed by a woman on the throne. Restricted to the comple-tion of fine needlework, musical entertainment and the rearing of small children, Lady Elizabeth led a cloistered exis-tence compared to that of her husband. Wollaton Hall employed only twelve women in all, out of its two hundred staff and these included gentlewomen of the family cham-bers, chambermaids and laundresses. Those tasks later allo-cated to female service, cooking, cleaning and serving, were alloted to men.[28] In this way women 'inhabited a separate culture parallel to, but concealed behind the more powerful

24] Fairs and markets provided a scenario for the exchange and observation of fashionable information, especially for those women whose social life was otherwise circumscribed by convention or status. A wide range of peasant, merchant and courtly styles can be identified from this representation.

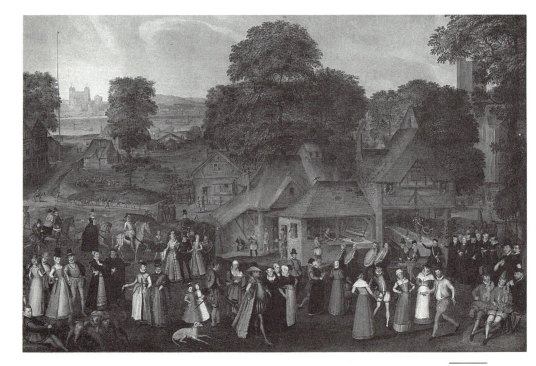

official male culture', occasionally diverging 'at dinners in the great chamber, at suppers or card games in the dining parlour, at banquets in the gardens'. Important calendar moments like these were presumably the times when the wider economic and social relevance of female dress and appearance reached fulfilment in terms of patriarchal status, languishing at other times in a remote and exclusively feminine world. Divisions between male and female members of the household were replicated within the experiences of women according to social position. Serving women, for example, enjoyed greater freedom than their mistresses in terms of contact with a wider community, experienced through their duties as suppliers of provisions and maintainers of household stuffs. In their attendance at fairs, markets and festivals the opportunity for interaction with changing fashionable styles, and participation in gossip based on observation, was more immediately available to female estate workers than to the mistress of the household who lived the fashionable life one step removed from its actual centre, the court. The gradual role-shift of the country house from agricultural factory to private home further alienated the aristocratic woman from a world of public display, leaving her increasingly reliant on the beneficence of her husband and the visits of the dressmaker. Paradoxically, however, a move away from the house as the functional focus of the regional farming economy increased its role as a symbol of private wealth and indolence, an arena in which female display took on an enhanced importance. The contradictions implicit in woman's role as both powerless private chattel and loaded public symbol were picked up by commentators such as Platter: 'Now the women folk of England, who have mostly blue grey eyes and are fair and pretty have far more liberty than in other lands, and know just how to make good use of it, for they often stroll out or drive by coach in very gorgeous clothes, and the men must put up with such ways'.[29]

In a sense, then, fashion and fashionable appearance, rather than revealing signals of rank and region in a literal manner as had formerly been the case, tended in the late sixteenth century towards a perverse form of concealment, designed with the intricacy of a puzzle. As a result Platter misread the signs of relative female emancipation, and 'gorgeous' apparel is quoted by Friedman as evidence of more limited opportunities. Distinction in the appearance of male and female, mistress and servant, townsman and country dweller, old and young was by no means straightforward or

translucent. This sort of confusion points to the obscuring nature of elements of Elizabethan dress, and the evolution of codes and symbols as a means of reading costume in an increasingly sophisticated manner. In dealing with its representation in a late twentieth-century context, the historian is forced to reinterpret and translate such signs in order to gain anything more than a surface impression.

Symbolising status – costume as courtly language

> The courtier must, above all else, avoid affectation and must employ, in his every deed, a certain studied nonchalance – 'sprezzatura'. Every action should seem to be performed without conscious thought or effort. Evident strain renders any feat less striking: 'therefore, that may be said to be a very Art, that appeareth not to be Art; neither ought a man to put more diligence in anything than in covering it'.[30]

Sydney Anglo, in his discussion of Castiglione's widely read guide to etiquette *Il Cortegiano*, draws attention to the importance attached to appearance and its manipulation in the Renaissance court, in the Italian princely states and throughout Europe. The courtier 'is always aware of an audience, admiring, criticising and judging him; and he is expected to fashion himself like a work of art, arranging his good qualities to maximum effect, as skilful painters "with a shadow make the lights of high places to appear"[8]' Of course, Castiglione

was using the idea of appearance as a conceit, and referred more to the creation and maintenance of political virtues than he did to the quality of the wardrobe itself. But the emphasis on art and creativity is astute and directly illuminates sixteenth-century attitudes towards self-presentation through clothing. Choice of garments, colours and applied decoration was governed to a great degree by an understanding of, and engagement with, both hidden and blatant visual codes that communicated carefully considered and highly measured messages of gentility to the initiated.

The importance of overt and indirect symbolism in dress to Elizabethans across the social scale is difficult to overestimate. It was a phenomenon that 'has been seen as a consequence of the almost obsessive interest in heraldry as a means of defining status and family position in a society that both perceived itself to be and was, in fact, increasingly mobile'.[31] Louis Montrose quotes the dream of the physician and astrologer Doctor Simon Forman, recorded on 23 January 1597. For an astrologer, dream imagery obviously carried a heightened pertinence, but the rare and direct access it allows into the late Elizabethan psyche can reveal much about attitudes towards appearance and its cultural significance:

> I dreamt that I was with the Queen, and that she was a little elderly woman in a coarse white petticoat all unready; and she and I walked up and down through lanes and closes, talking and reasoning of many matters. At last we came over a great close where were many people, and there were two men at hard words. One of them was a weaver, a tall man with a reddish beard, 'distract of his wits . . . and then we went through a dirty lane. She had a long white smock, very clean and fair, and it trailed in the dirt and her coat behind. I took her coat and did carry it a good way, and then it hung too low before. I told her she should do me a favour to let me wait on her, and she said I should.'[32]

Identifiable through the descriptions of the Queen's person are those signifying symbols that functioned as shorthand for the visual characteristics of the English monarch, recognisable throughout the Western world. The French Ambassador summarised the distinguishing features in the same year as Forman's dream:

> she was strangely attired in a dress of silver cloth, white and crimson . . . she kept the front of her dress open, and one could see the whole of her bosom, and passing low, and often she would open the front of this robe with her hands as if she was too hot . . . her bosom is somewhat wrinkled . . . but lower down her flesh is exceeding white and delicate as far as one could see.[33]

The significance of the component parts, the white colour of the costume symbolising virginity and chastity, the bared breast both the maternal sustenance of the Madonna or the pelican and the erotic provocation expected from the focus of a cult of heightened femininity, was immediately apparent both to the ambassador graced with a personal audience and to the common subject who picked up the signals in a dream and may have had little or no access to the Queen's person in life.

One of the ways in which such a language could work on a universal scale was through the exchange and appreciation of two-dimensional images and emblems, both portraits and the more public forms of emblems or *impresa*. For this reason portraits are an important key to an understanding of the meanings attached to Elizabethan dress, used not as a literal record of material appearance, as has been the tendency with traditional costume history texts, but decoded in a literary manner that reveals original intentions and nuances. William Segar, portraitist and herald, attested to the central place held by the two-dimensional likeness as a record not just of physical characteristics, but of reputation and personal history: 'Portratures, Pictures and other Monuments were devised to

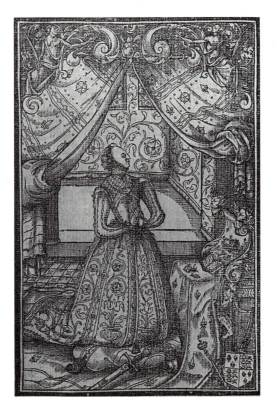

26] This heraldic image of the Queen from a prayer book, underlines the symbolic power invested in representations of clothing.

ornifie Temples, Cities and Princes Pallaces . . . they were
made to retaine in memory, the excellent Actions of such
men, as had lived honourably, and died vertuously.'[34] The
communication of reputation relied not so much on individ-
ual choice as it did on the recognition and comprehension of
a complex set of formal visual codes that included references
to colour, shape, texture, and specific recourse to figures
taken from mythology, history and the natural world. All of
these emblems, incorporated into the dress of a sitter, trans-
lated smoothly into the stilted and artificial manner of
recording personality in both everyday appearance and the
act of portraiture, resulting in a style in which 'the face
becomes an element in an arrangement of fabrics and jewels
. . . the sitter . . . transmuted into a jewel-encrusted icon'.[35]
The two processes – dressing and drawing – should perhaps
be interpreted as striving towards similar ends, both con-
cerned with the potential of textiles and clothing as a surface
to be read and deciphered. Any reading depended on the
viewer making connections between symbol and symbolised.
Michel Foucault typifies this process as one of 'resemblance'
and places it at the centre of sixteenth-century cultural
systems and ways of seeing:

> Up to the end of the sixteenth century, resemblance played a
> constructive role in the knowledge of Western culture. It was
> resemblance that largely guided exegesis and the interpretation
> of texts; it was resemblance that organised the play of symbols,
> made possible knowledge of things visible and invisible, and
> controlled the art of representing them. The universe was folded
> in upon itself: the earth was echoing the sky, faces seeing them-
> selves reflected in the stars, and plants holding within their
> stems the secrets that were of use to man. Painting imitated
> space. And representation – whether in the service of pleasure
> or of knowledge – was posited as a form of repetition; the theatre
> of life or the mirror of nature, that was the claim made by all
> language, its manner of declaring its existence and of formulat-
> ing its right of speech.[36]

The value of the visual code was expressed in Elizabethan
culture through the publication of various books of emblem-
atic devices, the two most famous being Whitney's *Emblems*
of 1586 and Peacham's *Minerva Brittannia* of 1612. Works
such as these generally contained a collection of short
admonitory verses, often concerned with the nature of dis-
guise, transformation and deceit, illustrated with small wood-
cuts that visualised the conceit described. The ideas and
images expressed in the works were easily translated into the

medium of oil or silk thread by the painter and embroiderer.
Whitney in a typical verse entitled 'Ex maximo minimus'
describes the popular associations of the skull with transience
and transformation, providing an emblem eminently suitable
for the decoration of funerary furniture and commemorative
portraits:

> Where lively once, Gods image was expreste
> Wherein, Sometime was sacred reason plac'de,
> The head, I meane, that is so ritchly bleste,
> With sighte, with smell, with hearinge, and with taste.
> Lo, nowe a skull, both rotten, bare and drye,
> A relike meete in charnell house to lye.[37]

Peacham's emblems were more emphatic in communi-
cating specific meanings which might be attached to various
animals, minerals and objects and perhaps gave a stronger
sense of the layered readings which could be ascribed both to
elements of dress and to the motifs contained within them.
'Cui candor morte redemptus' described an image of the
ermine, which like the skull, was particularly relevant to
considerations of the superficiality of fashion and vanity, but
ironically was itself a sumptuous component of elite dress:

> The Ermin heere, whome eager houndes doe chase
> and hunters have, around environ'd in,
> (As some doe write) will not come neere the place,
> That may with dirt, defile his daintie skinne:
> But rather chooseth, then the same should soile,
> be torne with dogges, or taken with the toile.
>
> Me thinkes even now, I see a number blush,
> To heare a beaste, by nature should have care,
> To keepe his skinne, themselves not care a rush,
> with how much filth their mindes bespotted are;
> Great Lordes, and Ladies turne your cost and art,
> From bodies pride, t'enrich your better part.[38]

The adoption of *impresa* was particularly suited, perhaps
even contributed to, the overriding aesthetic environment of
the Elizabethan court. Roy Strong in his work on the cult of
Gloriana refers to 'a lost sense of sight' in which the displace-
ment of objects and images in paintings and court ceremo-
nial conform to 'an earlier neo-Gothic convention of space as
a constant alternation or movement in the subjective experi-
ence of the observer as he views . . . elements . . . successively
in time'.[39] The sources for English visual culture rejected con-
temporary continental moves towards realism and per-
spective, in a deliberate evocation of late medieval concerns

with schematic and fantastical decoration. In this way fash-
ionable costume referred not so much to the forms or comfort
of the three-dimensional body hidden underneath, respond-
ing instead to the dictates of portraiture and constant display,
becoming itself a canvas or panel for the loaded plant, animal
and architectural forms described through the flat patterns of
blackwork embroidery, woven silk and applied jewellery. The
spiky distortions in fashionable form that this gave rise to, the
widened foreparts and lengthened stomachers and doublets,
all accommodating intricate surface messages and signifiers,
could be harmonised through sensitive use of colour. But
even the dyer found his wares imbued with added meaning.
Whitney described the symbolic connotations:

> For mourners, blacke for the religious, white,
> Which is a signe of conscience pure and free.
> The greene, agrees with them in hope that live:
> And eeke to youthe, this colour we do give.
> And yelowe next, unto the coueteous wighte,
> And unto those, whome jelousie doth fret.
> The man refus'd in Taunye doth delite.
> The collour Redde, let martiall captaines get.
> And little boies, whom shamefastnes did grace,
> The Romaines deck'd in scarlet like their face.
> The marriners, the blewe becometh well.
> Bicause it showes the colour of the sea:
> And prophettes that of thinges devine fortell,
> The men content, like Violet arraie.
> And laste, the poore and meaner sorte provide,
> The medley, graye and russet, never dyde.[40]

Ellen Chirelstein, in her analysis of the late Elizabethan
portrait of Lady Elizabeth Pope, successfully illuminates the
resulting juxtapositions of body and image that typified the
presentation of the self through fashion. She points out the
relationship between the textile of the robe as portrayed on
the panel, and its role in communicating the sitter's status:
'Its descriptive power, as Lady Elizabeth touches it, quite liter-
ally fashions her identity, and at the same moment she seems
to invite the beholder to share the intimacy of that touch and
to feel the palpable fabric that creates her presence.[41] This
must have been a representational relationship that existed
not only between the garment worn and the garment
described on panel, but also between the garment as clothing
and the garment as symbol on the body itself. The overriding
emphasis on symbolic systems in the end 'appears to control
the display of Elizabeth Pope's 'body' so that 'references to
volume, space and motion', references to the natural, in

Chirelstein's words 'lie on the surface rather like the hand-painted colours of an old photograph that do not alter or disturb an underlying structure'.[42] The sense of artificiality that such systems lent to representations of fashion and the clothing itself throughout the second half of the sixteenth century is what gives much of the surviving historical evidence its characteristic and strangely archaic flavour. The final decade of Elizabeth's reign, however, saw a parallel method of self-presentation which succeeded in revealing a physical and emotional 'naturalism' in dress that had formerly remained disguised. To quote Strong, 'People when they sit for their portraits in the 1590s are beginning to want to see themselves depicted less as symbols and more as vehicles of human emotions and feeling.'[43] Expressed through the humour of 'melancholy' the new sensibility manifested itself in deliberately 'untidy, negligent clothing' which revealed as

27] Identity, image and dress literally fuse in this allegorical portrait of Lady Elizabeth Pope.

much as it obscured the body, and a preference for the pastoral over the cosmopolitan, reflected in the adoption of simple floral and herbal embroidered motifs. What the craze for the melancholic signifies most of all, however, is the ability of clothing to reflect a new sense of 'private self' as much as it symbolised public status and history.

Clothing, personal identity and the body

Amico Ficto nulla fit injuria
Since fauning lookes, and sugred speache prevaile
Take heede betime: and linke thee not with theise.
The gallant clokes, doe hollowe hartes conceile,
And goodlie showes, are mistes before our eies:
But whome thou find'st with guile disguised so:
No wrong, thou doest, to use him as thy foe.[44]

Whitney's emblem presented an image of two masked dandies accompanied by a verse that warned of the dangers inherent in passing judgment on the evidence of surface adornment alone. So far this chapter has itself concentrated on a description and analysis of the surface features of Elizabethan clothing. Equally valid is an investigation of the relationship between dress and the individual body which it simultaneously protected from, and presented to, observation. Historical anthropologists and recent art historians, using the evidence of a rise in the popularity of portraiture and etiquette books, have isolated the mid- to late sixteenth century as a significant moment of change in relation to attitudes towards individuality and a new sense of self. In the words of one historian, 'there is in the early modern period a change in the intellectual, social, psychological and aesthetic structures that govern the generation of identities'.[45] Having shown how costume was constructed to communicate its meanings to an audience, there remains the problem of establishing its relevance to the self-perception of the wearer in the light of this change.

Stephen Greenblatt makes explicit the connections between 'an increased self-consciousness about the fashioning of human identity as a manipulable, artful process' and etymological changes in the meaning of the word 'fashion' itself: 'As a term for the action or process of making, for particular features or appearance, for a distinct style or pattern, the word had long been in use, but it is in the sixteenth century that "fashion" seems to come into wide currency as a way of designating the forming of a self.'[46] It is suggested that fashion could simultaneously mean the

'imposition upon a person of physical form' and the more general cultivation of a 'distinctive personality' or consistent mode of behaviour. Choice and style of clothing obviously played a central role in this heightened form of address, controlled in a manner that is highly suggestive of the theatrical. Greenblatt isolates 'rhetoric', the Renaissance mode of communication which prioritised oratory, reason, classical erudition and imagination, as the method by which members of the court could shape their world. 'Rhetoric', he states, 'served to theatricalize culture, or rather it was the instrument of a society which was already deeply theatrical'.[47] At the centre of this theatrical, enclosed and hierarchical world lay the symbolism of dress, itself a powerful rhetorical weapon in an intensely political arena where struggles for power, recognition and attention demanded a constant and 'virtually fetishistic emphasis' on the cultivation of manner and appearance. Its widest potential was in the possibilities it offered for broadcasting, changing and disguising social and political intentions, a concept that has conveniently fallen under the title of 'masking' – 'essentially a matter of playing a series of roles, each entailing certain predetermined attitudes and modes of activity, status relationships and types of dress and deportment – in other words each having its appropriate, figurative mask.'[48] That contemporaries were aware of such strategies is betrayed by Whitney's emblems:

> A face deform'de, a visor faire doth hide,
> That none can see his uglie shape within;
> To ipocrites, The Same may bee applide,
> With outward showes, who all their credit winne.
> Yet give no heate, but like a painted fire;
> And, all their zeal, is, as the times require.[49]

Costume therefore, alongside such cultural constructions as manners, language, even physical gestures, marked the barriers in early modern society that would come to define such distinctions as class, sexuality, and nationality in 'modern' society. Robert Muchembled in his work on gesture in sixteenth-century France sees these new constructs of 'self' as 'mediations which permit the passage from nature to culture, i.e. from the body (gender, sensation) to comportment, the latter being the transmitter of collective mentalities'.[50] In physical terms the implications of this shift in perceptions about the formation of the self has been illustrated in two case-studies which form the final focus of this chapter. Vigarello, in his work on historical constructions of cleanliness in France, shows how the visible whiteness of the new

linen shirt was a manifestation of deeper changes in the structure of society:

> Cleanliness had thus penetrated beyond the surface of clothes, though the surface did not cease to dominate attention. It had merely diversified its qualities and significance. What lay beneath the clothes had reordered the frame of reference. This cleanliness remained essentially social, indeed had never been so visible. It opened up a new sphere of refinement to a court society of a new type, one which saw the appearance of the courtier. This highly centralised milieu, constantly revolving around the king, thus found an additional criterion for demonstrating distinction . . . It was with the invention of etiquette that linen became a recognised sign of refinement. It emphasised manners . . . Its very visible materialisation encompassed a spectrum ranging from clean clothes to clean bodies. Appearance thus acquired new connotations; it emphasised criteria of cleanliness, and it was deemed, in this regard, to suggest what was not seen.[51]

Vigarello fills out the gaps left by Norbert Elias and Erving Goffman,[52] who though working respectively in historical and twentieth-century anthropological fields, fail to make explicit, obvious and underlying links between ideas of individuality expressed through social interaction and projections of the body through visual codes such as dress. What all three conspicuously ignore, however, is the role played by shifts in the status of the self in articulations of gender. We have seen the foundations of specific links between femininity and the construction and display of clothing established in the medieval period. Peter Stallybrass makes the point that moralists and legislators were themselves relatively silent on the subject of women's bodies in the Elizabethan period compared with the preceding epoch, interpreted by the author as 'a sign less of women's liberties than of the implicit assumption that women's bodies were already the object of policing by fathers and husbands'.[53] This is certainly a view shared by Elizabeth Honig in her explanation of the mid-sixteenth-century portraits of Richard and Joan Wakeham:

> While man was created whole and perfect, it was said, woman was created as the mere image of him, defective, incomplete; the traits she lacked were the 'immutable' aspects of the soul . . . Woman and picture became parallel, as both exist as images of man, dependent upon him, lacking those things which are immortal. A further common ground between woman and painting is that both are defined in terms of the senses, with all the attractions and dangers this denotes . . . sensuality and pure appearance come together in man's greatest charge against woman . . . that she is vain.[54]

28] This miniature of the new Queen, Anne of Denmark, by Isaac Oliver, gives little indication of any immediate visual effects arising from the transference of political power at the turn of the century. A concern with artifice and theatrical display remains intact.

An interpretation such as this goes some way towards an explanation of those images of women, encrusted and embellished with the symbols of vanity, that form the staple evidence for a chronology of Elizabethan fashion. They both fulfil and suggest the noblewoman's role as a hollow cipher within Elizabethan society, emblematic vessels lacking any sense of individuality other than the details of dress. Presentation of women in this way, whilst illustrating an awareness of fashion's potential as a civilising mask, naturally left them open to familiar misogynistic accusations, as Honig states, 'Woman is the artificer, the trickster, the dealer in that which is superficial yet attractive.'[55] This was a problem that would come to fruition in the seventeenth century's concern with fashion as moral confuser, muddying divisions, particularly in terms of sexual role-play, and calling to mind Stallybrass's claims for a study of the body, which stand as a justification for any attempt to draw sixteenth-century dress

and its representation into a wider and problematised arena of debate: 'To examine the body's formation is to trace the connection between politeness and politics. But because these connections are never simply given, the body can itself become a site of conflict.'[56]

Notes

1 T. Tomkis, 'Lingua or the Combat of the Tongues', 1607, in J. Arnold, *Queen Elizabeth's Wardrobe Unlock'd*, Leeds, 1988, p. 110.

2 J. Ashelford, *Dress in the Age of Elizabeth I*, London, 1988.

3 Arnold, *Queen Elizabeth's Wardrobe Unlock'd*, p. 123.

4 J. Woodall, 'An Exemplary Consort: Antonis Mor's Portrait of Mary Tudor', *Art History*, 14, 2, 1991, pp. 192–224.

5 Ashelford, *Dress in the Age of Elizabeth I*, p. 46.

6 Ashelford, *Dress in the Age of Elizabeth I*, p. 44.

7 Ashelford, *Dress in the Age of Elizabeth I*, p. 49.

8 Ashelford, *Dress in the Age of Elizabeth I*, p. 47.

9 Arnold, *Queen Elizabeth's Wardrobe Unlock'd*, p. 157.

10 Ashelford, *Dress in the Age of Elizabeth I*, p. 44.

11 P. Stubbes, ed. F. Furnivall, *Anatomy of Abuses in England in 1583*, London, 1882, Vol 1, p. 78.

12 Ashelford, *Dress in the Age of Elizabeth I*, p. 44.

13 Ashelford, *Dress in the Age of Elizabeth I*, p. 40.

14 T. Platter, trans. C. Williams, *Thomas Platter's Travels in England 1599*, London, 1937, p. 153.

15 Platter, *Thomas Platter's Travels*, pp. 156–7.

16 Platter, *Thomas Platter's Travels*, p. 181.

17 Platter, *Thomas Platter's Travels*, p. 167.

18 Harte, 'State Control of Dress', p. 139.

19 Harte, 'State Control of Dress', p. 141.

20 Harte, 'State Control of Dress', p. 147

21 G. Gascoigne, 'The Steele Glass' in J. W. Cunliffe, ed., *The Complete Works of George Gascoigne, Vol II*, Cambridge, 1910.

22 J. Thirsk, *Economic Policy and Projects: The Development of a Consumer Society in Early Modern England*, Oxford, 1978, p. 14.

23 Thirsk, *Economic Policy and Projects*, pp. 15–16.

24 J. Wolfe, pub., *A Quip for an Upstart Courtier; or, A Quaint Dispute between Velvet Breeches and Cloth Breeches*, London, 1592.

25 Thirsk, *Economic Policy and Projects*, p. 121.

26 A Friedman, *House and Household in Elizabethan England: Wollaton Hall and the Willoughby Family*, Chicago, 1989.

27 Friedman, *House and Household*, p. 27–8.

28 Friedman, *House and Household*, p. 46.

29 Platter, *Thomas Platter's Travels*, p. 181.

30 S. Anglo, *The Courtiers' Art: Systematic Immorality in the Renaissance*, Swansea, 1983, p. 6–7.

31 E. Chirelstein, 'Lady Elizabeth Pope: The Heraldic Body', in L. Gent and N. Llewellyn, eds, *Renaissance Bodies: The Human Figure in English Culture, 1540–1660*, London, 1990, p. 48.

32 L. Montrose, 'A Midsummer Night's Dream and the Shaping Fantasies of Elizabethan Culture: Gender, Power, Form' in M. Ferguson, M. Quilligan and N. Vickers, eds, *Rewriting the Renaissance: The Discourses of Sexual Difference in Early Modern Europe*, Chicago, 1986, p. 65.

33 Montrose, 'A Midsummer Night's Dream', p. 66.

34 W. Segar, *Honor Military and Civill*, London, 1602, pp. 254–5.

35 R. Strong, *Hans Eworth: A Tudor Artist and his Circle*, Leicester, 1965, p. x.

36 M. Foucault, *The Order of Things: An Archaeology of the Human Sciences*, London, 1970, p. 17.

37 G. Whitney, *A Choice of Emblemes and Other Devises: For the most parte gathered out of sundrie writers, Englished and Moralized*, London, 1586, p. 229.

38 H. Peacham, *Minerva Britannia, or a garden of Heroical Devices, furnished, and adorned with Emblemes and impresas of sundry natures, newly devised, moralized and published*, London, 1612.

39 R. Strong, *The Cult of Elizabeth: Elizabethan Portraiture and Pageantry*, London, 1977, p. 43.

40 Whitney, *A Choice of Emblems*, p. 134.

41 Chirelstein, 'Lady Elizabeth Pope', p. 38.

42 Chirelstein, 'Lady Elizabeth Pope', p. 39.

43 R. Strong, *The English Icon: Elizabethan and Jacobean Portraiture*, London, 1969, p. 36.

44 Whitney, *A Choice of Emblems*, p. 226.

45 S. Greenblatt, *Renaissance Self-Fashioning*, Chicago, 1980 p. 1.

46 Greenblatt, *Renaissance Self-Fashioning*, p. 2.

47 Greenblatt, *Renaissance Self-Fashioning*, p. 162.

48 D. Smith, *Masks of Wedlock: Seventeenth-Century Dutch Marriage Portraiture*, London, 1982, p. 8.

49 Whitney, *A Choice of Emblems*, p. 226.

50 R. Muchembled, 'The order of gestures: a social history of sensibilities under the Ancien Regime in France' in J. Bremner and H. Roodenburg, eds, *A Cultural History of Gesture*, Cambridge, 1991, p. 133.

51 Vigarello, *Concepts of Cleanliness*, pp. 63–4.

52 E. Goffman, *The Presentation of Self in Everyday Life*, New York, 1959.

53 P. Stallybrass, 'Patriarchal Territories: The Body Enclosed' in Ferguson *et al.*, *Rewriting the Renaissance*, p. 125.

54 E. Honig, 'In Memory: Lady Dacre and Pairing by Hans Eworth' in Gent and Llewellyn, *Renaissance Bodies*, pp. 78–9.

55 Honig, 'In Memory', p. 79.

56 Stallybrass, 'Patriarchal Territories', p. 123.

29] *facing page*
The Francophile tendencies of the court of Charles I encouraged the soft lines, falling lace and iridescent sheen of silks and pearls introduced by Henrietta Maria.

3 Seventeenth century: clothing and crisis

She will have a fig leafe to cover her shame: but when the fig leafe is dry and withered, it doeth shew their nakednesse to the world; for take away their painted cloathes, and then they look like ragged wals; take away their ruffes and they looke ruggedly; their coyfes and stomachers and they are simple to behold; their haire untrust and they look wildly; and yet there are many which laies their nets to catch a pretty woman, but he which getteth such a prize gaines nothing by his adventure, but shame to the body, and danger to the soul.[1]

The Elizabethan preoccupation with surface symbolism in fashionable dress, and its growing relationship to personality and the individual body, continued after the death of Elizabeth I in 1603. The typically ornate and loaded portraits of court favourites by Larkin and Oliver, completed in the first two decades of the seventeenth century, give few hints of a transformation of aesthetic values to coincide with the transference of political power. The prominence that considerations of clothing held in popular debate, however, took on a widened and troubled significance. The dark, bitter misogyny of the pamphlet reproduced above, with its rejection of Elizabethan alliances between decorative symbolism and moral probity, lends some flavour to those historical interpretations which make claims for growing divisions within society that colour contemporary and later perceptions of the period as one of strife and confusion.

This was after all a century which witnessed massive political upheaval. A thirty-year religious war in Europe saw the explosion of latent tension between Catholic and Protestant states and princes. In England similar religious and political tensions were manifested in the lurching momentum of consolidation and revolution that produced a chain of significant events. Initial recognition in 1603 of a kingdom of Great Britain incorporating Scotland under the rule of James I was followed by the 1605 Gunpowder Plot, which threw internal religious differences and extremism into sharper perspective. The 1628 petition of rights typified the growing conflict between the demands of Parliament and the traditional prerogatives of the Crown, symbolised by Charles I. Increasing antagonism between the two culminated in a six-year civil war followed by regicide, and eleven years of rule by the Commonwealth from 1649. A return to the monarchy with the restoration of Charles II in 1660, rather than signalling constitutional calm, resulted in continuing religious and parliamentary confusion. This unsettled state of affairs remained unresolved until the 'Glorious Revolution' of 1688

and a declaration of rights in 1689 which set the foundation for a modern system of democracy and government.

Traditionalist costume history has made claims for an implicit link between divisions motivated by such political and religious disagreements and sartorial trends in the seventeenth century. It is undoubtedly attractive and convenient to match, for example, the stiffness of Counter-Reformationary zeal and declining world power with the archaic formality of Spanish dress at the Court of Philip IV, contrasting it with the contrived opulence and hierarchical significance of French court dress under Louis XIV, symbolic of absolutist power and rising commercial and military prowess. One prominent historian has gone so far as to describe the diplomatic meeting arranged to cement the marital and political alliance between France and Spain in 1660 as the 'costume clash of the century'. Similarly, divisions between the forces of Parliament and king in the English Civil War have often been popularly perceived in terms of straight-laced, monochrome puritans and round-heads pitted against flamboyant, decadent cavaliers and royalists. Such tendencies towards creating typicalities or partisanship in dress are unhelpful in their obvious generalisations. Having stated that fashion was well suited to the description of individuality, it seems to make more sense to establish the ways in which wider political change and upheaval informed the formation of appearance in the private sphere where formations of character and personality were initially engendered. In response to historical moves away from the interpretation of 'grand' political events, this chapter will concern itself more closely with the problems that concurrent shifts in morality and social roles presented to the consumer of fashionable dress on the more intimate domestic stage. Firstly, though, it is necessary to sketch out a backcloth of those stylistic changes that occurred within political and court circles over the course of an undeniably turbulent century. As with earlier periods, sources for a history of seventeenth-century dress are generally restricted to the problematic evidence of two-dimensional images, paintings and prints. These, together with the few surviving items of embroidery, lace and occasional complete bodices that form the earlier exhibits in most museum costume collections, can obviously provide only a very limited suggestion of contemporary clothing and habits, confined to the world of the rich and powerful. Having set out a chronology of elite style change, the remainder of the chapter will aim to place such evidence within the context of more ephemeral documentary material.

From decadence to decorum: fashionable change in seventeenth-century dress

The melancholy effeminacy that had typified late Elizabethan ideals of beauty translated easily into the aesthetic and sexual milieu of the Jacobean Court. James I, in his adoption and promotion of a succession of tall, young, beautiful male favourites, ensured the continuation of a fashionable court style for men which demanded an elongated figure, a profusion of decorative embellishments and the display of richly furnished textiles. Portraits and surviving items of clothing from the opening two decades of the century reveal that the sixteenth-century arrangement of male clothing around such staples as the doublet, trunkhose and knee-length cannions survived the transition of monarchs relatively unscathed. From about 1613, however, perhaps following the death of Henry, Prince of Wales, who had encouraged a cult of ascetic chivalric masculinity at odds with his father's more immediately physical attachment to the male physique, aristocratic men's clothing literally blossomed into a visual celebration of embroidered surfaces and rich textural contrasts. The outline of the body itself became obscured under yards of stiffened, padded, gathered and draped material. The starched linen collar, which had previously laid limp across the shoulders, untied at the neck, now formed a rigid semicircle framing the head on which long hair was now trimmed and frizzed to echo the circular shapes of the cutwork and lace collar trim. This flower-like arrangement was repeated at the cuffs and on large rosettes which adorned the shoes. Hose and cannions were now subsumed by full flared breeches gathered at the waist and just above the knee to form a loose puffball shape. Embroidery and the use of contrasting heraldic colours were unrestrained, spreading to cover the calves of stockings, gloves and sword belts. Valerie Cumming typifies the resulting appearance as 'combining . . . elegance and brashness',[2] its heightened theatricality more suited to the displays typical of the popular court masques than the business of everyday life, indeed designed expressly for the rituals associated with service as a courtier.

Female dress followed a similar pattern, retaining the cartwheel farthingale, elongated stomacher, padded sleeves and open ruff favoured by both Elizabeth I and the new Queen, Anne of Denmark. Surface decoration became a little more formal and dense in its patterns and colours, rejecting the gauzy silver and white typical of late Elizabethan costume

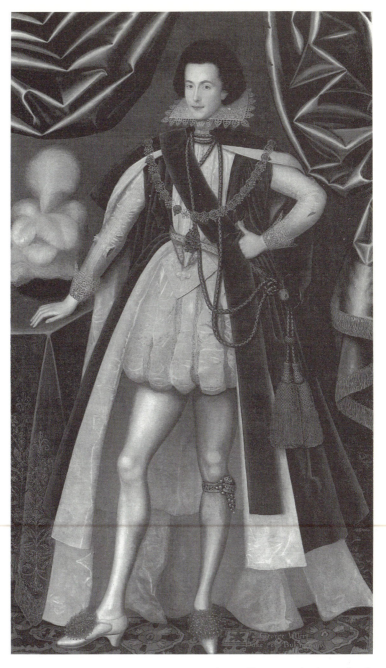

30] Male favourites at the court of James I took Elizabethan notions of effeminacy to ostentatious extremes. An attenuated, epicene delicacy marks George Villiers out as the archetypal Jacobean dandy.

imagery for more substantial weighty effects including thick folds of material placed in a radiating fan over the table-like top of the skirt, heavy use of contrasting embroideries, and deeper materials such as velvets and brocades. Echoing treatments of the male head, women now chose a fuller hairstyle and the ubiquitous face-framing high ruff or standing collar. Portraits dating from the middle years of the second decade

depict a gradual decrease in the size and angle of the farthin-
gale, leading to a smoother outline in which the padding of
the skirt followed the natural shape of the hips. By 1620, and
following the death of the Queen in 1619, the waist had risen
to just below the bust and the formality of earlier Jacobean
court styles gave way to a restrained elegance which priorit-
ised a less exuberant use of fabrics and lightly applied decora-
tion on a dull ground. The folds of the skirt now fell in
straight lines to the ground, forming a conical silhouette
accentuated by deep falling ruffs and plain turned-back lace
cuffs.

The final years of the 1620s witnessed a full transition
towards the relaxed style commonly associated with the court
of Charles I. The extravagance formerly associated with male
dress had abated by about 1624, succeeded by a darker,
narrower line which in purely stylistic terms bore some

31] The weightless
appearance of aristocratic
women, gradually
transformed into the
heavier, more centred
demeanour, adopted here
by the Countess of
Somerset, before 1620.

similarities to the patrician seriousness and sober understate-
ment of Netherlandish wardrobes. Great play was made from
the contrast between stark white linen and lace and the
unembellished brown and black of doublet and breeches.
Henry Peacham, writing a guide for the conduct of gentlemen
in 1622, recommended the adoption of simple, even humble
attire:

> using that moderate and middle garbe, which shall rather lessen
> than make you bigger than you are, which hath beene and is yet
> observed by our greatest Princes, who in outside goe many times
> inferior to their groomes and pages . . . I have many times seene
> his Excellence the Prince of Orange that now is, in the field, in
> his habite as plaine as any country gentleman, wearing com-
> monly a suite of haire coloured slight stuffe of silke, a plaine
> grey cloake and hat, with a greene feather, his hatbande onely
> exceeding rich.[3]

From 1628 the soft falling lace collar, long loosely curled
hair, puffed sleeves composed of panes of satin over an under-
sleeve, secured in two tiers at elbow and upper arm, and rela-
tively high waists were common to fashionable men and
women. In contrast to this 'loosening up' the provincial and
merchant classes retained the stiffer ruffs and composure and
broad-brimmed beaver hats of the previous decades right
through the middle years of the century. Male dress at this
point began to assume the uniform cut, longer breeches
tucked into soft leather boots, loose jerkin over shorter
doublet and conformity of colour that suggest early tenden-
cies towards the masculine three-piece suit, which had
evolved into a staple of the male wardrobe by 1700. Female
dress, on the other hand, especially those flowing aristocratic
styles depicted in the portraits of Van Dyck, mislead the
costume historian into a mistaken assumption of concurrent
moves towards classical simplicity. Sitters were often shown
with a deep revealing decolletage unprotected by the gauze or
lace collar and sleeves or scarves of billowing silk loosely
attached to the high bodice with brooches. The attendant
wild flowers and pastoral setting, however, described a sense
of informal and mythological unreality, a mode of presenta-
tion that bore only a passing resemblance to the more mea-
sured appearance of cosmopolitan wardrobes and 'causes
confusion for costume historians, intermittently, for the rest
of the century'.[4] Contemporary ballads and erotic poetry are
similarly misleading in their preference for the undressed
state. Robert Herrick's 'Delight in Disorder' of 1648 was
typical of its playful fetishism:

A sweet disorder in the dresse
Kindles in clothes a wantoness
A Lawne about the shoulders thrown
Into a fine distraction
An erring lace, which here and there
Enthralls the crimson stomacher
A cuffe neglectfull, and thereby
Ribbands to flow confusedly
A winning wave (deserving note)
In the tempestuous petticoat
A careless shoe string, in whose type
I see a wilde civility
Doe more bewitch me, then when Art
Is too precise in every part.

Inspired by the stiff formality of French court etiquette intro-
duced by Henrietta Maria, (see fig 29) and instituted in her
classical state apartments at Greenwich, female court dress
was nevertheless comparatively simple compared to the
earlier dictates of farthingale and ruff. By 1640 the formal
gown was distinguished by its uniform colour and restrained
satin sheen. Pearls, lace and contrasting ribbon ties consti-
tuted preferred decoration with the plain white texture of the
undersmock doubling up as a neat border for the cuffs and
low neckline.

The 1640s, a decade in which the country edged towards
internal conflict, witnessed a growing looseness and broad-
ening of male dress. The strong vertical lines of the previous
decades were tempered by loose full breeches cut fairly high
to the knee, and shorter bulky garments generally worn
unbuttoned at the front and in the sleeves to reveal the lace
and linen of the undersleeves. A sense of undress was accentu-
ated by the windswept tousled appearance of shoulder-length
hair and the adoption of wispy beards and moustaches. It is
no coincidence that contemporary portraits of male sitters
also include the accoutrements of contemporary war, rather
than the stylised neo-Gothic armour of earlier seventeenth-
century representations. Pistols, buckskin jerkins and breast-
plates accentuate the unstable and deliberately rushed effects
of the fashionable male toilette. Female dress, on the con-
trary, assumed a tighter, more respectable demeanour,
coming closer to an approximation of the sober town dress of
prosperous merchants' wives rather than the diaphanous
robes of nymphs and shepherdesses chosen as props by fash-
ionable portrait painters. Wenceslaus Hollar, engraver of
London life and style, depicts a preference for dark gowns,
divided at the front of the skirt and arranged in double tiers

at the sleeves, relieved by linen kerchiefs and cuffs judiciously trimmed with lace.

Assumptions that the period of the Commonwealth entailed a rejection of fashionable excess or aristocratic style, inspired by Puritan ethics of simplicity and denial, are not born out so directly by depictions of dress in the 1650s which reveal an assured elegance and worldliness that is somewhat surprising. The informal aspects of male dress were extended to include a more contrived treatment of the hair, which was cut short on the crown and fringe but left full and long to the jawline or shoulders. Lace collars and cuffs were replaced with deep bands of plain linen accentuating the return of a simple tubular cut in doublets and breeches, alleviated by the addition of repeated loops of ribbon, fringes, and panels of brocade at the edges of garments. Women's clothing went through further simplifications, the bodice lengthening and seeming to stiffen, and the neckline broadening to reveal much of the upper chest. Lace collars and kerchiefs disappeared to be replaced by gauze scarves arranged symmetrically at the shoulder and cleavage. The swelling shape of low-set sleeves were echoed above by the extension of the coiffure into two wired masses of ringlets falling out from a tightly scraped parting just above the ears.

The restoration of Charles II after a decade of exile in France speeded up the process of innovation in fashionable clothing. It was unavoidable that the new court, with a king experienced in the ritual and display of the court of Louis XIV and a Portuguese queen familiar with the Catholic formality of Habsburg court styles, should reflect a heightened European sophistication lacking in London during the previous ten years. The most significant advance in the arrangement of male garments was the development of the doublet, jerkin and breeches (anticipated since the 1640s and expressed through constant variations in cut and length in the intervening period) into a unified whole, specifically the tunic (or coat) and vest (or waistcoat) in matching textiles. The basic looseness of these garments, covering wide petticoat breeches, was embellished and exaggerated by a profusion of hanging ribbons and the adoption of a deep lace collar or cravat from about 1670. The growing of hair by men was replaced by full wigs, repeated in the cultivation of more luxurious curled and wired styles for women. In all other regards, women's dress remained relatively static, though the informal nightgown,

a loosely dressed one-piece coat worn over a white linen smock and decorated with pearl brooches, was an increasingly popular choice for day wear and approximated well to the classical ideal demanded by portrait painters. By the late 1670s the easy line of the nightgown was complemented by more formal wear that relied on an erect and stiffly boned bodice, elaborately ruffled sleeves (which in the French court denoted levels of status) and a trained skirt for ceremonial impact.

The final decades of the seventeenth century present the

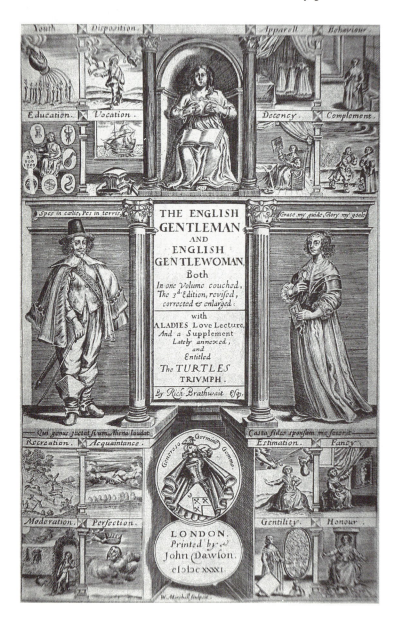

32] This etiquette guide from the 1640s presents a model of respectable dress for the middling class. The fluid aristocratic lines of the previous decade have been replaced by a more solid restrained cut.

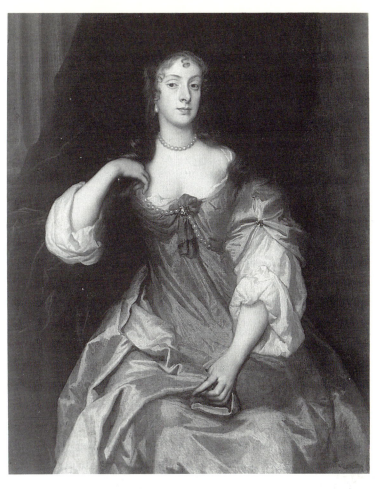

33] Often misleading to the dress historian, the typically flowing drapes adopted by courtiers and courtesans in classical settings, do give some idea of the way in which the casual nightgown was adapted to practical need, providing a basis for the rise of the mantua from the 1680s.

34] A stiff formality inherited from the court at Versailles is evident in the severely boned gowns and wired coiffures of Queen Catherine and her ladies. The unified adoption of a loose coat, vest and breeches by the male figures is embellished by extravagant use of buttons, lace and ribbons.

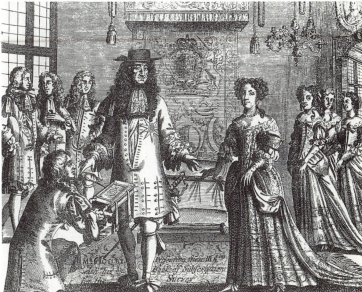

dual images of increased artifice and visual grandeur with growing comfort and ease of cut. Most important in terms of cut and style during the middle years of the 1680s was the introduction of the gown or mantua to the female wardrobe. Capitalising on the practicality suggested by the nightgown, the bodice and skirt now joined at the waist to form a complete garment. The skirt was divided at the front and pinned up to form a small bustle at the back of the waist, revealing the contrasting material of the petticoat beneath. A stiff stomacher tied into the front of the bodice with ribbons accentuated a sense of verticality which was further suggested by 1690 in the tall frills of the fontages, a close-fitting cap incorporating reinforced tiers of lace at the front of the head and trailing lappets at the back. Hair could be piled up in peaks against the tiers. The growing length and volume of men's wigs and the rising heels of shoes during the same period ensured a sense of equality between the sexes in terms of height. But otherwise the long knee-length coat, waistcoat and breeches established for men had stabilised, and the exuberant additions of ribbon loops were replaced by the late 1680s by discreet decorative buttons and occasional military frogging on dark brown, green and grey velvet. Rich brocade and patterned silk might be reserved for cuffs, pockets and waistcoats, leaving a pattern of stylish but reserved elegance that would serve as a sober patriarchal model for gentlemen interested in, but not obsessed by fashion, through much of the succeeding century. The limited, but nevertheless contentious appeal of elite metropolitan style at the turn of the eighteenth century, with its bizarre mix of the extravagant and the refined, is attested to by Charles Saumarez Smith. His summary allows us both to place seventeenth-century dress within the wider context of material goods, and to assess its significance for design generally in the coming decades:

> Through the influence of the Royal household and because of the abundant availability of a supply of cheap, highly skilled labor, the dominant taste of the political and metropolitan elite in the reign of William and Mary was for very substantial and highly ornamented furniture, for richly embossed and engraved silver, and for elaborate displays of wares imported from the Far East. Yet it is important to acknowledge that this taste was confined to an extremely small sector of the population and that, from what evidence survives, its flamboyance and ostentation aroused fierce opposition.[5]

Poles apart – sexual difference and dress in the seventeenth century

There are several threads running through the history of seventeenth-century fashion that suggest the playing out of diverse struggles between sections of society for sartorial definition and supremacy. For example, the growing influence of a simple bourgeois style can be seen infiltrating the hierarchical and symbolic importance of aristocratic dressing. Emphasis switched from allegory and rhetoric in dress, a reliance on the specific meanings of decorative motifs and colours, to an appreciation of quality in terms of precise cut and smooth finish. Actual possession became more important than symbolic display, a trend identified in the growing naturalism of portraiture during the period which tended to incorporate fashionable objects of real worth as a replacement for the more traditional emblem:

> A skull in the hands of a man making an expository gesture, makes the substance of his implied discourse quite specific . . . symbolic objects of this sort become much scarcer in seventeenth-century portraits. They are replaced by other motifs, such as gloves, fans, or handkerchiefs, which fit more naturalistically into the framework of social encounter. Though unassuming to the modern eye, such possessions were both expensive and fashionable. There can be little doubt that part of their function is to display their owners' wealth and status.[16]

The change is basically iconographical, the deliberate symbolic gesture or motif replaced by a more amorphous code of ownership; it is not the surface image that counts but the substance of what is represented. Such shifting meanings can be attributed to a variety of causes: the growing power of a merchant class whose religious biases and pragmatic attitudes towards business presented a very real cultural, political, and, in the 1640s, military threat to more traditional ideas of aristocratic power and capital. (This was a state of affairs not confined to England; Simon Schama has shown how similar trends towards the control and manipulation of material goods by a rising middle class defined the nature and atmosphere of the Dutch Republic during the same period.[7]) A shift towards naturalism in the arts and sciences rejected artifice and its inherent elitism for an espousal of new neo-classical methods of representation and a closer understanding of the body and its environment, overturning the older reliance on systems of belief based upon superstition and mystery for a new humanism and 'scientific' sense of

order. Joan Thirsk identifies a similar trend, from rhetoric to pragmatism, within the organisation of economic thought and practice:

> In the sermons and pamphlets of the 1530s and 1540s the two words 'covetousness' and 'commonweal' constantly recur. They are antitheses which illuminate the anxieties and sympathies of their time. The covetousness of rich men obtruded itself and offended men with a social conscience; the commonweal summed up the aspirations of those who sought a new kind of society to replace the old . . . Towards the end of the sixteenth century, however, concern for this abstract ideal, the commonweal, switched to more material concerns and in the seventeenth century two of the keywords that characterised the new era were 'project' and 'projector'. . . . The concrete noun is significant. A project was a practical scheme for exploiting material things; it was capable of being realised through industry and ingenuity. It was not an unattainable dream like commonweal.[8]

Whatever the causes, the evidence for any claim that one of the most significant shifts in seventeenth-century fashion was a gradual wearing down of previous overt strategies of social division and identification in dress is displayed clearly in the development of clothing styles themselves. The basic forms of mantua and suit which emerged at the end of the century were able to cross social boundaries in a manner inconceivable to the orchestrators of courtly ritual in 1600, and where strictly defined sartorial codes based on symbolic display remained (at the court of Louis XIV for example) they appeared anachronistic and archaic. Hidden, however, in the emergence of relatively democratic forms of dress is a division or struggle more profound in terms of the evolution and meanings attached to fashion than the triumphalism of a new bourgeois outlook. The rise of the strictly differentiated mantua and suit embody a division or struggle between the sexes more entrenched than that suggested by any previous gendered styles, and reflects a debate that concerned consumers of dress consistently throughout the period.

Threads of struggle usually intertwine, and it is often impossible or historically simplistic to unpick them. Changes in the hierarchical and gendered connotations of dress are obviously connected, structured around the central problems of authority and power. Indeed authority lies at the centre of all debates concerning appearance in the seventeenth century, and before analysing its pertinence to problems of sexuality, Susan Dwyer Amussen presents a useful characterisation of its wider place in cultural and political formations:

Authority is socially constructed. The authority of particular individuals or groups rests on the conception of society developed in a particular period. It is also a product of social relations – hierarchies, distances and power – rooted in both the material and the ideological worlds. Authority carries with it social and political consequences. Any change in one of the components of authority will have consequences for the others; the equation must be balanced.[9]

The control of masculine and feminine appearance was constantly kept in balance, reflecting the authority invested in constructions of patriarchal behaviour and demeanour, and the subservient position of femininity in social discourse. Fashion as an expressive and imaginative pursuit received short shrift from the etiquette manual publishers and sermon writers who helped to keep such constructions in place. For them the cultivation of dress and finery was a weakness associated with the moral laxity of women, even when applied to the visual effects of military apparel:

> Philopoemen cauled his souldiours to bee spare in Apparell and Diet (saith Plutarch) and to come honourably armed into the field: wherefore hee commanded in goldsmiths shoppes to breake in peeces pots of gold and silver, and to be imployed in the silvering of bittes, guilding of Armours, inlaying of saddles, & C. For the sumptuous cost upon warlike furniture, doth encourage and make great a noble heart; but in other sights it carryeth away mens minds to a womanish vanitie, and melting the courage of the mind.[10]

The true gentleman was encouraged to indulge in more ascetic pursuits: 'let the Bible and other books of piety, such as treat of Philosophy, Naturall or Morall History, the Mathmatickes, as Arithmetick, Geometery, Musicke, Sometime Heraldry, and the like be your chiefe company: for you shall finde books no flatterers'.[11] Biblical advice underpinned attitudes towards social roles and behaviour, forming, in an era before mass communication, something of a national culture. Regardless of wealth, status or geographical position, every subject was expected to attend weekly instruction at church: 'the Canons of 1604 required that the "youth and ignorant persons" of every parish be catechised by the rector, vicar or curate . . . in addition to its doctrinal instruction, the catechism taught young people how to be good subjects. In doing so it asserted that the family was the fundamental social institution, and that order in families was both necessary for, and parallel to, order in the State.'[12] Social roles within the family were closely monitored and controlled so

that women trod a particularly precarious path between scriptural purity and a more pragmatic economic usefulness. As in earlier periods, women took a direct part in the economic management of the household, with care of textiles and attention to clothing prioritised. This is reflected in the advice in the many manuals published for female consumption during the seventeenth century. *The Accomplisht Ladys Delight In Preserving, Physick, Beautifying and Cookery*, published in 1683, included not only health and nutritional advice, but 'also some new and excellent secrets and experiments in the Art of Angling'.! Such works are also useful for the information they provide concerning attitudes towards the female body and standards of beauty or hygiene, which often rejected the stern admonitions of pamphleteers and religious pundits:

> 6 A water to whiten the skin and take away sunburn.
> Take of Rain Water, the juice of unripe Grapes, each a like quantity, boyl them together till one half be consumed, then whilst it boyls, add so much juice of lemons as was boyled away before, when it is boyled take it off, and add four whites of eggs after it is cold, and keep it for your use.
> 50 For the lips chopt.
> Rub them with the sweat behind your Ears, and this will make them smooth and well coloured.

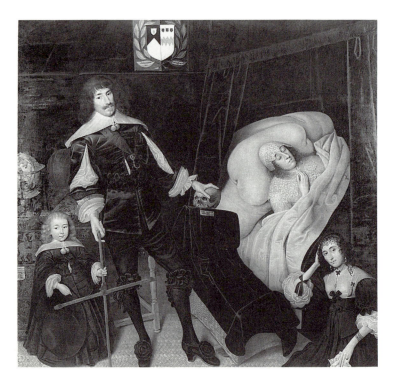

35] The sympathetic poses and tangible textures of seventeenth-century allegorical portraits, differ from the play with surfaces and meanings that preoccupied Elizabethan painters. This shift towards the material world is of enormous importance to the historian of clothing and its representation.

17 To make the Breasts small.
Take of Rock Allom powdered, and Oyl of Roses, of each a like
quantity, mix them together and anoint the breasts therewith.
21 To make the body fat and comely.
Take of milk and spring-water each one pint, boyl them together
till the water be consumed then add Sugar of Penedies, Fresh
Butter, each one ounce, Oyl of sweet Almonds newly drawn,
half an ounce, give them one boyling more, and so let it be
taken betimes in a morning Fasting, and sleep upon it.[13]

Readership of such titles is difficult to ascertain. The fron-
tispiece depicted a well-furnished panelled city interior with
a lady of fashion engaged in the mixing of recipes, and many
of the entries are given affidavits by titled, though anony-
mous, users. However, such devices were likely to have been
attempts at creating a sense of exclusivity as much as they
reflected a particular audience. What they do suggest, in their
inclusion of more humble instructions for household clean-
ing agents, popular medicines and economical meals are the
twin demands made upon seventeenth-century women
across a range of social classes for physical attractiveness and
thrifty management of time and resources. In this light the
misogynistic ravings of other commentators seem particu-
larly contradictory, though they shed light on Amussen's
claim that instructive manuals were merely reflecting the
goals of the state, and any ambiguities between their content
and the popular preconceptions or demands made of
femininity were a consequence of wider political conflicts,
especially in the 1640s.[14] The pamphlets themselves were
entirely unambiguous, presenting a vision of woman as a
trivialising drain on the male purse:

The pride of a woman is like the dropsie; for as drink increaseth
the drouth of the one, even so money enlargeth the pride of the
other: thy purse must be alwaie open to feed their fancy, and so
thy expenses will be great, and yet perhaps thy getting small:
thy house must be stored with costly stuffe, and yet perhaps thy
servants starved for lacke of meat: thou must discharge the
mercers book, and pay the haberdashers man; for her hat must
continually be of the new fashion, and her gowne of finer wool
than the sheepe beareth any: she must likewise have her jewell-
box furnished, especially if she be beautiful; for then commonly
beauty and pride goeth together, and a beautiful woman is for
the most part costly, and no good huswife.[15]

Love of fashion and the attendant sin of vanity were viewed
as pathological traits of the female condition, an addiction
like alcoholism, sustained by a conspiracy of women with the
aim of entrapping men like flies: 'For commonly, women are

the most part of the forenoon painting themselves, and fri-
zling their haires, and prying in their glasse, like Apes to
prancke up themselves in their gawdies, like Poppets, or like
the Spider which weaves a fine web to hang the flie. Amongst
women she is accounted a slut which goeth not in her silks.[16]
Beneath such fashionable display, moral decay was an
inevitability: 'A woman which is faire in shew, is foule in
condition: she is like unto a glow worme, which is bright in
the hedge, and blacke in the hand; in the greenest grasse lyeth
hid the greatest serpents: painted pottes commonly hold
deadly poyson: and in the cleerest water the ugliest Tode; and
the fairest woman hath some filthines in her.'[17]

By the time of the Restoration, according to Amussen,
such aggressive commentaries on female fashionability were
rare. She suggests that in some respects their calls for a
puritanical rejection of excess and a cultivation of more
homely virtues had been incorporated into a more general-
ised polarisation of gender roles within society, echoing
similar divisions concerning social status, that ensured
greater stability than that experienced in the middle years of
the century: 'The relative absence of conflict about both class
and gender after the Restoration rested on this increasing dis-
tance between women and men, rich and poor; distance

36] An association between
femininity and the fripperies
of fashion was maintained
through the images and
rhymes of broadsheet
publishers. Here the
adoption of the fontages or
tall ribboned cap in the
1690s attracts ridicule.

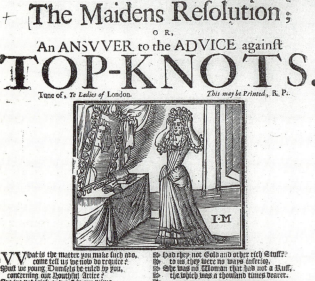

simultaneously made the elite more secure and deprived those they ruled of the proximity – social and economic – necessary for effective challenges.'[18] It would of course be overly simplistic to translate the evolution of more strictly defined modes of male and female deportment and appearance directly into such a reading. But it is possible to identify here the beginnings of those trends and arguments which established acceptable forms of feminine and masculine dress that signified 'respectability' for the middling classes in the eighteenth and early nineteenth centuries, a 'norm' that was always seen to be under attack from more subversive, expressive elements within society.

Deviance and gendered dress

Signs of a challenge to the authority invested in differentiation between male and female ways of dressing erupted simultaneously in the 1620s. As previous chapters show concerns regarding gender confusion caused by trends in fashion were not a phenomenon peculiar to the early seventeenth century, but occur perennially as attacks by monastic moralists in the fourteenth century and Puritan poets in the sixteenth prove. From about 1570, however, the perceived emergence of specific transvestite behaviour, especially by women, presented new challenges. Gascoigne identified the trend in his poem 'The Steele Glas' of 1576:

> Women? Masking in mens weedes?
> with dutchkin dublets and with Jerkins jaggde?
> with Spanish spangs, and ruffes set out of frame,
> with high copt hattes, and fethers flaunt a flaunt?[19]

Forty years later, what had begun as a satire on the extravagance of London fashions developed into the full-blown attack of the pamphlet '*Hic Mulier*', or the Man–Woman: Being a Medicine to cure the Coltish Disease of the Staggers in the Masculine–Feminines of Our Times', designed to rid the streets of women whose choice of masculine clothing challenged the natural order. Philip Stubbes, writing in the mid-1580s had established the importance of costume as a signifier of biological and social difference between the sexes: 'Our apparell was given us as a signe distinctive to discern betwixt sex and sex, & therfore one to weare the Aparel of another sex, is to participate with the same, and to adulterate the veritie of his own kinde. Wherefore these women may not improperly be called Hermaphrodita, that is, monsters of bothe kindes, half women, half men.'[20]

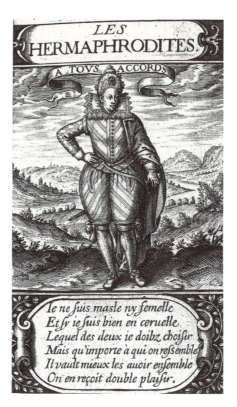

LES
HERMAPHRODITES.
A TOVS ACCORD

Ie ne fuis masle ny femelle
Et fy ie fuis bien en ceruelle
Lequel des deux ie doibz choifir
Mais qu'importe à qui on refsemble
Il vault mieux les auoir enfemble
On en reçoit double plaifir.

37] The adoption of the clothing of the opposite gender by various subcultures in the seventeenth century gave cause for widespread moral panic in sections of the media and the church.

Hermaphroditism or the concept of androgyny played a central role in early modern discussions of gender. In the most positive readings of the position and function of women within society, Renaissance rereadings of Plato's *Symposium* helped to fill out arguments which attested to the essential lack of spiritual difference between the sexes, even recalling heretical medieval suggestions that Adam himself was a hermaphrodite, separate from Eve only after the Fall. However, despite the enlightened philosophy of neo-Platonic scholars, the material reality of indeterminate fashionable creatures on the streets could do little else but inspire misogynistic and fearful condemnation, the gap between abstract symbolism and concrete deviance underlying the ambivalent nature of cross-dressing.[21] A correspondent of January 1620 marked the translation of criticisms of such monstrosities of nature from the scandal sheets of pamphleteers to the more respectable pulpits of London churches:

> Yesterday the bishop of London called together all his clergie about this towne, and told them he had expresse command-ment from the King to will them to inveigh vehemently and bit-terly in theyre sermons, against the insolencie of our women, and theyre wearing of brode brimd hats, pointed dublets, theyre

haire cut short or shorne, and some of them stilletaes or poinards, and such other trinckets of like moment; adding withall that yf pulpit admonitions will not reforme them he would proceed by another course; the truth is the world is very far out of order, but wether this will mend yt God knowes.[22]

In February of the same year '*Hic Mulier*' appeared with a woodcut on the title page showing two women in the male domain of the barber-surgeon's shop; one is trying on the tall plumed hat associated with men's dress whilst her partner has her long hair cropped into a masculine style. The writer attested, in alarmist tones, to the prevalence of the fashion across the social spectrum, unconfined by geographical distance, 'an infection that emulates the plague and throwes it selfe amongst women of all degrees, all deserts, and all ages, from the Capitoll to the Cottage'[23] and described the costume as including a plumed broad-rimmed hat, a doublet unbuttoned to the navel, exposing naked breasts, a sword, breeches or a full skirt and the requisite short hair. The survey of changing style presented at the beginning of the chapter shows that many of these features were unremarkable components of the wardrobes of city merchants' wives, where neat cut and severity of colour lent a masculine flavour anyway. Obviously the sword and breeches signify more directly 'un-feminine' behaviour and reveal the true nature of the pamphlet as a symbolic warning against wider social dislocation rather than an accurate record of the status quo in terms of fashion. Woodbridge pinpoints the usefulness of such works in reconstructing attitudes rather than concrete appearance: 'The problem is that the expression of reality is nearly always oblique: it must be extrapolated from recurring plot structures, unravelled from patterns of characterization, coaxed from odd twistings of stereotype, winkeled out of costume and imagery and word.'[24] By using the language of cultural commentary '*Hic Mulier*' achieves a misleading gloss of objective journalism denied the more metaphorical explorations of cross-dressing presented by contemporary writers:

'T'is strange to see a mermaide, you will say,
Yet not so strange, as that I saw today,
One part of that which 'bove the waters rise,
Is woman, th'other fish, or fishers lies.
One part of this was man or I mistooke . . .
The head is mans, I judge by hat and haire,
And by the band and doublet it doth weare,
The bodie should be mans, what doth it need?
Had it a codpiece, 'twere a man indeed.[25]

Undoubtedly, to some extent such pamphlets and poems were responding to existing trends. As the centre and disseminator of fashionable style, the court of James I was renowned for its relaxed and libidinous attitude to male same-sex relationships, its espousal of effeminacy in dress and behaviour as a cultural norm, and its rampant misogyny. Whilst only the latter phenomenon can partially explain the prevalence of negative comment on women acting and dressing as men, courtly fashion is reflected in the publication of a further anonymous article '*Haec Vir*; or, The Womanish Man: Being an answere to the late booke intituled *Hic Mulier*', which dealt with the epicene appearance of male dandies during the same period. In a subtle manner the charge of effeminacy levelled against noblemen did not centre so much around accusations that the adoption of un-masculine clothing would shake the moral and social order. Instead it simply repeated the usual anti-materialistic diatribes based on denial, thrift and the 'honesty' of appearances usually levelled at the vanity of women. Fashion and fashioning was in this way constructed very much as an intrinsically feminine pursuit. Anna Bryson underlines the contradictions apparent in such interpretations of fashionable display as an artificial feminine layer placed over more essentialist, biological determinants of masculine gender:

> there was a . . . paradox at the heart of the newly 'representational' view of manners. Through his manners the gentleman was supposed to proclaim his 'natural' virtue and title to authority, but such manners were self-evidently the product of education, effort and artifice . . . From the later sixteenth century, and particularly in the politically troubled early Stuart period, the courtier was a figure which came in for a great deal of moral criticism on the grounds of vanity, hypocrisy and an effeminate obsession with display . . . the paradox of nature and artifice in concepts of gentlemanly manners . . . pervaded writing on prestigious social conduct regardless of the author's attitude to courtiers. 'Take heed of affectation and singularity' wrote the Puritan fifth earl of Bedford to his sons, 'if so you act the nobleman instead of being one'.[26]

Dress, popular culture and agency

The problems associated with the articulation of gender differences through dress were accentuated by the increasing importance given to the city as an arena for cultural display throughout the seventeenth century. Much recent historical work has focused on the specific cultural life of metropolitan

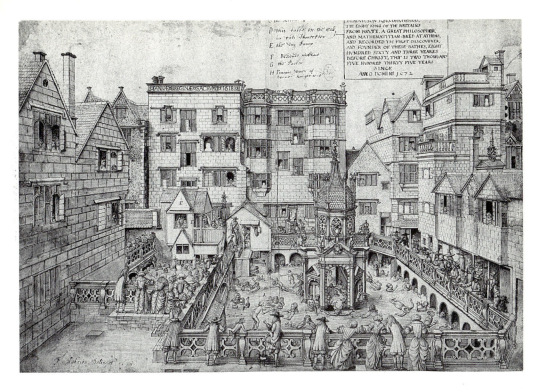

Some illegible handwritten annotations appear within the illustration, including a list beginning:

D this ... on the ...
E the ...
F ...
G the ...
H ...

and a block of text at upper right reading in part:
"... THE EIGHT KING OF THE BRITAINS / FROM BRVTE, A GREAT PHILOSOPHER, / AND MATHEMATITIAN, BRED AT ATHENS, / AND RECORDED THE FIRST DISCOVERER, / AND FOVNDER OF THESE BATHES, EIGHT / HVNDRED SIXTY AND THREE YEARES / BEFORE CHRIST, THAT IS TWO THOVSAND / FIVE HVNDRED THIRTY FIVE YEARS / SINCE / ANNO DOMINI 1672"

38] The environment of the city was a rich breeding ground for the development of specific and individual fashionable styles, many of them bound up with sexual activity and political subversion.

and rural communities during the period, attempting to define a new sense of 'popular culture' essential for the fostering of specific class and sexual identities outside of the concerns of the court. A popular culture can loosely be defined as those elements of entertainment which ran alongside, within, and often counter to the elite structures of courtly entertainment, tournament, masque, ball and opera, that Norbert Elias quotes as civilising agents for an aristocratic society. Plays, fairs, blood sports and drinking rituals were mass pastimes that tapped into a much older sense of the carnivalesque and from the seventeenth century onwards became subject to increasing entrepreneurial control and commodification, widening their appeal to a new urban merchant class. A new conception of the 'popular' was especially pertinent to the potential of dress as a communicator both of social distinction and of belonging, preceding and contributing to the consumer and technological revolutions of the eighteenth century. Barry Reay has identified the 'middling sort' or the rising urban commercial classes as the focus of such 'popular' cultural and social changes between 1600 and 1700, participating in and extracting the greatest benefits from limited improvements in levels of literacy, expansions in political franchise and involvement in religious radicalism.

In grand political terms it could be claimed that the middling sort were solely responsible for 'forcing the pace of the English Revolution'.[27] In the humbler but parallel domestic sphere of personal appearance and physical adornment the same group was certainly setting the cultural agenda in a manner that would have been inconceivable to the merchants and professionals of the previous century. The peculiar nature of seventeenth-century fashionable dress, simplified, elegant and 'easy' in comparison to elite styles of the previous century, is central to any understanding of such shifting trends.

One of the biggest problems facing the fashion historian who attempts to explain the relationship between social position and dress in the early modern period is the question of agency. If seventeenth-century English fashionable style saw a broad rejection of aristocratic Elizabethan symbolism in favour of the less opaque and more pragmatic aesthetic of the middling sort, through what channels of communication and social discourse was the shift purveyed or indeed acted upon? Reference to research in early forms of popular culture is obviously of potential help here. Much attention has been given to the revolutionary role played by the expansion of magazines in the late eighteenth and early nineteenth centuries in the wider broadcasting of fashion change, but there is little explanation of the alternatives available in the preceding periods. Later publishers relied to some extent on increases in literacy achieved from the time of the civil war. Reay shows that 30 per cent of men and 10 per cent of women were able to write in the 1640s (figures which imply a greater proportion of readers, reading being an elementary skill, upon which the acquisition of writing skills depended). Most of the literate originated from professions associated with the middling sort (yeomen, shopkeepers, craftsmen) and the towns and cities. But despite this tangible rise of a culture centred around the medium of print, a more traditional oral culture predominated in most people's lives until the education acts of the nineteenth century. Alongside forms of communication which centred on gossip, legend, ballads and family folklore was an intense understanding of the visual world, a reliance on the theatricality of the sign and the spectacle to impart values and information. The visual power of clothing had a special relevance within such a culture, both in a very literal sense with labouring men, for example, lining up at hiring fairs with different coloured ribbons in their caps to publicise their specialities (it may be pertinent to note here

that ribbons and other items of haberdashery have been iden-
tified as the means by which members of the lower social
orders could take elements of elite fashion, customising them
for their own use without incurring the expense or moral
problems of the whole package), or 'the lavish use of music,
costume and free food and drink' employed to ensure public
attention to Government decrees or Church traditions,[28] and
in a deeper sense as a source of sensual stimulation and imag-
inative creativity. It is no coincidence that commentators
should employ textile metaphors in their descriptions of the
nature of popular culture 'pre-print':

> What Edward Thompson has called the theatre and counter-
> theatre of popular culture runs through the seventeenth century
> like a brightly coloured thread . . . A certain poverty of imagina-
> tion in the sphere of print was more than compensated with a
> richness in festivity. For what can best be described as the car-
> nivalesque was surprisingly strong in early modern England.[29]

However, whilst a kind of visual literacy may have been
highly developed in the cities, the personal world of those
living outside the major population centres was severely
limited, nine kilometres being the median distance travelled
to fairs and markets, and the country at large divided by
dialect and local tradition. In circumstances such as these, the
communication of fashionable information either orally or
visually was slow. Women particularly found their horizons
narrowed by their exclusion from many organised features of
popular culture such as sport or drinking. Female participa-
tion when it was allowed tended towards the passive rather
than the active. Reay suggests a more informal pattern for the
exchange of feminine values which offers some scope for an
explanation of ways in which changes of style and fashion-
able nuances followed a necessarily hidden, rather than a
public route:

> We need to know more about the contact points for female
> popular culture. Much of women's labour was domestic, and
> collective, so presumably the entry points for this almost invis-
> ible cultural world are the places where, or the times when,
> women gathered: the parish pump, well or stream where they
> washed clothes and collected water, at the bakery or mill, during
> harvesting, spinning or when dung or wood was collected for
> fuel, or on their frequent trips to fairs and markets. All provided
> opportunities for female interaction and exchange of views.[30]

Reay explains wider patterns of seventeenth-century
popular culture through recourse to the Marxist theory of
hegemony proposed by the Italian theorist Antonio Gramsci,

the idea that 'a dominant social group or class can maintain its supremacy . . . through ideology and culture' rather than 'through force, coercion or barefaced suppression'.[31] Through institutional, economic, political and other public and private channels such as the church, the home and the school, those with a vested interest in power and control, whether men over women, or aristocracy over commoners, can maintain a hierarchy or the sense of a status quo. Of course the practice of domination in this way also suggests a capacity for struggle and revolt by the suppressed, the creation of alternative or oppositional cultures. But hegemonic theory makes little allowance for any deviance from these two alternatives. Cultural values do not necessarily shift around one central axis of domination, assent and dissent, but can maintain a momentum of their own dependent on locality, generation and sexuality, motives based around a sense of the immediate and personal. Seventeenth-century clothing fits a lot more snugly into an explanation which makes allowances for difference independent of a generalised concept of a hegemonic hierarchy. In the most basic terms hegemony cannot fully explain the divergence of rural and urban cultural forms or the decline of traditional methods of aristocratic display alongside the ascendancy of urban non-aristocratic materialism. It is a concept that depends too greatly on the existence of a nation-wide cultural norm. As the argument of this chapter implies, such a norm could not easily exist in a period before standardised literary forms and unproblematic channels of communication (the catechism providing a rare example of a text common across the whole country).

The seventeenth-century city itself stands as a contradictory symbol of parallel but separate hegemonic struggles focused around she-men and he-women, cavaliers and roundheads, landed gentry and homeless mob, a source of rich sartorial confusion and overlap. The safest explanation would seem to suggest that while general and slow-moving fashionable trends do appear to have existed in town and country, meanings generated by such trends were highly specific to those able to receive them and not at all prescriptive or comprehensive. It is the fashion historian's duty to identify a multitude of strands and unpick those lost nuances, a perhaps unenviable task in the face of a century marked by contradiction and conflict, where the old assurances of explicit links between social standing and choice of clothing underwent rapid change and permutation.

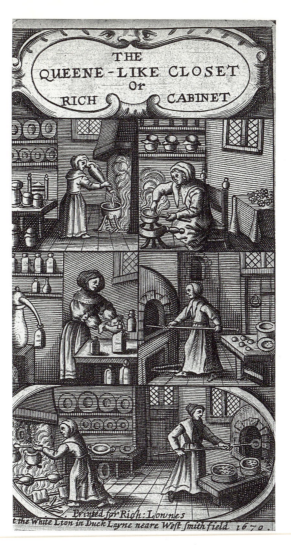

39] Despite the misogyny explicit in anti-fashion broadsheets, women were also expected to fulfil a role as household manager and physical representative of patriarchal power, which entailed a demand for the display and personal cultivation that was otherwise condemned. Health manuals and etiquette guides helped the wives of merchants to overcome some of the more obvious contradictions.

Fashionability and the city – seventeenth-century subcultures

> An aggregate of various nations distinguished from each other by their respective customs, manners and interests.[32]

John Addison writing in 1712 described the social formation of London in terms which perfectly encapsulated a view of seventeenth-century cosmopolitan society as divided and demarcated. The capital city was an ideal stage for the enactment of division in purely visual terms. Peter Burke in his study of the metropolis comes close to utilising the very contemporary idea of 'subcultures' as a way of identifying the separate social formations included within its boundaries:

To what extent true subcultures existed in this period is a question which the fragmentary evidence does not allow us to answer with confidence. Sailors and thieves each had their own jargon, unintelligible to outsiders. So did homosexuals, who also employed hand signals to identify each other in public. The Huguenot silk weavers of Spitalfields differed from their neighbours in trade, language and religion . . . All the same, I have the impression that subcultures were less clear cut in the seventeenth century than they have since become, and the cultures of different subordinate groups overlapped to a large extent. Even learned and popular groups were not hermetically sealed off from one another.[33]

The city then was a centre for social intercourse, the exchange of ideas and goods, a natural focus for fashionable display, and in the eyes of contemporaries a source of sexual temptation and sin with implications central to the meaning and uses of clothing. G. R. Quaife in his work on the sexual behaviour of seventeenth-century rural peasants identifies a combination of tightly-laced upperbodies and loose but all-enveloping skirts and breeches as a deciding or controlling factor in the rushed and clumsy nature of bucolic lovemaking and courtship.[34] Sexual encounters in the city, by contrast, were presented as commonplace and equally characterised as clothed, but ritualised, fetishised and bound up with the follies of fashion, gratuitous consumption and entertainment. H. Pecham produced a cautionary guide entitled *The Art of Living in London* in 1642 which included a familiar tale centred around female inconstancy and the inherent lasciviousness of fashionable metropolitan display:

> A Tradesmans wife of the Exchange one day when her husband was following some businesse in the Citie, desired him he would give her leave to go see a Play, which she had not done in seaven yeares. Hee bade her take his Prentice along with her and goe, but especially to have a care of her purse: which she warranted him she would. Sitting in a Box among some gallants and gallant wenches, and returning when the play was done, returned to her husband, and told him she had lost her purse. Wife quoth he, did I not give you warning of it? How much money was there in it? quoth shee, truly foure peeces, six shillings and a silver tooth picker: quoth her husband, where did you put it? Under my petticote, betweene that and my smocke. What quoth he, did you feele no bodies hand there; but I did not thinke hee had come for that. So much for the guard of your purse.[35]

The sexual implications of clothing within a city environment were only one example of the relationship between

dress and popular culture in the seventeenth century and its
status outside of traditional ideas of clothing as a simple
status symbol. Central to wider conceptions and discussions
of fashionable appearance during the years of civil war and
Commonwealth is the political division between king and
Parliament. The sartorial basis of this division can in fact be
traced back to satirical cultural formations that share the
same popular city-based pamphleteering roots as the debates
on cross-dressing and sexual misdemeanours quoted earlier
in the chapter. Tamsyn Williams in her recent work on
polemical prints of the English Revolution has shown how
the labels 'cavalier' and 'roundhead' arose through an
attempt by printsellers to capitalise on armed clashes
between London merchants and apprentices and 'gentleman-
like' officers brandishing swords during the winter of 1641.
Commentators picked up on the exchange of abusive terms
across partisan lines and through them found a convenient
visual medium through which to emphasise deeper religious
and political extremes. In the words of Williams 'what they
emphasised in woodcut and in word was the overriding
difference between the two groups. Visual images served
to polarise opposites in the hope of mobilising public
opinion.'[36]

The enduring image of voluptuous cavaliers pitted
against self-denying roundheads corresponded more closely
to the definitions of popular publishers than it did to a con-
crete rejection or adoption of certain elements and styles of
clothing by opposing armies, lending weight to the idea that
sartorial codes were much more fluid than costume historians
would have us believe. However, the printsellers were also
drawing on older stereotypes that must have held some con-
temporary currency or maintained a core of recognition
amongst city-dwellers at mid-century for the prints to have
had any market or credibility. Extravagant dress, as we have
seen, attracted constant condemnation from moralists, repre-
senting vanity, moral weakness and effeminacy. In the most
extreme readings, clothing itself stood as a symbol of man's
fall from grace and the expulsion from Eden. By 1640
exaggerated apparel had become closely associated in
Londoners' minds with the behaviour and appearance of
'roaring boys', young wealthy male members of the minor
gentry, whose exploits approximated closely to the supposed
immorality of the court. Anna Bryson typifies such outland-
ish aristocratic behaviour as an ironic or inverted attempt to
establish a place at the top of the social hierarchy:

A great deal of colourful evidence for the roistering and thoroughly uncivil behaviour of young gentlemen on the loose, particularly in London, suggests that the response of the elite to ideals of gracefully controlled carriage and modesty of demeanour was less than complete. Status could be associated with deliberate licence, as was most bizarrely illustrated by the fashion among Restoration courtiers for 'streaking' naked through the streets. This kind of joke, and the more usual form of 'gentlemanly' extravagance in conduct, effectively inverted the 'civil' values of hierarchy, locating social superiority in freedom from rules and restraints, and locating inferiority in an obligation to self-control.[37]

The implied social arrogance of cavalier dressing was one amongst several connotations that printsellers relied upon to encourage buyers. The obvious theatricality of courtly styles, together with their French origins, also located royalist

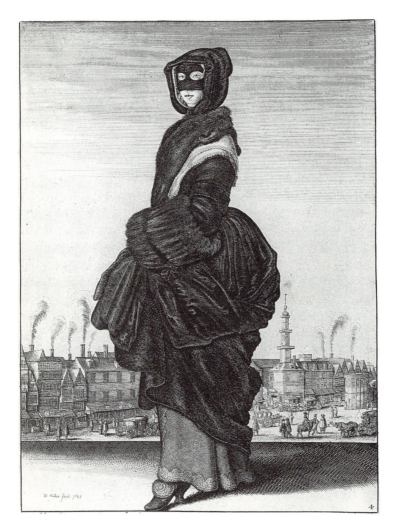

40] The early fashion plates of Hollar form a graphic example of the way in which the comfortable, relaxed and self-aggrandising dress codes of the newly powerful middling sort began to replace the rigid styles of the Court as a model of fashionability in England from the mid-century onwards.

supporters within the sphere of dangerous and foreign popery, setting them against the Puritan or Nonconformist leanings of parliamentarians. But the most visible sign that could be called upon to differentiate between factions was the representation of hair. The long locks of the model cavalier immediately suggested tendencies towards a base animal nature and a damaging degree of effeminacy, despite the claims of a commentator in 1642 that 'many long-haired youths supported Parliament and that not all royalists had bouncing curls'.[38] The formation of the New Model Army in 1646 heralded a counterblast of royalist pamphlets depicting parliamentarians with the cropped, shorn and bristly appearance of the professional soldier. Prior to this pamphleteers had relied on the staple figure of the religious maniac, whose tall black hat and baggy breeches connoted an adherence to late Elizabethan standards of masculine merchant dress and a deliberate rejection of contemporary style. This deliberate manipulation of ideals of fashionability and reliance on sartorial stereotypes may well have led successive historians, dramatists and painters to misinterpret carefully coded propaganda as evidence of actual dress. Its very coding, however, can reveal much about the propensities of seventeenth-century consumers, across social divisions, for reading and fashioning the clothed body.

Through recourse to representation, even the humble seventeenth-century observer was well placed to decode and decipher physical appearance in a new and sophisticated manner. According to Williams, 'explicitly and implicitly, aesthetic was tied to polemic. The terms were based on description, but the origin of the tags and their subsequent developments in print were tied to prejudices about bodily appearance'.[39] It is as if the vocabulary of dress and its meanings developed and expanded in tandem with the political and social problems of the era, the emblem books and *impresa* of the previous century becoming increasingly ill-equipped to deal with such confusion and diversification. The discourse of fashion had extricated itself from the clutches of court ceremonial and aristocratic prerogative, and although this intensified the moral problems of consumers, a useful precedent had been set for the rising fashion-conscious classes of the following century.

Notes

1 T. Archer, *The arraignment of Lewd, idle, froward and unconstant woman: or the vanitie of them, choose you wether. With a commendation of wife, vertuous and honest women. Pleasant for married men, profitable for young men and hurtful to none*, London, 1615, p. 25.

2 V. Cumming, *A Visual History of Costume, The Seventeenth Century*, London, 1987, p. 29.

3 H. Peacham, *The Complete Gentleman*, London, 1622, p. 191.

4 Cumming, *The Seventeenth Century*, p. 60.

5 C. Saumarez Smith, 'Decorative Arts' in R. Maccubbin and M. Phillips, eds, *The Age of William III and Mary II: Power, Politics and Patronage 1688–1702*, Williamsburg, 1989, p. 299.

6 Smith, *Masks of Wedlock*, p. 74.

7 S. Schama, *The Embarrassment of Riches*, London, 1987.

8 J. Thirsk, *Economic Policy and Projects: The Development of a Consumer Society in Early Modern England*, Oxford, 1978, p. 1.

9 S. Dwyer Amussen, *An Ordered Society: Gender and Class in Early Modern England*, Oxford, 1988, p. 187.

10 Peacham, *The Complete Gentleman*, p. 192.

11 H. Pecham, *The Art of Living in London; of, a caution how Gentlemen, Countreymen and Strangers, drawn by occasion of businesse, should dispose of themselves in the thriftiest way, not only in the citie, but in all other populous places*, London, 1642.

12 Dwyer Amussen, *An Ordered Society*, p. 35.

13 B. Harris, *The Accomplisht Ladys Delight*, London, 1683, pp. 115–39.

14 Dwyer Amussen, *An Ordered Society*, p. 47.

15 Archer, *The Arraignment of Lewd, idle, froward and unconstant women*, p. 7.

16 Archer, *The Arraignment of Lewd, idle, froward and unconstant women*, p. 28.

17 Archer, *The Arraignment of Lewd, idle, froward and unconstant women*, p. 12.

18 Dwyer Amussen, *An Ordered Society*, pp. 186–7.

19 L. Woodbridge, *Women and the English Renaissance: Literature and the nature of Womankind 1540–1620*, Brighton, 1984, p. 139.

20 Woodbridge, *Women and the English Renaissance*, p. 140.

21 Woodbridge, *Women and the English Renaissance*, p. 141.

22 Woodbridge, *Women and the English Renaissance*, p. 143.

23 Woodbridge, *Women and the English Renaissance*, p. 144.

24 Woodbridge, *Women and the English Renaissance*, p. 150.

25 R. Niccols, 'The Furies', 1615, in Woodbridge, *Women and the English Renaissance*, p. 142.

26 A. Bryson, 'Gesture, Demeanour and the Image of the Gentleman' in Gent and Llewellyn, *Renaissance Bodies*, p. 153.

27 B. Reay, 'Introduction' in B. Reay, *Popular Culture in Seventeenth-Century England*, London, 1985, p. 1.

28 J. Barry, 'Popular Culture in Seventeenth-Century Bristol' in Reay, *Popular Culture*, p. 69.

29 Reay, *Popular Culture*, p. 8.

30 Reay, *Popular Culture*, p. 11.

31 Reay, *Popular Culture*, p. 17.

32 P. Burke, 'Popular Culture in Seventeenth-Century London' in Reay, *Popular Culture*, p. 33.

33 Reay, *Popular Culture*, p. 34.

34 G. R. Quaife, *Wanton Wenches and Wayward Wives: Peasants and Illicit Sex in Early Seventeenth-Century England*, London, 1979, p. 165.

35 H. Pecham, *The Art of Living in London; Or, A caution how Gentlemen, Countreymen and Strangers, drawn by occasion of businesse, should dispose of themselves in the thriftiest way, not only in the citie, but in all other populous places*, London, 1642.

36 T. Williams, 'Magnetic Figures': Polemical Prints of the English Revolution' in Gent and Llewellyn, *Renaissance Bodies*, p. 89.

37 Bryson, in Gent and Llewellyn, *Renaissance Bodies*, p. 152.

38 Williams, in Gent and Llewellyn, *Renaissance Bodies*, p. 93.

39 Williams, in Gent and Llewellyn, *Renaissance Bodies*, p. 94.

4 Eighteenth century: clothing and commerce

41] Soft silks and fashionable accessories mark the Shudi family out as quintessential consumers of luxury. A new degree of comfort was becoming increasingly available for the prosperous middling classes. Burkat Shudi, a harpsichord maker, sports an exotic wrapping gown, whilst his wife is the image of respectability in her neat mantua and cap.

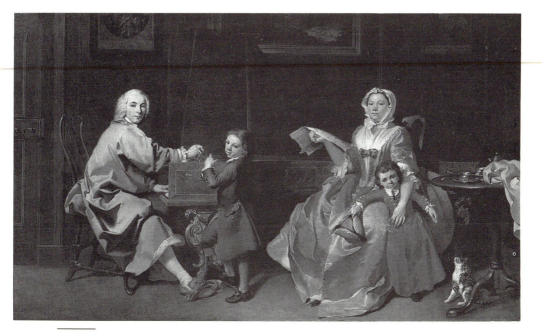

Where the newest fashions are brought down weekly by the stagecoach, all the wives and daughters of the most topping tradesmen vie with each other every Sunday in the elegance of their apparel. The same genteel ceremonies all practised there as at the most fashionable churches in town. The ladies immediately on their entrance, breathe a pious ejaculation through their fansticks and the beaux very gravely address themselves to the Haberdashers bills glued upon the linings of their hats.[1]

The correspondent in *The Connoisseur* of 1756 captured several of the shifts which social, economic and fashion historians have identified as central to any understanding of clothing and fashion in the context of the eighteenth century. It is generally agreed by such scholars that over the course of the period the impact of fashionable trends in all areas of production and consumption, from architecture through interior decoration, household furnishings, tableware, food, gardening, print and literature, music, theatre, and most importantly from our perspective, textiles, underwent something of a metamorphosis. Through innovations in manufacturing techniques, supply structures and retail strategies, a degree of luxury, comfort and fashionability was made available to a market no longer restricted to either the elite or the metropolitan. The mid-century journalist quoted above satirises the broadening tastes and aspirations of a group of consumers, who although not new, formed the most distinctive segment of a society increasingly identified not through the sartorial trappings of hierarchies based on status at birth, but on commercial acumen and material possessions which represented worldly success. The middling and respectable provincial classes, empowered by those political crises identified in the previous chapter, undoubtedly grew accustomed between 1700 and 1800 to a degree of unprecedented prosperity and a heightened familiarity with 'the newest fashions, . . . genteel ceremonies' and 'haberdashers's bills'.

In this context it is easy to understand why various historians have made generous use of the word 'revolution' in attempting to characterise the nature of eighteenth-century society and its material culture. Most typically the terms 'Industrial Revolution' and more recently 'consumer revolution' have served their time as all-encompassing explanations for an obvious and quantifiable transformation of habit and lifestyle. In the most general and traditional of historical surveys, changes in the organisation, technology and output of industry, focusing at first on the production of cotton from

42] Gillray's critical pen was often directed towards what he perceived as the follies of contemporary fashion. Here, the light clinging folds of new cotton dresses produce an effect perhaps too close to the desired nudity of antique statues.

the 1750s onwards, but gradually expanding to touch most areas of manufacturing, can be read as both an impetus for and a reaction to a rapidly growing domestic and overseas market, encouraged by innovations in distribution, retailing and advertising. More recent work has challenged the idea of an uncomplicated 'given' relationship between changes in production and consumption in the eighteenth century. The 'classic industrial revolution' if it is indeed possible to categorise historical change in such sweeping phrases, has been pushed forward into the mid-nineteenth century in the light of interpretations which stress the continuity of craft techniques running alongside the introduction of mechanised technology.[2] This has coincided with a wider recognition of the much earlier adoption of organisational processes which allowed a degree of standardisation and large-scale batch production broadly approximating to contemporary ideas of the 'mass-produced' within so-called 'traditional' eighteenth-century industrial practice.[3]

A re-evaluation of the supply side of the equation has resulted in an increased analytical emphasis on the demand for fashionable products, with the result that historians are now dragging the dissemination of consumer durables

further and further back into the late seventeenth century and earlier (a trend not entirely disputed by the central arguments of this book).[4] Such debates fulfil an important function in problematising and informing the more simplistic assumptions of traditional fashion histories, which fail to place a narrative of elite fashion change in the context of economic and market determinants. There is an unanswered problem, however, in the widening gap, which new historical approaches have broadened, that constitutes the ill-defined area of how and why those new eighteenth-century consumers made their choices in terms of fashionable clothing. What were the implications of commercial and technical change for self-image in terms of gender, nationality, sexuality and class? Attempts to define the nature of 'revolutions' appear irrelevant, or at best far too broad, in the context of the much more subjective relationship between individuality, culture and clothing which forms the core of new approaches to fashion history. In this light the following chapter will focus on the more specific effects that an increased and 'speeded up' familiarity with fashionability as a new commodity might have had for the 'individual' consumer faced with what might justifiably be termed the beginnings of a 'modern' and 'democratised' fashion system. Before drawing connections between the social and the sartorial, however, it is necessary to define those changes in style and dress that occurred over the course of the eighteenth century. It should be noted that the narrative concentrates on elite fashion, which perhaps formed the central model in terms of form, if not material, for new manufacturers, retailers and advertisers, coinciding occasionally, though more frequently as the century progressed, with the wardrobe of the average consumer.

Ancien Régime to consumer culture? Fashion change in the eighteenth century

The sober formality and rigid models established in the 1690s remained the staple of British court style until the mid 1720s. Elite male dress was typified by the heavy vertical emphasis of the coat and waistcoat, cut the same length and both embellished from cravat to knee by a long string of buttons, often decorated with silver or gold twist which relieved the dark blues, browns and greens favoured as suit colours. The coat, augmented with wide funnel sleeves generously turned back at the buttoned cuffs, broad and deep pocket flaps also

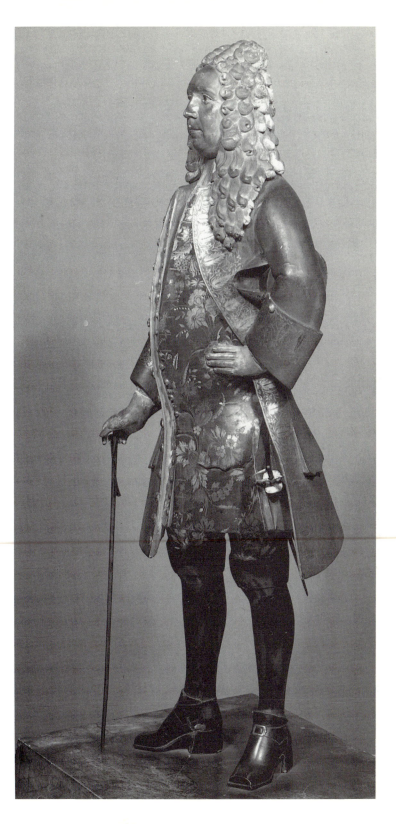

43] Late-seventeenth-
century formality continued
to dictate the forms taken
by elite male dress in the
first decades of the next
century. Most striking in this
statuette is the full periwig
and the display of rich
designs on the waistcoat.

trimmed with buttons or fringes, and thick pleats at the sides of the full skirt, was generally left unfastened (at least for the purposes of portrait painters) to reveal the luxurious designs of the waistcoat. The flat expanse of the torso, framed by and contrasting with the darker curtains of the coat front lent ample opportunity for display of the latest Spitalfields silk patterns which were usually drawn and manufactured to limited orders from silk mercers due to their inherent expense. Between 1700 and 1712 designs have been categorised as 'bizarre', identified by the obvious influence of oriental motifs already popular as decoration for lacquer and porcelain goods, but distorted and juxtaposed with an unusual choice of subjects. Natalie Rothstein quotes a perhaps apocryphal account of the genesis of bizarre patterns that nevertheless illustrates the novel quality of the silks produced and the manner in which they departed from the more traditional French sprigs and pomegranates: 'Mr Budwine, the first that brought the flowered silk manufacture in credit and reputation here in England' made several sketches which failed to please the client. He then asked what he should draw. 'The servant maid happening to broil some sprats on a grid iron, the customer pointing to the chimney' told him 'draw the grid iron and sprats it will make as odd a pattern as you can think on'. This was done, the silk woven 'and it sold well'.[5]

The length of the upper half of the suit usually obscured the dark knee-length breeches worn above silk stockings and black square-toed shoes with an elevated red heel adopted for court occasions from standards set twenty years before at Versailles.[6] Accessories were particularly important in differentiating between elite and middling styles when the only other indicators of social rank lay in the choice of silk over wool rather than major differences in cut. Fine kid gloves, lace handkerchiefs and cravats, walking canes and swords all helped in marking out the cosmopolitan gentleman. The full-bottomed periwig, divided into twin peaks and falling in curls to the lower shoulders appears to have been ubiquitous for urban life generally, replaced by an informal cap or turban for more private occasions.

The upholstered appearance of masculine fashion in the first third of the century was certainly reflected in the more restrictive, boned and padded outline of fashionable feminine dress. The predominance of French court styles continued for aristocratic women through an extended adoption of the seventeenth-century 'grand habit', typified by severe boning and luxurious trimming on separate skirt and bodice,

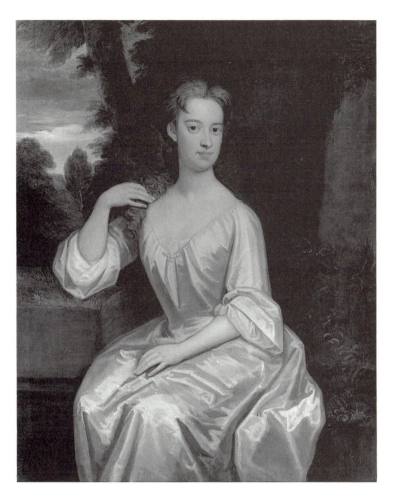

44] Details and accessories have been kept to a minimum by the artist of this portrait in a bid to lend the sitter the requisite pastoral values. Nevertheless, the basic forms of early-eighteenth-century fashionable style are implicit, especially in the arrangement of the sleeves.

reserved for the most formal ceremonial events. The one-piece mantua, draped from the shoulders or waist at the back (respectively *à la française* or *à l'anglaise*) and open at the front to reveal a brocaded, embroidered or lace-trimmed petticoat formed more usual and up-to-date day wear, its formality heightened in the evening or on lesser state occasions by the insertion of a separate stomacher at the front, again heavily trimmed or be-ribboned. In common with masculine dress, textiles in the first decades of the century were typified by exuberant large patterned silks, contrasted with plain satins in clear blues and pinks or darker browns and greens. Fashionable portrait painters such as Godfrey Kneller, Michael Dahl and Charles Jervas continued to depict wealthy female sitters in the classicised open morning robes, first favoured by Lely in the 1660s, well into the 1720s, though visual references to Greek and Roman nymphs were now intermingled with suggestions of an exotic orient, intensified

by growing colonial and imperialist tendencies amongst the English elite. Though it is difficult to disentangle the metaphorical associations of simple flowing silk from the material adoption of relaxed wrapping gowns, the portraits provide a telling contrast to the sophisticated though archaic stiffness of court dressing, allowing us to infer that fashionability lay in juggling idyllic pastoral values with a more urbane observation of polite metropolitan etiquette codes, a contrast promoted in the poetry of Alexander Pope:

'She went, to plain-work, and to purling brooks,
Old fashion'd halls, dull aunts, and croaking rooks . . .
To pass her time 'twixt reading and Bohea,
To muse, and spill her solitary Tea,
Or o'er cold coffee trifle with the spoon,
Count the slow clock, and dine exact at noon;
Divert her eyes with pictures in the fire,
Hum half a tune, tell stories to the Squire.'[7]

By the late 1720s an emphasis on the modernity encapsulated in both country house and town villa lifestyles, revolving around ceremonies of civility and communication,

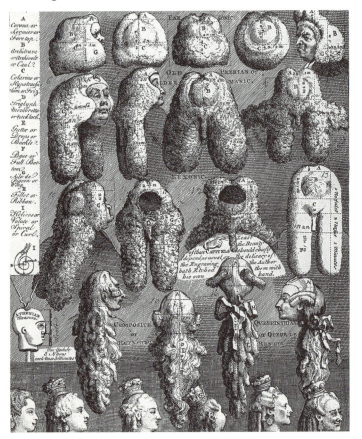

45] Hogarth uses the wide variety of wigs available in the middle years of the century to caricature both the current craze for phrenology, the science of skull size and facial expression, and an obsessive interest in classical antiquities. Thus the wigs are arranged in orders like the columns engraved in publications such as James Stuart's *The Antiquities of Athens* of the same year.

the taking of tea, the consumption of chocolate, caffeine and the latest scandal in coffee houses, political debate in the private salon or the contrived hierarchical pomp of the rural hunt, required a renegotiation of the components of fashionable dress. Clearly demarcated lines between the clothing of the landed gentry and the urban middling classes or the formal and the informal were further blurred as the overblown qualities encoded in bizarre silk designs and courtly dress codes were superseded by an adoption of a more fluid, simplified fashionable line. This shift is particularly evident in the rise of new forms of portraiture, specifically the aptly named 'conversation piece' which prioritised the description of domestic intimacy rather than ceremonial magnificence.

Male dress was perhaps less overt in displaying change, the staple 'coat, waistcoat, breeches' suit arrangement undergoing little significant alteration until the first decades of the succeeding century. Stylistic progression can be traced through nuances of cut, decoration and colour, rather than through more emphatic shifts. Certainly by the mid-1730s the line of the coat was slimmer, rejecting the padded chest and pleated skirt panels formerly favoured for a simple slightly flared shape. More significant change occured in the arrangement of the sleeve, which by 1725 was turned over at the wrist, falling back in a funnel or 'boot cuff' buttoned just above the elbow. The length of the waistcoat gradually shortened, taking on the practical considerations of informal country wear and generally produced in a plain textile to tone in with the coat. If a patterned silk was selected for formal wear the design conformed to a lighter style, characterised in the 1720s by delicate lace and trellis forms and a movement towards a bolder naturalistic rendition of flowers and vegetables through the 1730s. The combination of the two styles culminated in the stylised delicacy of French-inspired rococo asymmetry from the 1740s onwards, typified by the work of Spitalfields silk designer Anna Maria Garthwaite.[8] The front of the more expensive dress coat might also be embellished with intricate gold or silver thread embroidery around the buttonholes. In accordance with a tendency towards lightness, the ponderous periwig shortened to form the powdered bob-wig popular with the middling and professional classes, its curling rolls pulled back from the face into a black silk bag to form a more military and elite style adopted for court dress by the 1730s. Natural hair dressed into simple shoulder-length ringlets was also a plausible alternative by this stage.

It is in female dress that a tendency towards the intimate

and the domestic can best be discerned. Round skirts sup-ported by hoops reorientated the emphasis of the mantua from severe vertical to softer horizontal arrangements popular across class divisions, the junction with a fitted bodice at the waist emphasised by the adoption of either a plain linen or a lace apron, depending on purchasing power. With the demise of large-scale silk patterns and their atten-dant heightened formality, the light, frivolous associations of lace were also particularly well suited to the decoration of sleeve ruffs and the lappets of women's caps. Santina Levey quotes the journalist Addison as proof of an arena in which heaviness was losing ground to a new sense of studied informality, encouraging a wider use of lighter fabrics and colours. Delicate silks and novel cottons replaced glossier satins as textiles of choice, with gauze and lace adding to an illusion of doll-like weightlessness: 'The fashionable world is grown free and easie; our manners sit more loose upon us. Nothing is so modish as an agreeable negligence.'[9] The con-trast between the growing expanse of panniered (side-hooped) skirts and loose sack backs, and a much flatter, stiffly-boned bodice evolved into a peculiarly English formal-isation of the sack dress, with an intricately gathered train favoured during the 1750s. Combined with a wide-brimmed straw hat, the wearer was able to achieve a look that approx-imated well to fashionable ideals of the pastoral and a growing awareness of an English national identity redolent with associations of shepherdess and milkmaid. The increas-ingly military appearance of elite masculine dress, prioritising deep tones of blue and red for all three elements of the suit, the coat cut into a graceful curve away from the chest and trimmed simply with plain gold braid at the edges, empha-sised the complementary trend towards a sober patriotism.

In many respects the styles of the 1760s witnessed a return to more sophisticated or metropolitan values. Whilst a strong sense of continuity ensured that the sack dress with its arcadian floral connotations remained a staple of the femi-nine wardrobe, the emphasis shifting from the hips to a growing bustle at the back of the waist, a more knowing use of historical and oriental sources highlighted urban fashion-ability alongside a sentimental informality. Women's hair, for example, kept neatly knotted under tidy lace caps for four decades or more, progressively attained greater height and fullness, built up over pads at the front and secured exotically with a turban. Increasing adoption of extravagant jewellery accentuated the new worldliness. Printed cottons and

muslins imitated both the richness of Indian textiles and the simplicity of rural life, whilst portrait painters such as Reynolds prioritised a feel for the fanciful and the classical using sources from Van Dyck, Rubens, the Renaissance and antiquity. Though limited in their impact on daily dressing amongst the middling classes, trends towards masquerade, alongside the fantasy implied by aristocratic portraiture, illustrate the growing commodification of leisure pursuits and display for all sections of society aided by the concurrent expansion of pleasure gardens, assembly rooms and theatres in towns across the country. Pursuits and pastimes previously restricted to a clearly defined 'court society' found a wider audience through print shops, newspaper reports and advertisements and the promotional expertise of the new entrepreneurs.

In retrospect the 1770s and 1780s present to the fashion historian a seemingly neat illustration of the decadence and artifice of the old European order before the irrevocable changes wrought by political revolution in America and France. It is difficult, however, to transfer such readings on to fashion change in Britain during the same period. In many ways the profusion of choice in terms of dress during the last quarter of the eighteenth century is more indicative of development and continuity; not so much evidence of outdated aristocratic extravagance as of a healthy and expanding consumer culture. If anything the dress of the English gentry appears to have undergone a self-imposed process of modification from the 1740s onwards, toning down elements of overt display in favour of a propriety and sense of responsibility ironically influential for elite methods of presentation on the continent. Caricaturists and satirists looked instead to the pretensions and avaricious appetites of the middling classes for illustrations of fashionable folly. The provincial tradesman's wife and the single metropolitan male attracted particular and vociferous ridicule for their eager consumption of fashion change.

By the mid 1770s the vertical extension of feminine hairdressing was complete, transforming its original smooth bouffant appearance into a mass of frizzed and powdered curls beneath extravagant straw and ribbon hats by the 1780s. The adoption of light muslin and cotton fabrics or silks decorated with tiny repeating sprigs, stripes and spots necessitated a move away from the carefully structured sack gown designed with maximum pattern display in mind, towards a more informal high-waisted dress style with long-tight arms,

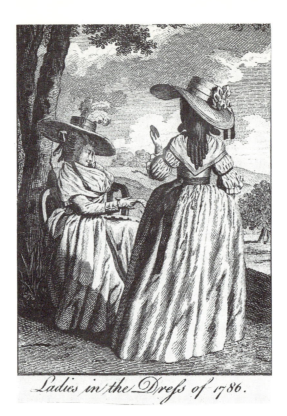

Ladies in the Dress of 1786.

46] A move towards informality is clearly discernible in this image, taken from an early women's magazine, of light cotton dresses, puffed out buffon neck cloths and fanciful straw hats, worn over a mass of powdered curls.

47] Lady Mary Wortley Montague is depicted here in dress derived from Turkish sources, attended by Turkish servants, with a view of Constantinople in the distance. Whilst this fascination with the exotic must be read as a construction rather than a literal recording of consumption choices, there are parallels to be made with the expansion of Empire and a fashionable taste for the oriental.

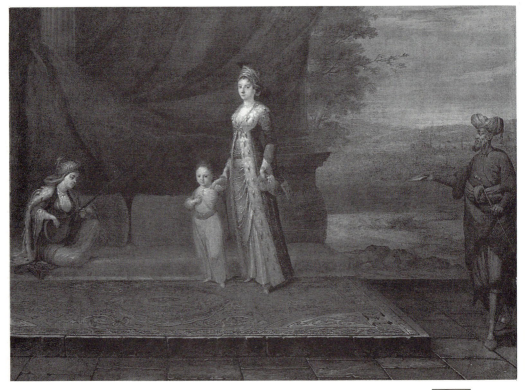

48] The figure of the Macaroni, though not necessarily one associated with same-sex attraction, was viewed with suspicion as a subversive, undermining recognised patterns of dressing and behaving. Here the voluminous coat, long pigtail, tasselled cane and nosegay underline his mannered effeminacy.

49a] A basic chemise, devoid of boning and padding, together with real hair, loosely styled to resemble classical prototypes, lends aristocratic dress of the late 1790s dangerous associations of republicanism.

49b] The Earl of Sheffield presents himself in the sober attire of the English landowner, prioritising patrician duty over the ostentatious display favoured by the aristocracy in the earlier years of the century.

A MACARONI.
in a Morning Dress in the Park.

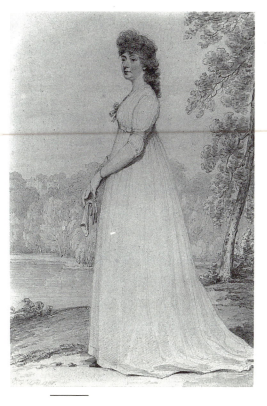

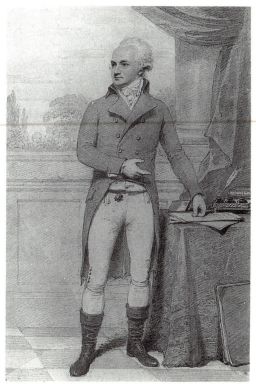

the skirts open-fronted (the polonaise) or closed, falling over hip pads or rumps which replaced the hoop to give a softer silhouette. The puffed-out effect was reflected in the adoption of the buffon, a starched square of cotton or linen worn around the shoulders and tucked, bunched-up fashion, into the front of the bodice to emphasise the bosom. Such pneumatic informality was particularly fitting for new constructions of fashionable femininity which stressed emotional innocence, prioritising familial and maternal ties above the stiff artificiality that had described the ideal woman in representations of the preceding decades. The predominance of pale, floating textiles and the new emphasis given to the forms of the body, underpinned by an academic and popular interest in the classical world, led to the simple neo-classical lines of the turn of the century, rejecting padding and ingenious cut for the basic shift-like chemise gathered under the bust. The connotations of republicanism, empire and democracy embodied in copies of Greek and Roman drapes and informally curled hair may well have increased their relevance to fashionable consumers in Directoire and Napoleonic France. In Britain vigorous marketing and design strategies employed by a cotton industry at the height of its economic powers, together with publicity stunts organised by London showmen and producers of luxury goods such as Thomas Hope (the publisher of folios including *Household Furniture and Interior Decoration* of 1807 which drew attention to the scholarly adaptation of Greek, Roman and Egyptian archaeological finds to elements of contemporary design, including fashion), may have had a more direct effect on the popularity of a relatively cheap and practical style.

Whilst the rural, equestrian style of the English gentleman proved an effective fashionable export in the latter half of the eighteenth century, it would be simplistic to claim that the flow of influences was one-way only. In terms of metropolitan style, the standing of London as a cosmopolitan centre of display, together with the rise of the European grand tour as a prerequisite for the education of the elite or aspirational male, ensured that masculine dress also reflected continental tastes. The Macaroni, a focus of satirical criticism from the late 1760s on, was lambasted principally for his ostentatious adoption of Italian and French style. Whilst his extravagant make-up and coiffure and choice of bright colours formed a subcultural badge, pitted against sober ideals of 'Britishness', the tightness and brevity of Macaroni dress, revealing the male physique, announced the later and

wider popularity of buff-coloured breeches and short waist-coats amongst all levels of male society in the 1780s and '90s. To these items of dress were added a more relaxed 'Augustan' treatment of the hair, resulting in the gradual rejection of the wig for all but the most formal events. The dark enveloping frock-coat, lacking trimming other than the addition of velvet collars and large metal buttons, with a cut-away front and tails at the back by about 1790, epitomised the supposed grace of English patrician style. The arrangement of high cravat and stiff shirt collar allowed for a degree of individual expression otherwise denied by a code of dressing that was rapidly anticipating the inexpressive but apparently 'democratic' masculine uniform of the following two centuries.

Spinning demand: fashion, industry and innovation

> The new relationships being created between producers and the environments they were forging for themselves – environments not just physical but social, cultural and psychological – were generating spiral upon spiral of desire and demand. New scenarios of propensities and possibilities were being called into being, which, in their turn, were engulfing, mastering, their own authors. Dreamworlds were turning into Gothic nightmares, creators became creatures of their own fantasies; in the modern metropolis, at the masquerade, in the speculative paper-money world of the exchange, in the new industrial landscape of the pit, the furnace and the factory, man was making monsters which he couldn't control.[10]

In apocalyptic terms, Roy Porter dramatically describes a transformation in attitudes and values which goes some way towards explaining the much more energetic, loaded and socially influential eighteenth-century fashion cycle outlined in the earlier part of this chapter. Arguably many of the frequent shifts in style recorded above can be applied to a much wider audience or consuming public than was the case for the more segmented fashion market of the seventeenth or sixteenth centuries. Porter ascribes the existence of such an increased and speeded up scenario of fashion consumption to new opportunities afforded by changes in production and promotion. But like many commentators, contemporary and retrospective, he chooses to present the resulting surfeit of choice in a negative light, disregarding the empowering qualities of fashionability in a bid to represent the eighteenth century as the birthplace of all these social and economic problems associated with modernity and mass consumption. In Porter's own words, 'From Mandeville onwards, boosters

galore cheered the birth of what has been called "the first consumer society". But they were matched by a counterpoint of Jeremiahs traumatised by the shock of the new, lamenting the world that was being lost: honest traditions, simplicity, hospitality, stability – all were being swept away by the flood-waters of luxury and artificiality, ephemerality and corruption.'[11] The loaded evidence of indignant clerics, philosophers and caricaturists does indeed paint a picture of cataclysmic change, of spending running out of control. Recent investigation focusing specifically on the nature of industrial change and marketing policies in the area of textile and fashion production has produced rather more measured, but equally revealing results, which help to provide a more positive history of eighteenth-century fashion, based on change and its cultural effects. In the wake of broader historical enquiries which have identified the period from the 1680s onwards as an era of increased luxury consumption, it becomes necessary to locate the production of fashionable dress within such a context, problematising those readings that view increased consumption in the negative terms of industrial blight, greed, and machine-inspired dehumanisation.

The established literature on the growth and development of eighteenth-century textile industries is extensive but tends to follow a highly prescriptive method which sees expansion in terms of a fortuitous geographical and economic situation, aided by timely technological and organisational intervention; a simple sequence of cause and reaction.[12] Cotton is taken to be the focus of change in most accounts, positioned at the forefront of both industrial and marketing revolutions. It provides a useful case-study of the increasing impact that manufacturing technique, design processes and publicity had on the generation of trends and styles in dress over the course of the century, and perhaps suggests a more complicated relationship between consumer desire and industrial innovation than the classic texts have allowed. Building on a foundation of cottage production of coarse woollens and linens established in Lancashire and the North-West since the sixteenth century, and serving both a home and foreign market with cheap, roughly coloured textiles, masters and middlemen, who controlled the supply of raw materials, the renting of spinning and weaving equipment to a network of small home producers and the transfer of their semi-finished products to seasonal fairs, local outlets and the London cloth market, found that raw cotton imported from the Middle East could easily be combined with

Scottish and local linen yarns to form fustian. This was a popular heavy-duty cloth adaptable for work wear and furnishings, which evidently posed serious competition to London dealers who were petitioning Parliament for special protection from the successes of northern fustian producers by the middle of the seventeenth century:

> about twenty years past diverse people in this kingdom, but chiefly in the county of Lancaster, have found out the trade of making of other fustians, made of a kind of Bombast or Downe, being a fruit of the earth growing upon little shrubs or bushes, brought into this kingdom by the Turkey merchants from Smyrna, Cyprus, Acra and Sydon, but commonly called cotton wool; and also of Lynnen yarne most part brought out of Scotland, and othersome made in England, and no part of the same fustians of any wooll at all . . . There is at least 40,000 pieces of fustian of this kind yeerely made in England . . . and 1000's of poor people set on working of these fustians.[13]

By the turn of the eighteenth century the Lancashire cotton trade had expanded to include three major products. In addition to fustians, Manchester weavers could also offer linens, which were mainly used for upholstery and bedding materials, and small wares, which encompassed cotton thread, garters, tapes, ribbons, handkerchiefs and buttons (precisely the kind of cheap but easily personalised fashionable commodities that might appeal to consumers other than the elite, a market that formed the foundations for the continuing prosperity of the eighteenth-century cotton industry). John Dyer in 'The Fleece' (1757) described the process of diversification in the first half of the century, making direct reference to the fashionability of the new products:

> wool now taught to link with flax, or cotton, or the silk worm's thread and gain the graces of variety, whether to form the matron's decent robe or the thin shading trail for Agra's Nymphs (there is woven at Manchester, for the East Indies, a very thin stuff of woollen thread and cotton, which is cooler than the manufactures of that country, where the material is only cotton), or Solemn Curtains, whose long gloomy folds surround the soft pavilions of the rich.

The specialisation of the home market coincided with an expansion of trade with the New World, providing broadened opportunities for the export of goods specifically designed for foreign consumption (brighter colours and cooler weaves, for example). The early decades of the century also witnessed increasing competition with imported cottons from India and the East, encouraged by the entrepreneurial activities of

the East India Company. The lasting quality and heightened finish of Indian painted muslins and calicoes presented an exotic alternative to the basic patterns and limited colours achievable on Lancashire goods. The demand for Indian goods was undoubtedly boosted not just by quality or by price, but by a fashionable taste for the oriental and the 'bizarre'. Daniel Defoe, writing in the *Weekly Review* of 1708, drew attention to shifting markets:

> The general fansie of the people runs upon East India Goods to that degree, that the chintz and painted calicoes, which before were only made use of for carpets, quilts etc., and to clothe children and ordinary people, become now the dress of our ladies, and such is the power of a mode as we saw our persons of quality dressed in Indian carpets, which but a few years before their chambermaids would have thought too ordinary for them: the chintz was advanced from lying upon their floors to their backs, from the foot cloth to the petticoat; and even the Queen herself at this time was pleased to appear in China and Japan, I mean China silks and calico. Nor was this all, but it crept into our homes, our closets and bedchambers, curtains, cushions, chairs and at last beds themselves, were nothing but calicos or Indian stuffs, and in short, almost everything that used to be made of wool or silk, relating either to the dress of the women or the furniture of our houses was supplied by the Indian trade.

Lancashire producers responded gradually to a shifting market by attempting to imitate hand-painted patterns through more economical means, by employing local printers and designers from the 1760s onwards, rather than sending unfinished textiles to London for decoration, and through a wider use of block printing methods utilising continental advances in the chemistry of printing technology. But apart from the necessity of locating dye and print workers under one roof, the processes of cotton manufacturers were able to sustain increasing growth under the traditional auspices of a putting-out system until the 1780s at the earliest. The failed prohibition of foreign and home-printed calicoes for all but the export market in 1721, designed to protect the Spitalfields silk industry, whose patterns were coming under increasing competition from cheaper cotton copies or Indian alternatives, could do little but increase the desirability of cotton as a fashionable textile, boosting its production further. By the 1750s John Holker, a Jacobite spy, was able to produce a fairly representative survey of British fabrics for French competitors, in which of 115 samples 99 originated from Lancashire and at least 80 could be described as cottons,

ranging through checks, chintzes, cotton hollands (light stripes), cheryderys (silk/cotton mixes), handkerchiefs, velvets and fustians. The significance of the list lies in its description of an enhanced arena of consumer choice well before the impact of those technological advances, with their implied shift towards a factory system, which have usually been quoted as central to the development of an industrial and consumer revolution. The mantra generally provided for students of the textile industry includes Kay's Flying Shuttle (1738), Arkwright's Water Frame (1769), Hargreave's Spinning Jenny (1770), Crompton's Mule (1779) and Cartwright's Power Loom (1785). Undoubtedly changes in the organisation of the cotton industry from the 1770s onwards, in which increased mechanisation improved output to the extent that production now outstripped demand, does partly account for, and was a reaction to, the all-pervasive popularity of cotton in every area of fashionable British dress during the last quarter of the eighteenth century, from the spotted handkerchief and hardy corduroys of the urban labourer to the diaphanous muslin shift of the courtesan. However, more recent research has redirected attention to the greater importance of novelty and variety in design, in comparison to technological processes and innovation, pointing the fashion historian away from charting simplistic relationships between methods of production and fashionable trends and towards an understanding of the part played by consumer choice in the determining of available models and styles at all levels of the market. The history of cotton manufacture would seem to provide ample evidence for such a reorientation, though the channels by which such choice was communicated, newspapers, early fashion magazines, relationships between manufacturers, retailers and consumers; and more informal channels of news and gossip now require closer examination than fashion and textile historians have so far allowed. To quote Beverly Lemire:

> Recent accounts of the manner in which the market was served have revealed the strength of demand in Britain and the importance to most ranks of the niceties of life. Yet the characteristics of this market and its relationship with the cotton manufacturers has been too little studied. The choices made by British consumers directed the way in which the cotton industry would grow and determined the sorts of goods that would be produced. The products of this industry and the manner in which they were sold and used marked new patterns of consumer activity that altered the appearance of the nation.[14]

The culture of consumption

> Fashion or the alteration of Dress, is a great Promoter of Trade, because it occasions the Expense of Cloaths, before the Old ones are worn out: It is the Spirit and Life of Trade, It makes a Circulation and gives a Value by Turns, to all sorts of Commodities; keeps the great Body of Trade in Motion; it is an Invention to Dress a Man, as if he lived in a perpetual Spring; he never sees the autumn of his Cloaths.[15]

Nicholas Barbon writing at the end of the seventeenth century pointed to the importance of fashion and fashion-ability in the expansion of trade and consumer activity. His description goes beyond circular historical models that seek to explain the Industrial Revolution as a producer's response to an increasing market fostered by demographic and economic fortune and sits more comfortably with the recent

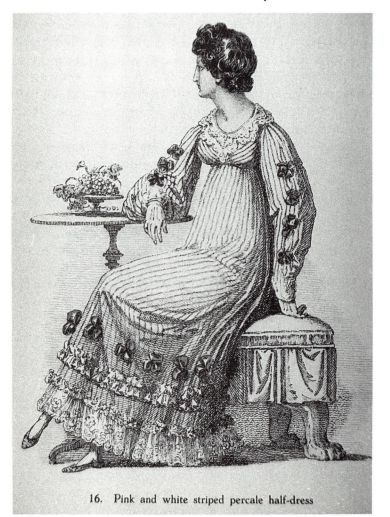

16. Pink and white striped percale half-dress

50] A gradual addition of trimmings to the simple Directoire line anticipates the fussier styles of the early nineteenth century; moral seriousness gives way to the pleasures of consumption.

refocusing of attention on the activities of suppliers and consumers, the efforts of retailers and publicists to broaden the scope of fashionable interest, and an interpretation of fashion that recognises its hallucinatory, seemingly anti-rational characteristics. As early as 1690 Barbon alluded to a fashion system that was organised around strikingly modern concerns, and by implication a consumer surprisingly sophisticated and demanding. The development of that relationship between the inventiveness of producers and promoters and the willingness of the population to respond to the increasing manipulation of fashion change lies at the heart of any attempt to define the characteristics of eighteenth-century dress. But caution is necessary before the fashion historian embraces any idea of an all-encompassing consumer revolution without question. In much the same way that historians have re-evaluated the impact of industrial change, it is essential that any changes in the level or nature of consumption are rooted firmly within the context of contemporary social, economic and cultural determinants rather than made to conform with ahistorical notions of some grand evolutionary development that links eighteenth-century warehouses with nineteenth-century department stores with twentieth-century shopping malls in one easy progression.

The most immediate evidence for a widening of consumer activity lay in the active engagement of the previously fashion-starved and parochial rural classes with metropolitan style. John Byng writing in 1781 complained: 'I wish with all my heart that half the turnpike roads of the kingdom were plough'd up, which have imported London manners and depopulated the country – I meet milkmaids on every road, with the dress and looks of Strand misses.'[16] Improvements in communications not only brought an increased range of luxury items to provincial consumers with extra spending power[17] but also allowed for a wider dissemination of the retailing methods and devices which had transformed the West End of London. Sophie von la Roche, recording her observations on the spectacle of Oxford Street and its environs in the 1780s, described a scene not so far removed in terms of surface detail from the excesses normally associated with the age of the great department stores a century later:

> First one passes a watchmaking, then a silk or fan store, now a silversmith, a china or glass shop. The spirit booths are particularly tempting for the English are in any case fond of strong drink. Here crystal flasks of every shape and form are exhibited;

each one has a light behind, which makes all the different coloured spirits sparkle. Just as alluring are the confectioners and fruiterers, where, behind the handsome glass windows pyramids of pineapples, figs, grapes, oranges and all manner of fruits are on show . . . Behind the great glass windows absolutely everything one can think of is neatly, attractively displayed, in such abundance of choice as almost to make one greedy . . . There is a cunning device for showing women's materials. They hang down in folds behind the fine, high windows so that the effect of this or that material, as it would be in a woman's dress, can be studied.

Display became an increasingly important element of the shopkeeper's repertoire, alongside the promotional panache of advertising, in a bid to convince buyers that they too were engaging in a world of refined fashionability, prompting Wedgwood's claim that 'Fashion is infinitely superior to merit.' A growing use of trade cards, which sometimes depicted the well-appointed interior and goods of the shop alongside a customer generally clothed in the latest styles, proved useful in encouraging a local reputation. At the same time an expansion in newspaper and magazine publishing opened up opportunities for marketing across a wider geographical area. Typical city-placed advertisements would read: 'All orders from Gentlemen and tradesmen in the Country will be punctually observed.'[18] In comparison with nineteenth-century periodical advertising the notices of the 1700s were undoubtedly crude, both in message and in typographical finesse. But they do illustrate a thriving language of consumption that was strengthened and refined by the mid-1760s with the particular language of women's magazines. Produced in the main for elite women, the journals included a mix of satire, gossip, short stories, reviews, and most importantly full-page engravings of fashionable men, women and children, in poses chosen to illustrate the finer points of postural etiquette and seasonal changes in cut and style. Images of fashionability had been available since the mid-seventeenth century at least, through the hawking of chapbooks, almanacs, pocket-books and memorandum books; but the new periodicals represented a more structured ordering of the provision and dissemination of fashion information that must have had a significant effect, alongside shifts in the environment of shopping, on the increasing pace with which visual identities were formed and reformed, discussed and negotiated amongst the comfortable sections of society across the country.

Who will buy? Consumers and identity

> No man is ignorant that a Taylor is the Person that makes our
> Cloaths; to some he not only makes their Dress, but in some
> measure, may be said to make themselves. There are numbers of
> Beings in and about this Metropolis who have no other identi-
> cal Existence than what the Taylor, Milliner and Periwig maker
> bestow upon them. Strip them of these Distinctions and they
> are quite a different species of Beings; have no more Relation to
> their dressed selves, than they have to the Great Mogul, and are
> as insignificant in Society as Punch deprived of his moving
> Wires, and hung upon a peg.[19]

Having identified those changes in production and market-
ing strategies that allowed for an expansion in consumer
activity during the second half of the eighteenth century, the
historian is left to question how such factors influenced the
attitudes and appearance of those consuming the new goods.
Campbell, in his guide to the trades of the capital quoted
above, gives ample evidence of the continuing power of
clothing to create identity, status and a sense of distinction
from the crowd. In a period when it was becoming increas-
ingly possible to purchase cheap cotton textiles and acces-
sories that competed favourably with the most fashionable
and expensive silks, could clothing continue to perform its
function as a translucent guide to rank and taste? As Beverly
Lemire reports:

> To elevate oneself to the ranks of the fashionable might entail
> no more than the wearing of a petticoat of the prescribed colour,
> an apron suitably embroidered set at the right length, a printed
> handkerchief agreeably draped, or the retrimming of a gown or
> petticoat to meet the current mode. These touches denoted the
> aspirants to fashion in whatever rank of society they were
> placed. Contemporary comment both before and during the
> eighteenth century suggests that the lure of fashionability
> affected the dress of most of the ranks of British Society. The
> farmers' wives noticed by the visiting Swedish botanist, Per
> Kalm, drew his attention precisely because of their air of fash-
> ionability. He wrote of the Hertfordshire women: 'Here it is not
> unusual to see a farmer or other small personage's wife clad on
> Sunday like a lady of quality at other places in the world and her
> everyday attire in proportion.'[20]

There is obviously a danger in reading evidence of
increased luxury consumption in terms of a levelling or
democratisation of taste, in which social groups are obscured
by a generalised process of fashion diffusion based upon
social emulation and competition. Similarly, to impose a
neatly compartmentalised structure which sees innovation

gradually trickling through society is equally problematic. Amanda Vickery in her work on elite women consumers in the second half of the eighteenth century[21] criticises the smooth pyramidical fashion system put forward by 'dress history orthodoxy'. In such traditional readings 'a mobile and fairly fashion-conscious gentry, having acquired their own clothes, were the people of fashion for the less mobile, less well-informed ranks below them . . . They presented generally the simpler, less ephemeral versions of fashion . . . The actual clothes of their everyday wear often became dress wear for those in the ranks below.'[22]

A careful examination of eighteenth-century commentary and statistical information suggests that divisions within society predicated by locality, gender, class, age and sexuality were enforced or underpinned, rather than blurred, by an increased consumption of fashion. Lorna Weatherill's empirical work on probate inventories between 1675 and 1725[23] shows that far from innovation filtering down from the elite through the supposed aspirational habits of the lesser gentry and professionals, a greater accumulation of fashionable goods was initially more likely, and perhaps more socially acceptable, in the households of urban tradesmen and retailers, making the intercessionary efforts of the middling ranks redundant. Vickery also quotes Colin Campbell[24] whose 'own explanation of the advent of [the] consumer revolution is the birth of modern hedonism among the Puritan bourgeoisie, which is expressed in and explains pleasurable consumption. Campbell finds evidence for this in the rise of the novel, romantic love and fashionable leisure.'[25] A renewed capacity amongst the middling and lower orders to find pleasure in fashionable possessions has already been identified in the previous chapter, and is far removed from the ethics of envy and imitation which traditional fashion historians see as the sole generator of fashion change in the early modern period. In Campbell's interpretation 'the mill girl who wanted to dress like a duchess' is superseded by a consumer who encoded luxury goods not with meanings attached uniquely to status, but also with a potential for dream-like escapism and the definition of individual character.

Increased consumption and the speeding up of the fashion cycle in the eighteenth century should therefore be interpreted through a variety of different readings according to the specific material and political circumstances of the consumer. The aristocracy are generally seen as the initiators of elite innovation in fashionable dress. Certainly their activ-

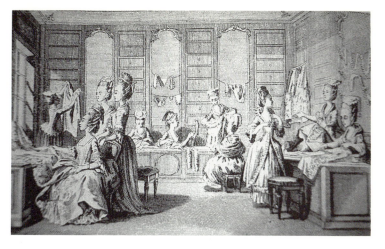

51] The richly furnished interior of a mantua-maker's shop in Paris.

ities and habits are those which are recorded most frequently in the portraits, conversation pieces, caricatures and novels which form the staple evidence for a history of eighteenth-century fashion, alongside examples of dress and textiles whose chances of survival have been enhanced precisely by their aristocratic pedigree. It is arguable that elite lifestyles shifted from the isolated, provincial concentration of material power identified in the sixteenth and seventeenth century towards a metropolitan existence that necessitated a greater concentration on fashionable display and consumption. The closer proximity of differing social groups in the city would certainly have broadened opportunities through which greater integration and exchange of sartorial information with suppliers and observers could have taken place. But as John Rule points out, in rather simplified terms

> The English Aristocracy was a tight elite and very much smaller than was the case on the continent . . . contemporaries reacted to what was perceived as an intrusion of moneyed newcomers into the aristocracy and gentry . . . So far as the upper crust of peers and baronets was concerned there is practically no substance to such claims. The eighteenth-century titled aristocracy was one of the most closed in Europe, despite the fact that there was no legal definition of noble blood.[26]

Linda Colley[27] identifies the vulnerability of the elite, specifically elite men, in terms of their limited numbers and restricted legal power, disadvantages which seemed to intensify in the context of the more ruthless treatment of their European counterparts in the later years of the century (especially during the blood-letting of the French Revolution from 1789). Such weakness is used by Colley to explain aristocratic choice in the fields of leisure, education and career. The

institution of such phenomena as the public school, the systematic patronage of native artistic talent, organised fox-hunting, and the reform of the armed forces can be cited as examples of a conscious attempt to redefine the English aristocrat as specifically British and patriotic, both strengthening and protecting him from those accusations of greed, indolence and self-interest which undermined the Ancien Régime in France. This reading is particularly useful in illuminating the political direction that lay behind the gradual militarisation of male dress and the rise of a more sober patrician appearance from the 1750s onwards, both of which can be attributed to a fostering of martial prowess and personal honour as prerequisites for membership of the establishment. In a very literal sense the introduction of regimental regalia or hunting paraphernalia into the Englishman's wardrobe provided useful camouflage for physical and moral shortcomings and an appropriate mask of nationhood:

> an insignificant head is hidden under a martial plumed helmet. The coat, padded well in every direction . . . is rendered small at the back by use of stays . . . Then as for bandy legs, or knock knees, they are totally unseen in long, stiff leather boots, that extend up on the thigh, to which two inch heels may be very safely appended, so that with the cuirass, and different accoutrement straps, it offers an effectual screen.[28]

Elite civilian dress, on the other hand, deliberately avoided excess when 'the magic of ostentation stopped having an effect on spectators who had learnt to add up the cost'. The ascetic, emaciated appearance of Pitt the younger, or the homely domestic trappings of King George and Queen Charlotte were compared favourably with the dandified excesses of Robespierre or Napoleon abroad, and the Prince of Wales or Fox at home. If anything Colley's argument reverses the logic of trickle-down theory, showing that in the second half of the eighteenth century the rakish behaviour and sartorial ostentation of the elite represented a negative role model for supposedly aspirant groups below them. The aristocracy responded by incorporating the more socially acceptable demeanour of the respectable middling sort in a deliberate reconstruction of their own self-image.

A renunciation of sartorial excess was also linked to the continued prominence of nonconformist religions throughout the century, with their emphasis on the links between plain dress and moral rectitude. Quakerism in particular provided an attractive role model that stood in stark contrast to the continental, and by implication Catholic and unpatriotic,

dandyism of metropolitan and aristocratic style. Joan Kendall in her useful work on the development of Quaker dress quotes the recollections of a Friend, James Jenkins, in the 1820s, illustrating the tension and irony that could arise from an exaggerated (almost vain) adherence to notions of sobriety and 'plainness':

> In those days, every man wore a three-corne'd hat, and the distance between the brim, and the crown constituted the criterion of plainness . . . some of the gayest young men wore them cocked up close, yet that was the extreme boundary, to have adopted the button and loop (so common to those not Friends) would have been considered as a virtual renouncement of Quakerism. . . . The plainest men Friends, wore large ones with the flaps low, their cloathes (the whole suit) and stockings of the same colour, which was often drab, but of whatever colour invariably kept to through life. . . . The dress of the plainest females was a drab coloured beaver hat, black silk-hoods with lappets which came down before nearly to the waist on each side, and were laced over the stomacher with white silk lace, causing the intermixture of black and white to form a pleasing contrast; many of them wore green aprons, adopted . . . for personal mortification.[29]

Arthur Young's descriptions of the lifestyle of the rural middling sort veer between a similar splenetic condemnation of consumption habits which challenged the natural order and a self-satisfied listing of 'comforts' which Young claimed were the 'natural inheritance of a farmer who has the enjoyment of a considerable business'. Thus, in a contradictory manner which reflects the confusion surounding the morality of class and dress, he is quick to condemn pretension:

> Sometimes I see a pianoforte in a farmer's parlour, which I always wish was burnt; a livery servant is sometimes found, and a post chaise to carry their daughters to assemblies: these ladies are sometimes educated at expensive boarding schools, and the sons often at University to be made Parsons. But all these things imply a departure from that line which separates these different orders of beings. Let these things and all the foppery, expense and anxiety that belong to them, remain among gentlemen: a nice farmer will not envy them.[30]

But at the same time he applauds conspicuous consumption as evidence of refinement and worldly success. Whilst both portraits are general, describing broad types rather than individual examples, they lend some credence to John Rule's assertion that 'the English middle ranks were usually first identified materially by the goods and services they purchased and by the status linked to and revealed by that

consumption. It was in part a circular definition, for many of the middle classes could also be identified as providers of the increasing range of goods and services marketed in eighteenth-century England.'[31] Both rural and more specifically urban tradesmen and professionals undoubtedly formed the focus for any expansion in the consumption of luxury items, including fashion, over the course of the eighteenth century. Criteria incorporating comfort and a taste for novelty established in the seventeenth century developed to include a greater emphasis on product elaboration and differentiation as a basis for the purchase of new fashionable lines. After food, clothing and textiles took priority over household furnishings and utensils as a medium for the display of informed choice by the middling sort. Though, as Henry Fielding cautioned, the cost of fashionability could still prove prohibitive, recounting the financial outlay required by a 'gentleman' who, desiring to present his wife and daughters at a masquerade, discovered that after the dresses had been bought, a four-guinea ticket was joined by a bill of eight guineas. Fielding commented 'I am convinced that many thousands of honest tradesmen have found their expenses exceed their computation in a much greater proportion.'[32]

If fashion and fashionability were inextricably bound up with pecuniary means in the inventories and account books of the middling classes, then the 'worth' of new fashionable commodities was even more pronounced in the consumption habits and dress of the eighteenth-century poor. The labouring poor have been identified as a shadowy but central constituency for the attentions of new manufacturers and retailers. Though inventory evidence is rare for poorer groups, records of street crime and burglaries reveal that cotton gowns and breeches, together with pocket-watches, whilst rare in 1700, had found a widespread ownership amongst labourers by the turn of the century. In common with the expansion of the spending habits of the middling sort, much of this shift can be attributed to falling prices, rising incomes and the increased availability of fashion products through new retailers and manufacturers. More directly related to the circumstances of consumers from the lower end of the market was the replacement of traditional sources of employment such as service or farm work, with their connotations of wages paid in kind through lodging, food and handed-down clothing, by newer manufacturing work which prioritised female and child labour, providing a larger family income more likely to be paid in ready money. Ready

money encouraged a habit of spending which must have held a potentially liberating attraction to consumers generally accustomed to a system of recycling or home production for the provision of clothing.

The poor were undoubtedly receptive to the attractions of novelty and an engagement with the fashion cycle, quickly replacing beer with gin and leather with fustian. A widespread interest in fashion and fashionability is attested to by the adoption of wigs by male workers in the first decades of the century, and an equally rapid display of disdain when wigs fell from fashion in the 1770s.[33] Evidence of the delay associated with emulation and the trickle-down theory is not substantiated here; it seems much more likely that consumption amongst the poor gave substance to a particular and individual plebeian identity. Hans Medick usefully compares the symbolic capital of elite consumption with the possibilities of the new 'ready coin' espoused further down the social scale:

> To press the point we may say that what P. Bourdieu's 'symbolic capital' did for the lord, 'ready coin' did for the working man. His money income found its meaningful expenditure – as did the symbolic capital of the lord – far more in public display and appearances than in precautionary savings. 'Ready coin' realised its worth – as did the capital of the lords – primarily in the transformation of economic goods into those symbolic and communicative acts, i.e. into socio-cultural actions and manifestations, which first and foremost gave meaning to the plebeian existence. The ambiguous symbols of this kind of 'expenditure' manifested themselves above all in drinking culture, but also in fashions and jewellery and in the consumption of colonial goods such as sugar, tea, coffee and tobacco. These symbols had a strong, socially associative and compensatory function. Especially at the local level, they constituted an important medium for the resolution of class oppositions, and not only with peasant proprietors, but also with the urban bourgeoisie.[34]

Located in a social realm distinct from a discourse of class and its material possessions was the rise of self-identified and externally recognised sexual subcultures at the beginning of the eighteenth century. Recent work in the area of Gay Studies has isolated the period between 1660 and 1750 as a pivotal moment in the transition from perceptions of homosexual activity as a prohibited but non-specific human activity to its definition as a 'dysfunctional' personality trait manifested through, but not necessarily related to, the sexual act. Randolph Trumbach locates the shift in European cities amongst metropolitan males. He provides evidence of a

seventeenth-century acceptance of licentious aristocratic behaviour, in which choice of sexual partner was not restricted to male or female, but could incorporate relationships with boys alongside mistresses without jeopardising ideals of 'manliness'. The playwright Aphra Behn's character Lorenzo of 1671 did not seem especially concerned at his mistaking a woman for a male page and desiring both just the same. Much of the confusion lies in a fluidity between the erotic symbolism of male and female appearance at the time: 'This stripling may chance to mar my market of women now – 'tis a fine lad, how plump and white he is; would I could meet him somewhere i' the dark, I'd have a fling at him and try wether I were right florentine.'[35]

Same-sex acts amongst members of the lower orders were usually condemned as manifestations of wider deviancy alongside, but not distinct from crimes such as bestiality and incest. After 1700, however, homosexual behaviour was increasingly constructed as a depraved activity associated with a minority of effeminate men, not necessarily from the same social background. Self-identifying groups of such men started to attract popular censure during the early decades of the century and were best known because of the raids on the 'molly houses' or male brothels that formed the focus for their social and sexual activities. Trumbach is a social historian, but many of his observations are relevant to the history of fashion, most specifically in his discussion of the changing associations between concepts of effeminacy and gender-specific possessions or social strategies of display. For example the usual misogynist accusation of an excessive love of luxury was levelled at an early example of the effeminate molly rather than a spendthrift woman in the anonymous novel *The Wandering Whore* of 1660: 'There are likewise hermaphrodites, effeminate men, men given to much luxury, idleness and wanton pleasures, and to that abominable sin of sodomy whose vicious actions are only to be whispered amongst us.'[36]

The bisexual rake, alongside the indolent aristocrat, fell to the growing power of romantic ideals of companionate marriage and the increasing confidence evidenced by the middling sort's espousal of domesticity and the family as a fitting focus for forms of popular culture such as the novel, the magazine and the theatre. The figure of the fop, an overtly fashionable effeminate, but distinctly heterosexual in terms of his love interest, represented an unthreatening comic manifestation of gender subversion on the stage and in the caricatures of the early eighteenth century. In Thomas Baker's play

Tunbridge Walks of 1703, the fop maiden confides 'I never keep company with lewd rakes that go to nasty taverns, talk smuttily and get fuddl'd, but visit the ladies and drink tea and chocolate.'[37] After 1720 the fop's effeminacy had come to be identified in the popular imagination with the effeminacy of the exclusive adult sodomite, the molly or queen. The transformation of the fop into the more problematic role of molly is linked by Trumbach with the evolution of rising concepts of respectable manliness, which, as we have seen, has a specific pertinence to the development of male dress over the course of the century. Extreme bodily gestures, affected mannerisms in speech and contrived magnificence in costume had come to indicate sexual preference. It was against these standards that mainstream masculinity evolved a system of restrained etiquette, handshakes and bows on greeting rather than kissing, and unobtrusive clothing, the sexual and patriotic associations of which remained beyond question. Tobias Smollet, in his autobiographical novel *Roderick Random* of 1748 was explicit in his description of the physical characteristics of a stylised sodomitical sea-captain called Whiffle, against which 'respectable' masculinity could construct itself:

> a tall thin young man with hair in ringlets, tied behind with a ribbon, wearing a white hat garnished with a red feather and a pink silk coat which by the elegance of the cut retired backward as it were to discover a white satin waistcoat embroidered with gold, unbuttoned at the upper part to display a brooch set with garnets that glittered in the breast of his shirt which was of the finest cambric . . . his crimson breeches scarcely descended so low as to meet his silk stockings which rose without spot or wrinkle on his meagre legs, from shoes of blue, studded with diamond buckles that flamed forth rivals to the sun.[38]

Aristocratic effeminacy retained something of the bravura and excess associated with the old-fashioned rake, but leading fashionable socialites adopted the distinctive, self-descriptive term of Beau to replace his former lewdness. However, proponents of lavishly flaunted effeminate characteristics now ran the risk of accusations of sodomy. Lord Hervey, though married with many children, affected Parisian habits, heavy white make-up, false teeth of mottled brown jasper, and a dramatic silk eye patch for his weeping eye. His effeminacy was a constant subject for satire amongst his many political enemies in the 1730s, most notably demonstrated by the poet Pope who styled him in 1735 as Sporus, the Roman Emperor Nero's castrated bride:

Let Sporus tremble – what? That thing of silk,
Sporus, that mere white curd of asses milk?
Satire or sense alas! Can Sporus feel?
Who breaks a butterfly upon a wheel?
Yet let me flap this bug with gilded wings,
This painted child of dirt that stinks and stings . . .
Fop at the Toilet, Flatt'rer at the Board,
Now trips a Lady, and now struts a Lord.[39]

Metropolitan mollies, located in a social milieu far broader than that of Hervey's, adopted yet more extravagant subcultural dress codes, incorporating elements of transvestism and reflecting or subverting the theatricality of many aspects of mainstream London life, from the pastoral affectations of the noblewoman to the grotesque parodies of the castrati. Trumbach relates contemporary reports of the arrest of a group of mollies returning from a ball in Holborn:

> Some had gowns, petticoats, headcloths, fine laced shoes, furbelow scarves, masks and complete dresses for women; others had riding hoods, some were dressed like shepherdesses, others like milkmaids with fine green hats, waistcoats and petticoats; others had their faces painted and patched and very extensive hoop petticoats which were then very lately introduced.[40]

Richard Davenport Hines provides a useful summary of the importance of eighteenth-century molly culture as a model for later subcultural movements and as an extreme example of the ways in which the trappings of material wealth and seemingly rigid sartorial codes can be subverted. It would be dangerous to read too much into an ultimately limited cultural phenomena, but it is more than coincidental that self-identifying groups of sodomites, choosing to express their difference through dress and the body, should emerge at a historical moment of material progress, expansion and diversification. Also, those significant links between the shifting culture of homosexuality and constructions of fashionability, which thread their way through the history of dress in varying degrees, found a particularly heightened sense of specificity in the eighteenth century, that has obvious repercussions for the relationship between dress codes and sexuality in the nineteenth and twentieth centuries:

> Although contemporary accounts emphasised debauchery, molly houses were above all places of refuge, often clandestine, sometimes inward looking and claustrophobic, at other times comforting, in which congregants could forget the perplexities, hazards or isolation of their lives, or the embattled loneliness of their marriages. The sexual desires of *habitués* were as much

Vi1 you give us a Glaſs
OF GIN.

I'll see you
D--N'D FIRST.

52] This caricature draws attention to the capacity of the 'lower sort' to engage with newly fashionable commodities, in this case gin. However, the quilted petticoat, buckled shoes and modish hairstyles also point to a knowledge of the 'new', even if the overall effect is a little dishevelled.

expressed in drinking, flirting, gossiping and discarding inhibitions as in copulation itself . . . The reasons which drove some men to seek emotional safety in molly houses were exactly the reasons which stopped other men from going that far. Ultimately molly houses were an expedient which by over-simplifying choices, levelling experience and restricting the diversity of human needs, satisfied persecutor and persecuted alike. The simplest explanation of molly effeminacy, that some men enjoyed it, should not be forgotten. For younger men, the tattling and wriggling of mollies became the most obvious role model available. At another level molly effeminacy gave cohesion to the subculture and seemed like the semblance of defiance. Yet mollies were colluding with their persecutors by offering a more distinctive and distinguishable minority than had previously existed.[41]

The variety and sense of difference uncovered by a closer examination of the eighteenth-century fashion scene is significant, providing evidence of a close relationship between

dress and considerations of class, gender, sexuality, age and locality, that is not necessarily as reliant on, or repressed by those conspiracies of strengthened capitalism, patriarchy and industrialisation claimed by more negative or reductive commentators on fashion change. The pace of the fashion cycle in the eighteenth century appears to have been generated as much from within as it was imposed from the outside, an increased choice of fashionable models selected to reflect specific and individual circumstances. That is not to say, however, that clothing in the 'age of revolution' did not reflect and adapt to those shifts in marketing, organisation and production identified in this chapter. It seems wholly apparent that social and technical change offered massive opportunities for the rapid growth and differentiation associated with modern fashion systems. Neil McKendrick, though treading on thin ice in his evocation of mechanisation and 'mass' fifty years too early, provides a useful conclusion in his description of the eighteenth-century expansion of fashionability, leading us swiftly into the truly technological environment of the 1800s:

> as long as the pursuit of luxury was limited to the few, it was more like an engine 'running in neutral than an element of growth'. Once this pursuit was made possible for an ever-widening proportion of the population, then its potential was released, and it became an engine for growth, a motive power for mass production. Explaining the release of that power, in terms of the release of a latent desire for new consumption patterns, goes a long way towards explaining the coming of the Industrial Revolution and the birth of a consumer society.[42]

Notes

1 *The Connoisseur*, 1756. in R. Porter, *English Society in the Eighteenth Century*, London, 1982, p. 223.

2 R. Samuel, 'Workshop of the World: Steam Power and Hand Technology in mid-Victorian Britain', *History Workshop* 3, 1977, pp. 6–72.

3 J. Styles, 'Manufacturing, consumption and design in eighteenth-century England' in J. Brewer and R. Porter, eds, *Consumption and the World of Goods*, London, 1993, pp. 527–55.

4 N. McKendrick, *The Birth of a Consumer Society: the Commercialisation of Eighteenth-Century England*, London, 1982; L. Weatherill, *Consumer Behaviour and Material Culture in Britain 1660–1760*, London, 1988; B. Lemire, *Fashion's Favourite: The Cotton Trade and the Consumer in Britain, 1660–1800*, Oxford, 1991.

5 N. Rothstein, *Silk Designs of the Eighteenth Century*, London, 1990, p. 38.

6 A. Ribeiro, *A Visual History of Costume, The Eighteenth Century*, London, 1983, p. 23.

7 E. Einberg, *Manners and Morals: Hogarth and British Painting 1700–1760*, London, 1987, p. 48.

8 Rothstein, *Silk Designs*.

9 S. Levey, *Lace, A History*, London, 1983, p. 43.

10 R. Porter, 'Addicted to Modernity: Nervousness in the Early Consumer Society' in J. Melling and J. Barry, eds, *Culture in History: Production, Consumption and Values in Historical Perspective*, Exeter, 1992, p. 181.

11 Porter, 'Addicted to Modernity', p. 180.

12 A. Wadsworth and J. Mann, *The Cotton Trade and Industrial Lancashire 1600–1780*, New York, 1968.

13 Wadsworth and Mann, *The Cotton Trade*, p. 15.

14 B. Lemire, *Fashion's Favourite*, p. 77–87.

15 N. Barbon, *A Discourse of Trade*, London, 1690, p. 65.

16 J. Rule, *The Vital Century: England's Developing Economy 1714–1815*, London, 1992, p. 249.

17 Rule, *The Vital Century*, pp. 252–62.

18 H. and L. Mui, *Shops and Shopkeeping in Eighteenth-Century England*, London, 1989, p. 225.

19 R. Campbell, *The London Tradesman*, London, 1747, p. 191.

20 B. Lemire, 'Developing Consumerism and the Ready-made Clothing Trade in Britain, 1750–1800' *Textile History*, 15, 1, 1984, p. 22.

21 A. Vickery, 'Women and the World of Goods: A Lancashire consumer and her possessions 1751–81' in Brewer and Porter, *Consumption and the World of Goods*, pp. 274–305.

22 A. Buck, *Dress in Eighteenth-Century England*, London, 1979, p. 210.

23 Weatherill, *Consumer Behaviour*, p. 191.

24 C. Campbell, *The Romantic Ethic and the Spirit of Modern Consumerism*, Oxford, 1987.

25 Vickery, 'Women and the World of Goods', p. 277.

26 J. Rule, *Albion's People: English Society 1714–1815*, London, 1992, pp. 22, 50.

27 L. Colley, *Britons: Forging the Nation*, London, 1992.

28 'The Whole Art of Dress! or, the road to elegance and fashion at the enormous saving of thirty per cent,' 1830, p. 83 in L. Colley, *Britons*, p. 186.

29 J. Kendall, 'The Development of a Distinctive Form of Quaker Dress' *Costume*, 19, 1985, p. 65.

30 A. Young, *Annals of Agriculture*, London, 1792.

31 Rule, *Albion's People*, p. 85.

32 H. Fielding, *An inquiry into the causes of the late increase in Robbers*, London, 1751.

33 Styles, 'Manufacturing, consumption and design', p. 583.

34 H. Medick, 'Plebeian Culture in the transition to Capitalism' in R. Samuel and G. Steadman Jones, eds, *Culture, Ideology and Politics*, London, 1982, p. 93.

35 R. Trumbach, 'The Birth of the Queen: Sodomy and the Emergence of

Gender Equality in Modern Culture 1660–1750' in M. Duberman, M. Vicinus and G. Channery, eds, *Hidden From History: Reclaiming the Gay and Lesbian Past*, London, 1989, p. 132.

36 Trumbach, 'The Birth of the Queen', p. 133.

37 Trumbach, 'The Birth of the Queen', p. 133.

38 T. Smollett, *Roderick Random*, London, 1895, p. 239.

39 Quoted in T. H. White, *Age of Scandal*, Harmondsworth, 1962, pp. 85–6.

40 Trumbach, 'The Birth of the Queen', p. 135.

41 R. Davenport Hines, *Sex, Death and Punishment: Attitudes to Sex and Sexuality in Britain since the Renaissance*, London, 1990, p. 86.

42 McKendrick, *Consumer Society*, pp. 65–6.

5 Nineteenth century: fashion and modernity

53] Horse-hair padding, boning and an ingenious cut helped to construct an outline that completely distorted the natural outlines of the body. A sense of the absurd was heightened by outlandish trimmings and accessories.

Just now our fashionable women are bitterly reprehended for copying the dress of the Anonymas who establish the fast pronounced fashions of Paris. Half of them do not know what model they have taken. The other half accept the various and tasteless costumes not because they are devised by Anonyma, but because they are striking. There is something in the commonplace of fashionable life which smothers all originality of thought, of action, even of device in costume . . . Love of dress develops itself in bold contrasts of colours, in bizarre and showy ornaments, in picturesque and often in grotesque and tawdry effects. But whatever the details, the whole is always striking. Our women, longing for the new, accept the absurd, desiring the picturesque, take the bizarre, and eager for the elegant, content themselves with the costly.[1]

A longing for the new and an acceptance of the absurd, motivations singled out for criticism by the journalist quoted above, illustrate a general ambivalence towards those effects in fashionable dress associated from the 1860s onwards with advances in the technology and organisation of the clothing industry and an ever-broadening scenario of metropolitan fashionable consumption. The recurring debates on the morality of modern dress cited the brashness of aniline dyes, the vulgarity of the steel-framed dress support and the enervating atmosphere of the department store as the terrible emblems of a shift towards the style of 'Anonyma' or the fashionable courtesan, who haunted the carriage drives of Hyde Park. Whilst the message purveyed by satirists and self-styled reformers was an old one, using the same misogynistic complaints against the timeless vanity and innate femininity of fashionable excess that seems to have obsessed religious and political reactionaries throughout the period covered in this book, the rhetoric through which it was conveyed was more directly concerned with the very contemporary effects of change and transformation initiated by the industrial and commercial expansion which dictated those forms taken by nineteenth-century society and material culture. If there is one major theme amongst many which can be isolated as a focus around which a discussion of Victorian clothing can be situated, it is this problem or idea of 'modernity'. There is a sense, when reconstructing the preoccupations and priorities of nineteenth-century consumers, of a waning of the attitudes and hierarchies which determined fashionable form in the previous century. The subtle problems of status and social grouping caused by the wider availability of new textiles and innovatory styles had lost their relevance in a market-place whose character had been completely reinvented by the

development of modern capitalism. The new promotional techniques of cotton manufacturers in the 1770s, for example, seem undeniably quaint and tentative when positioned beside the avalanche of advertising ephemera, mail order initiatives, and magazine publicity stunts which typified the fashion scene from the 1850s onwards, and whilst the term 'revolution' has already been identified as a problematic one, its application to the fashion system of the later nineteenth century is probably apposite in such a context. Violent changes in the broader scenario of production and consumption were also reflected in the style and form of fashionable dress itself, which in terms of variety and complexity underwent something of a visual transformation.

⌐It is the intention of this chapter to develop an argument that nineteenth-century style change, whilst in part resulting from new technologies and a sense of the modern, was also the product of shifting cultural and social attitudes regarding both the perception of acceptable forms of masculinity and femininity, and the nature and dissemination of fashionable taste. ⌐Whilst the politics of class-based fashion lost the urgency associated with those eighteenth-century sartorial definitions of the elite or the labouring poor, questions of sexuality and gender found a heightened significance in the context of an increasing delineation of acceptable public and private roles for men and women. ⌐This strengthening of pervasive middle-class moral codes perhaps sat uneasily with the growing commodification of fashionable trends and interests, which emphasised the worldly and metropolitan. The resulting tensions underlie that sense of the extraordinary that representations and surviving examples of nineteenth-century dress carry into the present; a sense which has often led fashion historians to make remarkable assumptions based on cod psychology and reductive readings of Victorian sexuality in their attempts to define motives for the adoption of crinoline, bustle and stove-pipe hat. In using more recent interpretations of areas such as print culture, industrial expansion, domestic ideology and the organisation of shopping the new fashion historian may hope to reach more informed, though equally problematised conclusions.

Madonna to Magdalene: fashion change and femininity, c. 1830–90

> All men whose opinion is worth having, prefer the simple and genuine girl of the past, with her tender little ways and pretty bashful modesties, to this loud and rampant modernization . . .

but all we can do is to wait patiently until the national madness has passed, and our women have come back again to the English ideal, once the most beautiful, the most modest, the most essentially womanly in the world.[2]

Thus did Elizabeth Lynn Lynton, writing in the family journal *The Saturday Review* in the late 1860s, pit the perceived vulgarity of the contemporary young woman of fashion, 'the girl of the period', against her more demure counterpart from the earlier half of the century. 'Loud and rampant' versus 'tender and modest'. She appears to have had in mind the recent enveloping and demure fashionable lines of the 1840s, but need only have looked back a further ten years to the early 1830s to locate a loudness more than equal to the current fast coquettishness that she so bemoaned. A comparison of the fashionable figure of the 1840s with that of the preceding and succeeding decades suggests that in formal terms at least some credence should be given to the otherwise simplifying costume history view that each fashion change is a direct reaction against the previous style. An examination of plates from society journals such as *The World of Fashion* produced between 1830 and 1845 give a graphic example of the slide from the exuberance of the early decades of the nineteenth century to the respectability of the middle years (though caution in using plates and fashion reports as evidence of anything other than propaganda for commercial concerns or carefully constructed escapist entertainment for readers is necessary here).

By the late 1820s the high-waisted, soft neo-classical line, popular amongst the elite since the late 1780s, had been adapted to accommodate a certain degree of control. C. Willett Cunnington records the complaints in 1820 of unfamiliar constriction: 'It is sad to be condemned to the ball dress of to-day; I abhor the long waists, the miserable busks and the whalebone that carry us back to I know not what Gothic period.'[3] The angular form reached a literal peak in about 1830, with the two padded triangles of skirt and wide-sleeved bodice meeting at a tiny belted waist. The sparse cut of the dress and profuse applied decoration at the ankle-length hemline of the skirt and across the low shoulderline served to emphasise the resulting egg-timer silhouette, balanced by a wide-brimmed picture hat, heavily laden with ribbons and feathers in the most affected plates. Slightly later figures show a shift towards a relative simplicity with draping and pleated folds replacing ostentatious trimmings. The fullness of the bell-shaped skirts was achieved with an arrangement of pleats

CARRIAGE & MORNING VISITING DRESSES.

54] Compliant models of ideal femininity expounded in the serialised novels of expanding women's magazines were accompanied by fashion plates depicting the dark, drooping forms of the new 'gothic' styles.

and gathers radiating all around the waist, and the use of multiple petticoats. Colours during the period generally conformed to light pastels, often contrasting. Fashion plates certainly tended towards light tints of pink, yellow, green and blue, though this may have resulted more from the limitations of hand colouring than from any attempt to approximate the range of available textile dyes.

By 1839 the emphasis had shifted considerably, the pertness of the early 1830s was pulled downwards, the shoulders drooping and narrow, the waist appearing much further down the bodice and the skirt reaching the floor. The vertical downward emphasis was strengthened by the addition of flounces to the lower half of the dress; and in the hair, falling cavalier ringlets, heavy with oil, framing the face and replacing those bunched curls that had formerly clustered around

the temples. Wide-brimmed hats were similarly replaced by narrow 'coal-scuttle' bonnets that literally blinkered the vision of the wearer. Plates from the mid 1840s show the reaction against earlier excesses completed. The bodice has lengthened to a point and the sleeves have narrowed to fit the arm completely. This basic form would remain unaltered for the next decade, so much so that the *New Monthly Belle Assemblee* could report in July 1858: 'There is nothing particularly new in the style of dress. The heat has abolished, for the time, the tight sleeve, which may be regarded rather as indicative of what may be hoped for when winter arrives, than a serious design to torture us in such weather as the present; and accordingly we rush into the other extreme, and wear them open to the elbow.'[4]

Colours during the 1840s appear to have deepened. Small floral sprig prints were popular and complementary bands of colour might be arranged in plaids or narrow stripes, arrangements that produced effects of crisp definition in the early calotype portraits of photographers such as David Octavius Hill and Robert Adamson. A ready market for the variety of dyes offered by an expanding print and dye industry was evidenced by the reports of the fashion columnists: 'We can announce as most fashionable, shades of light and dark green, deep shades of olive, blue de la reine, mixtures of cerise and blue, violet and brown, pink and lavender, blue and violet and the beetles wing.'[5]

By the middle years of the 1850s the growing volume of skirts was beginning to preoccupy the columnists. The means of supporting an ever-increasing width of material was a continuing theme for *The New Monthly Belle Assemblee* during the early months of 1856:

> The gowns for both morning and evening are made very full, the object is to make them hang out at the bottom, for this purpose bands of plaited straw, or of crinoline are placed in the gowns underneath. If the gown has flounces a band is placed inside each flounce, but this practice cuts a dress, particularly where straw is used . . . an immense number of under petticoats must be worn to hold out the dress for light materials. Crinoline does not sit well, flounced petticoats are much better.[6]

The years around 1855 represent something of an apotheosis for what both contemporaries and costume historians have termed the 'Gothic' style,[7] a particularly apt descriptive category replete with connotations of stylised, attenuated virgins and angels. Drooping compliancy in day wear together with a weightless prettiness for evening were both achieved

through heavy boning, constrictive cutting, and cumbersome petticoats. From the end of the decade, however, technological innovation together with a gradual redefinition of acceptable standards of femininity introduced a more strident note into the fashionable wardrobe. The waist rose, the sleeves and bodice becoming looser, and the circumference of the skirt increasing, reaching its widest diameter in the early 1860s. The strengthened presence that the growing volume of dress demanded was heightened by the gradual replacement of subdued colour and pattern with bright vivid shades and bold geometrical decoration. This gradual loosening and movement away from heaviness could in fact be detected as early as 1850 in some magazine plates. The sleeves had widened and new machine lace was employed both around the cuff and in early applications of flounces to the skirt. By 1856 illustrations showed the use of layered flounces and double skirts taken to an extreme, producing an image of femininity far lighter than the frail piety of earlier plates. The rivalry between the two styles was contested during the autumn of 1858, veering between considerations of practicality and beauty so that in September 'Robes are still garnished with flounces, but it is asserted that for winter double skirts will be in favour. All ladies are not possessed of equipages, and flounces are (to say the least) very embarrassing in the days of rain and snow', whilst in October 'Flounces are in important rivalry with double skirts, especially when a light material is in question. Their form is more elegant and gives a certain style to the wearer.'[8]

55] Tiered flounces, lace overskirts and funnel sleeves announced a loosening and widening of female clothing, depicted here in the pages of a popular newspaper.

The elegance and style quoted in the magazines of 1858 may have marked the turning-point identified in Mrs Lynton's critique of contemporary dress. It was perhaps still possible to identify in the fashion plates of 1856 the 'tender little ways and pretty bashful modesties' that she saw as the model of the English ideal. However, 1856 also marked the introduction of both aniline dyes and steel-framed crinolines, articles held up by reactionaries and moralists as prime examples of the immorality of modern dress. In the reports and illustrations of 1856 the basic construction of the dress still conformed to received notions of respectability. The skirts, although wide, remained conventionally gathered in at the waist and any fullness was achieved by a combination of layered petticoats and careful pleating. By 1860 wide circumference was achieved by a single light framed support and exact tailoring or 'goring' of the skirt. Thus it was possible to claim that a certain 'natural' honesty of construction

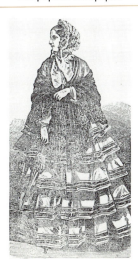

had been replaced by an 'unnatural' emphasis on artifice and effect.

The 1860s established themselves as the decade of the steel crinoline. Plates from 1864 present the gored skirt at its widest circumference, and constant variations in its specifications both dictated, and benefited from, an increasing use of the sewing machine, first manufactured in the early 1850s and more widely adopted for home alterations and the rise of free magazine dress patterns by 1865.[9] The desire to achieve fashion-plate contemporaneity was not without its problems, however. Carte-de-visite photographs of middle-class women unable to update their wardrobes in tandem with the instructions sent out by Paris show the unfortunate consequences of matching a narrow gored skirt with a wide crinoline and vice versa. It was precisely within the domain of the disadvantaged suburban or provincial fashion consumer that new women's periodicals such as *The English Woman's Domestic Magazine* aimed to intervene:

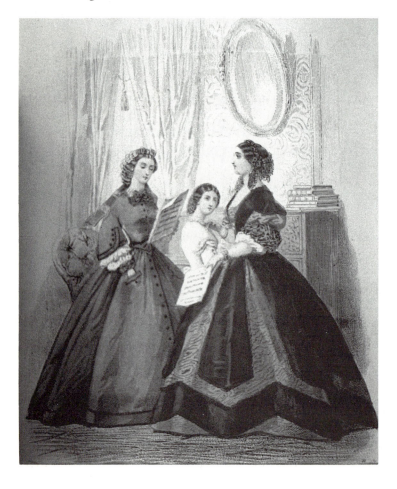

56] By the early 1860s the introduction of the steel crinoline allowed for a new assertive style of dress that worried moral commentators. Bright colours and bold trimmings enhanced a 'louder' presence for middle-class women within private and public spheres.

Dresses are worn very long behind and are much gored, even evening dresses of light material are arranged in this manner. As the mode appears to be to lessen the width of the skirt at the top, it is absolutely necessary that the material be well gored to give sufficient width to the bottom . . . many styles have been invented by which dresses somewhat passé may be made quite à la mode. One of the difficulties to contend with is the narrowness of the skirts of dresses made some years since, which at the present time are scarcely of sufficient width to go over a crinoline. To obviate this difficulty the skirts should have a tablier inserted in the front or small gores let in between each seam.[10]

By 1866 the use of gored skirts had evolved into the use of shaped panels for the whole of the dress, producing a form called 'the princess line' by advertisers, publicists and suppliers that enjoyed commercial success in different patterns for the following twenty years. *The World of Fashion*, in its reports on the styles put out by leading London and Paris fashion houses, drew attention to the sense of modernity that the new line embodied, puffing up its claims through careful reference to an important advertiser and manufacturer of the latest fashion technology:

The greatest and most striking novelty is in the form of dresses, a very large proportion are now being made in the princess style, the skirt and body being cut altogether without seam across at the waist. This form is most stylish and graceful, and well calculated to display an elegant figure to the best advantage. Even where the body is not cut with the skirt, the skirt is gored, or sloped at the top of the breadths so as to sit nearly plain around the hips. The new shape of sansflectum jupons advertised by Mr Bourne on our wrapper are admirably adapted for this new form of skirt and are light and convenient in wear.[11]

Having reached its widest circumference, and drawing the fullest visual impact through a combination of applied decoration in the form of stylised Greek key pattern borders or contrasting vertical bands of virulently coloured material, the crinoline began to subside in autumn 1866. By 1868, the year of Mrs Lynton's *Saturday Review* article, fashionable style had returned to an approximation of the jauntiness and fast bright colour, the padding and tight scant cutting typical of the early 1830s. High waists, ankle-length skirts, and false hair piled into chignons at the top of the head suggested a stooping posture that satirists coined the 'Grecian Bend'. Fashion journalists chose a variety of often contradictory historicist terms from 'empire' to 'Louis XV' to describe a form of dressing that was essentially 'modern' in its extroverted and metropolitan associations, suggesting an approach that

allowed the consumer possibilities of choice and experimentation intimately connected to wider developments in a new 'consumer society'. The *English Woman's Domestic Magazine* betrayed the overriding sense of fashionable fragmentation and diversifying markets in its attempts to characterise the features of contemporary clothing in 1868:

> With the Louis XV costumes, the pannier jupon is indispensable ... Crinolines are transformed, not given up. The modern jupon is fully puffed out at the back and sides; this fashion is not becoming to all figures – but what fashion ever was? It gives a very graceful tournure to tall slight ladies, and at any rate, it suits a far greater number of figures than did the empire dress, which rendered them all without exception, stiff and ungainly ... They say it is the Princess of Metternich who has given the vogue to panniers; together with many other ladies of fashion, she very soon discarded the empire dress ... Thus for once good taste has had the better of fashion, and from the scant, ungraceful robes of the first empire we are rapidly going back to the more becoming fashions of Louis XVI and Louis XV. Parisian couturiers study historical costumes of the period and think far more of copying than of inventing.[12]

The 1870s and 1880s witnessed a succession of competing styles based loosely on historical models. The death of Charles Dickens, for example, in 1870 and the resulting sale of a painting he had commissioned from the painter W.P. Frith of the heroine of his novel *Barnaby Rudge*, lent a topical tag to the 'Dolly Varden' style that took its inspiration from the polonaise dresses and floral silk designs of the 1760s. Inordinate lengths of skirt would be bunched up at the back of the dress, supported by the bustle or pannier frames that had replaced the crinoline. The need for any kind of skirt support became superfluous by the late 1870s, when the sheath-like princess line, cut without a waist seam and pulled in close around the legs by interior ties, threw the emphasis back on a carefully moulded bodice. Choice was further complicated at the turn of the decade by the gradual read-option of the bustle. Indeed, using the evidence of photographs, magazine articles and surviving clothing, dress historians have typified the early 1880s as a period of stylistic confusion, which could equally be interpreted as a broadening of consumer choice. On the one hand an emphasis on contrasting texture and applied decoration produced an over-ornamented silhouette, whilst at the same time the rise of tailoring in women's dress allowed for an alternative, severe style, that drew attention to the growing mass of the skirt and lent itself well to austere naval decoration. Both fashions were

HISTORY REPEATS ITSELF.

(FROM A *VERY ANCIENT VASE* IN THE POSSESSION OF *MR. PUNCH*.)

57] The cartoonists of *Punch* were notable for an anti-fashion stance that often verged on misogyny. Nevertheless their work provides a valuable source for social and dress historians. Here the 'Grecian bend' effect of high hair and bustle is ridiculed.

58] Late-nineteenth-century advertisement showing a masculine tailored style for skirts.

CHAPMAN & CO.
SILK AGENTS AND DRESS MERCHANTS.

COSTUME SKIRT

in the

NEW BOUCLÉ CLOTH

or

GLENEFER TWEED,

with

MATERIAL

for

BODICE

in

THIRTY SHADES.

ELEGANTLY

FINISHED

27s. 6d.

CHAPMAN & CO.,

2, NOTTING HILL, LONDON, ENGLAND.

Patterns free to all parts of the World.

condemned for a lack of taste and credited as the cause of a serious move towards dress reform. Willett Cunnington condenses the general trends of the mid 1880s:

> A contemporary sums up the fashions as 'puffs, frills, ruches and all kinds of fussiness for light materials, and majestic plain skirts for heavy fabrics. These are the two styles in vogue.' And we are reminded again that 'in English Society dress is totally different from what it is in Paris.' It is significant that 'a large and increasing number of women are dissatisfied with dress as it is'.[13]

Dress reform has formed something of a diversion for costume historians focusing on the nineteenth century, and has generated more than enough study[14] to excuse its lack of inclusion here. From the bloomer controversy of the early 1850s, through artistic Pre-Raphaelite dress of the 1860s and aesthetic 'Patience' modes of the 1870s and 1880s, its impact seems to have been restricted to the columns and caricatures of the satirical press and the pretensions of a metropolitan 'bohemian' minority. Nevertheless its general strictures regarding the adoption of healthy lightweight textiles, exotic patterns and colours and the rejection of constricting underwear periodically provided inspiration for more mainstream styles, and undoubtedly offered rich opportunities for marketing and publicity schemes to manufacturers and retailers across the board. Certainly by the late 1880s and into the 1890s, the growth of cycling and tennis as acceptable feminine pursuits, replacing the more sedentary pastimes of croquet and archery, demanded a greater ease of movement. The bustle, which had reached almost shelf-like proportions in 1888, was becoming increasingly anachronistic in the face of smoothly gored flared skirts, paired with simple mutton-sleeved jackets and blouses, which anticipated the greater egalitarianism of the twentieth-century mass market.

It is possible, then, bearing in mind the hallucinatory quality of fashion copy and plates, to construct a narrative of style change focusing around the pivotal middle years of the nineteenth century and using the evidence of the new women's fashion journals. The conservative modes of the 1840s and early 1850s can be seen to replace, perhaps in deliberate reaction against, the more flamboyant styles of the early 1830s. It is equally possible to perceive the worldly, extrovert styles of the 1860s through to the end of the century as a progression from, and reaction against, the subdued introversion of the previous two decades. We can

identify the moment of most dramatic change as occurring between 1856 and 1860, precisely the time when steel crinolines and aniline dyes went into commercial production. In terms of historical analysis this suggests that nineteenth-century fashion can be interpreted through a variety of readings, encompassing considerations of social pressure, technological advance and marketing panache, areas that will form the focus for the remainder of the chapter.

Crinoline and aniline, symbols of progress

Diana de Marly in her biography of the early couturier Charles Frederick Worth firmly locates the introduction of the wire crinoline within a wider history of technology, implying that its production would not have been possible without the impetus of contemporary industrial progress or invention. Most specifically it is implied that experiments with the Bessemer converter in 1856 pulled the crinoline into a well-recognised nineteenth-century rhetoric of engineering prowess:

> Mayhew drew attention to the technique that enabled iron to be turned into steel, which could then be drawn out into fine wires. Indeed this process was vital to the invention of the flexible cage frame. This form of crinoline was a true child of the industrial revolution, for it could not have taken place without it. By 1858 there were factories which made nothing but crinoline steel, and shops which sold nothing but crinolines. The cage was without doubt the first industrial fashion, a true representative of its age.[15]

Alison Gernsheim notes the granting of 'the first British patent for a metal crinoline in July 1856 – a skeleton petticoat made of steel springs fastened to tape'.[16] It was also in 1856 that Henry Bessemer presented his paper 'On the Manufacture of Malleable Iron and Steel without Fuel' to the British Association for the Advancement of Science. He proposed a process which would produce steel from iron at a lower cost and in greater quantities than the current cementation or crucible process, which was relatively laborious and uneconomical. However, to attribute the availability of steel crinoline wire to the Bessemer converter is simply erroneous. Its application to industry came too late and produced steel unsuitable for the precision trades. What is significant is the widespread public and commercial interest aroused by the potential of inanimate power and industrial might during the middle years of the century:

During the last eleven years from May 1851 to May 1862 no less than 177 applications for patents have been made for improvements in the manufacture of steel . . . This statement evinces the deep interest which is felt by scientific and practical men of the present day in reference to the production of this, the most useful of metals, and also the desirability of improving its quality, cheapening its price, and of being able to make it with certainty of such a uniform character, that it may be specially suitable for the various purposes for which it is required, whether those purposes be the watch spring, the lancet, the razor, the railway wheel or the heavy crank shaft of the steam engine.[17]

Crinoline wire, then, was manufactured from steel produced by traditional methods, usually the crucible or Huntsman process, which involved the melting down of pig iron and wrought iron. Crucible steel had been produced in Sheffield by the Huntsman process since the late eighteenth century, so its application to crinoline wire cannot be seen as a sudden innovation. The wider availability and comparative cheapness of steel wire in the late 1850s must be credited instead to operational changes in the rolling and drawing of the metal after its emergence from the furnace.

Until 1861 wire drawing, in which the newly fashioned crucible steel was pulled in rod form through sets of massive steam driven rollers, was performed manually. However, a growing demand for the product necessitated both higher production rates and a greater degree of standardisation. The crinoline trade itself required roughly one seventh of the weekly output of steel in Sheffield, according to the jurors of the 1862 International Exhibition: 'The recent application of this metal to crinoline has no doubt given a great impetus to the trade. It is computed that there are at the present time from 130 to 150 tons consumed weekly in the manufacture of this still favourite and fashionable part of female attire.' The Bedson Mill of 1862 was evolved specifically for the use of steel rod for fine wire drawing, and symbolises the extent to which the application of new technologies and the systematic organisation of industrial processes could underpin and reform the nature and character of nineteenth-century dress and design. Whilst terms such as 'mass production' and 'standardisation' have been shown to fit more closely into an early twentieth-century Fordist context, their application here does not seem so far-fetched. A description of the mill is especially evocative of the thundering juggernaut of industrial expansion that so alarmed contemporary design reformers and philanthropists. Several rolling stands were arranged in

tandem, the first was positioned next to the furnace, then the rod was passed through as many as sixteen until the required size was achieved. The arrangement of rollers was complicated by the frightening momentum that the red-hot rod gathered as it shot through the system. To accommodate this a steam-driven shaft ran alongside the mill, taking the drive to each stand through an arrangement of bevel gears, each successive bevel on the shaft larger than the previous one in order to increase the speed of the rollers as the process progressed. On completion the wire would be guillotined and dispatched to sheds where women workers would assemble the crinoline cages.

An early market for dress supports that disposed of the need for heavy petticoats and embraced new discourses of hygiene and technology is shown in the variety of applications for patent protection in the area of crinolines and skirt improvers taken out between 1847 and 1870. Of particular interest are those patents registered before Gernsheim's initial date of 1856. Whilst there is no proof that patented designs were ever put into production, the evidence suggests an innovatory emphasis on technological advancement, together with attempts by producers and manufacturers to fill gaps in the market, that undermine more simplistic fashion history narratives of style change:

> No. 985. Ladies Spring Dress Improver. March 3 1847.
> Ahrend Kohne of Laurence Pountney. Stay Maker.
> A steel or other light semi-circular band from which various metal ribs radiate. The intervals of this framework are filled up with wadded jean or with any other suitable material and the whole then covered in.

> No. 1161. The Ladies Petticoat or Dress Dilator. August 7 1847. Fashion having made it desirable that ladies dresses should fit full around them, it will be seen that the above design will completely effect this object without increasing the weight. It represents a ladies petticoat made like a pelise, open in the front, the bottom part of which is made of a fabric known as mackintosh so that it will retain the air when inflated . . . the fabrics are permanently united together by means of a preparation of India rubber.

> No. 1727. Design for a Ladies Improver or Bustle. Jan 10 1849. Thomas Cartwright. Birmingham.
> The Ladies Improver as ordinarily constructed is made of a material more or less rigid but perfectly elastic and hence when by pressure its form is altered it does not regain its form on removal of pressure or does so imperfectly. My improvement

consists in introducing steel springs . . . by the use of such springs the Ladies Improver regains its form when by pressure it has been temporarily compressed.

No. 1082/4267. Spiral Spring Petticoat Cord. June 20 1860.
George Grout. Wood Green. Tottenham. Middx.
A spring support or expander to petticoats, the said cord being fixed round the petticoat in the same manner as steel, cane or whalebone . . . it has the following advantages of yielding readily to local pressure, allowing the dress to fall in graceful folds and being more durable than anything at present in use.

The wide variety of skirt supports available at any one time, to suit the style of dress or the pocket of the purchaser, can be discerned from the reports of fashion journals, who in liaison with advertisers consistently promoted different supports as being most suitable for a particular model: 'I must not omit to relate that Messrs Carter of Ludgate Hill are selling a very nice crinoline for pannier skirts. It can be had covered or skeleton, and worn with or without the pannier bustle, steels being arranged to draw out and form a pannier. The price varies from 12s 6d to 16s 6d.'[18] At the bottom end of the market Henry Mayhew described 'Those huge, awkward, unwieldy hen coops which are hung out at the doors of the cheap selling off shops . . . hideous machines made of buckram and split sugar canes, which swing about and block up the pavements.'[19] By the end of the 1860s no amount of advertising or promotion could hope to retain the crinoline at the centre of fashionable interest. Manufacturers were forced to diversify into the areas of bustle and corset production. For at least ten years, however, the steel frame stood as an icon for wider aspirations and rapid change:

> Every woman now from the Empress on her Imperial throne down to the slavey in the scullery, wears crinoline, the very three year olds wear them. It may be safely calculated that every female in the kingdom possesses two sets of hoops; one for ordinary wear and one for best; one for the drawing room, another for the promenade, one to wear while cleaning the doorstep, another to distend the merino or the muslin for the Sunday out. Crinoline has become a vast commercial interest. It is no longer a matter affecting merely a few work girls in the London shops. It extends itself to the forge, the factory and the mine. At this moment and at any moment throughout the year, men and boys are toiling in the bowels of the earth to obtain the ore of iron which fire and furnace and steam will in due time, by many elaborate processes, convert into steel for petticoats.[20]

If the adoption of the wire-framed crinoline signified the 'acceptance of the absurd' that reactionary journalists like Lucia Calhoun, or satirical cartoonists in the pages of *Punch*, condemned in their criticisms of modern woman, then the simultaneous use of aniline dyes perhaps represented a 'longing for the new'. The two innovations, both introduced within the same few years, seem bound up with each other in terms of meaning and contemporary significance. Together they both reflected and helped to construct a vision of the independent female consumer that social commentators found so threatening.

The evolution of the synthetic dye industry is well served by a wide literature that orientates itself around the specific discovery of aniline purple or mauve by the training chemist William Perkin during the Easter of 1856.[21] Most of it, however, takes a modernist design history approach and prioritises the actions of individual genius, rather than focusing on the cultural implications of new colours and their reception. What was significant about Perkin's accidental discovery was the way in which it answered, and could be marketed towards, the requirements of a changing market. On sending samples of the pigment to Pullar's dye works in Glasgow, Perkin received the following encouragements:

> If your discovery does not make the goods too expensive, it is decidedly one of the most valuable that has come out for a very long time, this colour is one that has been very much wanted in all classes of goods and could only be had fast on silks and only at great expense on cotton yarns. I enclose you a pattern of the best lilac we have in cotton, it is done by only one house in the United Kingdom, Andrews of Manchester and they get any price they ask for it, but even it is not quite fast; it does not stand the tests that yours does and fades by exposure to air . . . I had no intention of being in London this season but will not think much of coming up should I find on trial that this is a good thing. We are always desirous here to have everything new as we do a large trade in manufacturing and a new colour in the goods is of great importance.[22]

Gaudiness and bright colour in women's dress was not a phenomenon solely associated with the 1860s. The Lancashire cotton printing industry was renowned for its production of cheap novelty designs from the beginning of the century. The ancient middle eastern Turkey red technique, for example, had been reintroduced to the industry in the 1780s and produced pink contrasting patterns against a rich red ground through the use of chlorine and stencils. Steam

fixatives and 'rainbow' designs that incorporated blended block-printed stripes were particularly popular in the mid-1820s. According to the printer Benjamin Hargreaves: 'the spring career opened with rich covered patterns, in rainbow stripes, of steam pink, blue green and orange, afterwards crossed with paler shades of the same colours in rainbowing. The effect of these styles was brilliant in the extreme.'[23] These were patterns designed for, and marketed towards, specific consumers in the Empire and poorer markets at home. What marked aniline dye out from earlier and contemporary natural dyes were the immediate connotations of heightened fashionability and a sense of 'modernity' that it was able to command. The reports by the jurors of the International Exhibition of 1862 are heavy with the language of hype and a pride in discovery and progress that typified the publicity surrounding the regular mass displays of contemporary culture and achievement occurring from the Great Exhibition of 1851 onwards:

> Near the entrance of the Eastern Annexe, in that part of the exhibition specially devoted to chemical processes and products, there are several cases which appear to excite in a more than ordinary degree, the interest and admiration of the public. In these cases is displayed a series of most attractive and beautiful objects, set in sharp contrast with a substance particularly ugly and offensive. This latter is a black, fetid semi-fluid, equally repulsive to sight, smell and touch; one of the most noisome, as it is also one of the most abundant and embarrassing of the gas manufacturer's waste products. It is in a word gas tar. The beautiful objects amidst which the tar is placed are a series of silks, cashmeres, ostrich plumes and the like, dyed in a diversity of novel colours, allowed on all hands to be the most superb and brilliant that have ever delighted the human eye . . . Conspicuous among them are crimsons of the most gorgeous intensity, purples of more than Tyrian magnificence and blues ranging from light azure to deepest cobalt. Contrasted with these are the most delicate roseate hues, shading by imperceptible gradations to the softest tints of violet and mauve. All these marvellously beautiful colours are derived by chemical transformations, more marvellous still, from the same prime origin, namely the noisome tar.[24]

The effects of the new colours, combined with the potential for display offered by the cage crinoline, certainly seem to have produced a quantifiable change in the physical presence and projection of fashionable femininity in the 1860s. The jurors of the 1862 exhibition referred to innovations which 'altered the very aspect of the public streets' and foreign

journalists were quick to draw connections between the luminescence of female dress and the brash entrepreneurial spirit of mid-nineteenth-century Britain:

> The exaggeration of the dresses of the ladies or young girls belonging to the wealthy middle class is offensive . . . gowns of violet silk with dazzling reflections, or of starched tulle upon an expanse of petticoats stiff with embroidery . . . gloves of immaculate whiteness or bright violet, golden belts with golden clasps, gold chains, hair falling back over the nape in shining masses . . . the glare is terrible.[25]

There is then much evidence for significant changes in forms and standards of female dress which coincided with technological discoveries between 1850 and 1870, and the enthusiastic consumption of drastically new styles by women previously cocooned in the equivalent of dark heavy straitjackets can be used by the fashion historian to substantiate claims for new freedoms and the importance of novelty as central concerns for nineteenth-century fashion. All of this suggests that industrial innovation can be used as an explanatory device for the evolution of fashion trends, though only within the context of social and cultural determinants. Ruth Schwartz Cowan has put forward an agenda for the study of technological advance that provides an attractive model for the further exploration and proper investigation of those physical changes outlined above:

> The sociology of technology, if it is ever to justify its existence as a sub-discipline, should take as its proper domain of study those aspects of social change in which artefacts are implicated. The processes by which one artefact supplants another (technological change) or by which an artefact reorganises social structures (technological determinism) or by which an artefact diffuses through society (technological diffusion) are fundamentally sociological in character, subsets, as it were, of the larger topic of social change. Properly constituted historical investigations can be used (and indeed must be used) as the raw material for studies of social change.[26]

Public and private spheres – the social context of fashionable consumption

Leonore Davidoff and Catherine Hall, in their book *Family Fortunes* have traced the formation of separate feminine and masculine, private and public spheres, which came to symbolise the foundation of a new middle-class morality from the late eighteenth century onwards. Quoting popular

publications like *The Magazine of Domestic Economy* they show
how over the course of the 1830s, under the influence of a
particularly vehement revival in nonconformist
Protestantism, respectable femininity increasingly came to be
associated with a narrow definition of 'home' and home life:
'We are born at home, we live at home, and we must die at
home, so that the comfort and economy of home are of more
deep, heartfelt and personal interest to us than the public
affairs of all the world'.[27]

Prescriptive journalistic views like this, whilst forming an
attractive if simplistic explanation and justification for the
introverted 'Gothic' forms of dress in the 1840s, disregarded
the complexities of a female position compromised by
mounting pressures of changing business practices and the
growth of a physical suburban segregation between home
and work, in favour of a spiritual, angelic construction of
'womanhood'. Within the dictates of the separate spheres dis-
course there arose a central contradiction between the tran-
scendental innocence of the model wife and mother, and the
demands of material fashionable display made of the domes-
tic feminine sphere by the aggressive capitalist dictates of the
public masculine world:

> In the spiritual realm . . . the true wife could create the desired
> atmosphere of Victorian domesticity out of thin air. However,
> middle-class Victorian beliefs functioned on levels other than
> the spiritual. There were as well generally accepted standards for
> the cultural environment of the ideal family, and just as the spir-
> itual well-being of the home was considered a feminine
> responsibility, so also was the creation of suitable standards of
> taste and manners . . . Two systems of assigning status, then,
> existed in the Victorian period, one based on material wealth,
> and one based on the manifestation of certain personal and cul-
> tural attributes. One way in which the conflict between these
> two systems was managed . . . was through the family's style of
> life displayed in its tastes . . . Women, not men, managed the
> outward forms that both manifested and determined social
> status.[28]

Fashion obviously accounted for the most part of those
'outward forms' and the split allegiance between public and
private was undoubtedly accentuated by mainstream moral
condemnation of material display, particularly fashionable
display, that made a woman's role as communicator of her
family's social position increasingly difficult and compli-
cated. In terms of personal appearance, before 1860 'the con-
trast between the straight lines, practical materials and
business-like image of men's clothes, and the soft, flowing

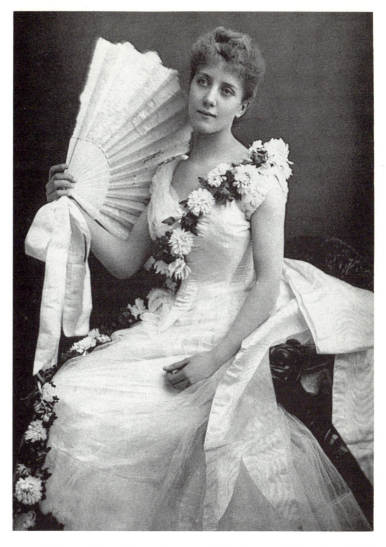

59] The flattering, theatrical style popular in the last decade of the century, modelled by actresses and society figures, became newly accessible to a wider public through the pages of newspapers and magazines.

curved lines, the rich colours and textures, elaborate detail and constricting shape of women's clothes, was becoming a powerful part of gender segregation'.[29] At the same time, however, any middle-class woman who ventured into a public space unaccompanied and dressed fashionably as above risked slander and ostracism as a virtual prostitute. Whilst the exterior trappings of fashionability, an adoption of more assertive models, louder colours and cheaper, more swiftly changing styles after 1860 provide ample evidence for modernisation, they should also be located within a perceptible relaxation, or at least more open discussion, of public and private morality. From the late 1850s a counter-trend to decorum began to gain ground in the popular press and other examples of cultural and social production, such as the rise of

music-hall and vaudeville, as acceptable rather than fringe entertainments. In the political domain, after two decades of repression and enforced ignorance, the problems associated with vice and morality acquired renewed recognition. From 1857 the press focused its attention on the problems of prostitution, and early moves towards a Divorce Act in the same year brought previously hidden and unsavoury topics into the realm of the middle-class household. A trend towards an acceptance of immorality as a pervasive social fact seemed to conservative commentators to be little short of promoting the lifestyle of the libertine as an acceptable role model: 'It is possible that at present this evil may, for the most part be confined to the higher classes or a section of them, but social manners soon spread. Tyburnia treads on the heels of Belgravia, and Bloomsbury presses close on Marylebone, and Islington and Hackney must follow the course of fashion.'[30]

Despite the protestations of *The Saturday Review*, after 1860 constraints on fashionability do appear to have relaxed, particularly in the cities (though as we have seen, standards in provincial and metropolitan contexts were often very different). A perceptible widening of the feminine sphere was constructed not only through the adoption of 'technological' fashions, but also through the emergence of practices which allowed and encouraged women to consume in a less schizophrenic manner. The rise of the department store and the expansion of women's fashion magazines, both designed to serve all classes, undoubtedly transformed and 'modernised' the culture and consumption of dress in the second half of the century.

At the risk of generalisation, the model for the large London department stores of the nineteenth century was French, although as we have seen in the previous chapter, the organisation and display policies of British shops had undergone significant developments during the eighteenth century. The Bon Marché and the Louvre were well established in Paris by 1870 and advertised in the English fashion press throughout the 1860s. They pioneered several customer services that marked the new store as innovatory, offering the widest range of new branded fashionable goods at low fixed prices rather than adopting the narrow practice of older, smaller establishments, and cultivating the select, pressured atmosphere of traditional shops. The emphasis on browsing that this encouraged fostered an attention to display and tempting luxury which in turn helped the department store ethic of brisk business and low profit margins. Dorothy Davis notes:

Of necessity they all arose in central positions where large numbers could reach them easily by the new means of public transport . . . Physically, they grew up in an era of big technical developments in building so that not only could they afford multistory palaces, but they could also have enormous plate glass windows for display, and gas lighting and novelties like lifts and cash tubes. But above all the department stores rose with the rise of the . . . white collar workers . . . whose women-folk had money to spare for a few luxuries and were gradually switching the emphasis of their housekeeping from food to other kinds of things.[31]

Hamish Fraser locates London stores in a resolutely middle-class sphere,[32] quoting Whiteley's and Barker's in the west London suburbs of Wesbourne Grove and Kensington as typical affluent examples. Dickins and Jones, Swan and Edgar, and Debenham and Freebody, located around Regent Street and Oxford Circus, catered for an upper-class carriage trade, whilst the Bon Marché in Brixton or Lewis's of Liverpool provided the spectacle of 'every Parisian and Continental novelty'[33] for the surburban and provincial lower-middle classes. Whatever the social resonance of the various establishments, their nature as repositories of a vast selection of fashionable commodities set them apart from the competition of dusty, enclosed and conservative family drapers and milliners, drawing parallel comparisons with the shift from the small reactionary women's journals of the 1850s and 1860s to the relatively extrovert character of new publications like *Myra's Journal of Dress and Fashion* in the 1870s and 1880s.

The visual world of the department store, like the world of the new magazines with their lavish plates and consumer-ist descriptions of shop goods or society events, was one that did not necessarily rely on the rationality of the market system or predominant social and cultural ideals, and recent authors dealing with the circumstances and implications of their rise, whilst rejecting the empirical narratives of earlier writers, have tended to emphasise their fantastic and other-worldly character, which tends to set off balance any attempt to define the material nature of consumer demand:

The question of who created consumer demand remains. In the alliance between dry goods bazaars and women customers, both sides could claim, with equal justice, that they controlled the system and were responding to it. It would be incorrect, however, to see the woman out shopping in the closing decades of the nineteenth century as a passive individual who had fallen victim to patently false or artificial events. Women had to walk a tightrope between real needs, defined by practical use, and

60] Despite lectures on health, ease of movement and taste, this fashion plate depicts energetic, independent consumers adopting the constricting and heavy princess line for travel.

61] Fashion magazines were quick to locate their models within the luxurious ambience of imaginary department stores.

stimulated wants created by a suggestive ambience, lavish display, and often manipulated prices . . . The categories were not clear cut, they overlapped and collapsed into each other, and in a setting that was dependent on high consumption and quick turnover, confusion about what was in fact a real need or a symbolic need was encouraged.[34]

The market-place and a feminine engagement with the goods and styles it had to offer had come to delineate the physical characteristics of civilised life. Michael Miller has claimed that 'the very definition of bourgeois . . . was no longer sharing a certain lifestyle, but rather buying certain goods in order to live that way of life . . . identity was to be found in the things one possessed. Consumption itself became a substitute for being bourgeois.'[35] At the centre of that shifting definition stood the department store and the fashion journal, their interiors, catalogues, advertisements, illustrations and editorials validating and reflecting the idea that femininity had become an agent of commerce. A typical description in the familiar magazine shopping report quoted below also substantiates Elaine Abelson's claim that fashion shopping formed a release from the pressures of the 'battle-ground and workshop' of the home; 'a good shop provided the context for diverse forms of public and even cultural life, yet it was sanctioned by the demands of the private sphere'.[36] In this context, the bustle, the corset, the acres of velvet, alpaca and moire silk suggest the empowering nature of fantasy encoded within consumption, rather than the decline in morals or metaphorical imprisonment that contemporary critics and more recent reductive historians have suggested:

Messrs Halling, Pearce, and Stone have now one of the finest mantle rooms in London, admirably lighted, and handsomely but appropriately fitted. On entering, one is immediately attracted by a considerable collection of choice Japanese and Chinese bronzes, porcelains, cabinets, and all the pretty trifles which, no matter how old they may be, are always new. Then come piles of Indian, Cashmere, Delhi and Chuddah shawls, mingled in admired disorder with embroidered fichus . . . From the centre of one side of the mantle room, a broad staircase leads to a fitting room, cosy, warm, and a perfect Palace of Truth, if Mirrors told the truth. The staircase branches off at this point, and leads by two short flights to the costume room . . . the opposite end of this part of the building is devoted to ball dresses, so light and fresh that they look as if none but fairy hands could have been employed in making them. A delicate salmon coloured dress of muslin and net, trimmed with a quantity of ecru Valenciennes lace was worthy of Queen Titania.[37]

62] The mannered pose, 'artistic' accessories and picturesque sleeve and yoke arrangement identify this sitter as an upper-middle-class adherent to rational and aesthetic doctrines. Nevertheless, many of the features associated with reform dress were influential outside of its original 'bohemian' social context.

The hidden consumer – men and fashion in the nineteenth century

Much of the recent literature dealing with Victorian fashion consumption has focused on the position of middle-class and aristocratic women as representatives of private wealth and public morality. Readings which use the late nineteenth-century economic theorist Thorstein Veblen's interpretation of feminine sartorial magnificence as a symbol of enforced leisure and masculine power are in danger, however, of relating only half the story. Male dress has undoubtedly been overlooked, subsumed by the assumption that a discourse of separate spheres, whilst constructing display and dress as innately feminine pursuits, enforced a model of masculinity

in which overt interest in clothing and appearance automatically implied a tendency towards unmanliness and effeminacy. Such interpretations have been used to explain the rise of those ultra-conservative, non-expressive male dress codes that prioritised the uniformity of the city suit as a model for the respectable middle classes for most of the nineteenth and twentieth centuries. What they cannot do is explain the ways in which men also consumed fashion. Whilst the Aesthete of the 1880s and the Dandy of the 1890s have received particular historical scrutiny within the area of Gay Studies, the more typical consumption patterns and aspirations of the middle- and lower-middle-class male have yet to receive adequate attention.

Evidence of masculine shopping habits and attitudes is perhaps difficult to come by; fashion magazines aimed at a general male readership were not published until the 1920s. Trade journals such as *The Tailor and Cutter* do provide evidence of a broad choice in terms of style, but can give little information regarding consumption patterns, and those periodicals directed towards men such as *The Field*, *Punch*, or *The English Workman* tend towards highly specific representations of sporting and hunting attire, generalised caricatures of formal and day wear, or a didactic, religious condemnation of any interest in clothing whatsoever. A lack of concrete material, and the overriding attention paid to feminine consumption and its representation within nineteenth-century cultural studies, has even led to claims that 'consumption became something that women undertook on behalf of men,[38] as if men abdicated all involvement in the world of material pleasure to wives, mothers and daughters. However, in contrast to such claims, carte-de-visite and portrait photographs throughout the century betray a self-conscious and highly individual interest in cut and style by male sitters, equal to the elaborate display of dress made by their female counterparts, and the advertising columns of newspapers and journals are filled with the accoutrements of male grooming, from shaving brushes to shoe polish. That public interest in fashion and its acquisition was not wholly the preserve of women is occasionally communicated, often subliminally, through the pages of novels, diaries and journalistic reports. George Sala in his description of fashionable London, *Twice Round the Clock*, of 1859, gave a graphic example of the way in which a concentration on the definition of femininity and commerce also implied a concurrent definition of masculinity:

In the magnificent linen-drapery establishments of Oxford and Regent Streets, the vast shop fronts, museums of fashion in plate glass cases, offer a series of animated tableaux of poses plastiques in the shape of young ladies in morning costume, and young gentlemen in whiskers and white neckcloths, faultlessly complete as to costume, with the exception that they are yet in their shirt sleeves, who are accomplishing the difficult and mysterious feat known as 'dressing' the shop window.

In terms of working-class culture between 1860 and 1930, the comics and artistes of the music-hall provided a loud-checked, bowler-hatted and bewhiskered icon of self-satisfied, belligerent masculinity for the 'masher' or young man around town. At the same time the neatly trimmed, tightly suited, and primly booted city clerical worker offered the alternative model of 'swell' to the rising lower-middle-class sons of Holloway and Peckham, satirised by the figure of Lupin in *The Diary of a Nobody*.

The received wisdom that middle-class Victorian male dress consisted of an undifferentiated, rather thick wool suit for day and informal wear, and a constricting arrangement of severe black and white for formal occasions, is not borne out by the variety of forms possible in the cutting and decoration of the staples of jacket, waistcoat and trousers from the 1830s onwards. Advances in the cutting of the suit had developed rapidly over the course of the eighteenth century, and the tight fit associated with male dress at the beginning of the nineteenth anticipated further advancements in the art of tailoring, which incorporated more sophisticated methods of achieving exact measurement and sizing. Sarah Levitt states that:

> English tailors were sought out: they alone could cut cloth and mould it to the body so that it fitted like a second skin. Science and art were brought together as studies of anatomy were used to develop complex measuring and cutting systems. A logical progression was the introduction of the tape measure in the early nineteenth century. Each tailor was naturally anxious to prove the supremacy of his own particular system, and many did so, either by publishing a book, or by perfecting a measuring or pattern cutting device, which could be marketed.[39]

In a trend similar to the embracement of technological advances by female dress, the adoption of scientific tailoring methods, coupled with a proliferation of cheap machine-woven cloth, sweated labour, and a system of modern retailing typified by the replacement of old slop-sellers (second-hand merchants) with new clothiers and outfitters,

63] Men's dress of the 1830s and '40s allowed for a fair degree of self-expression, especially in terms of pattern and cut.

64] The 1860s present the archetypal image of nineteenth-century masculinity: dark, dour and domineering.

by the 1860s men's clothing manufacturers were able to supply a growing market with increasingly sophisticated ready-made suits.

Bespoke tailoring remained the norm for middle- and upper-class consumers, and it was in this area of the clothing business that a range of differing styles could be consumed with an almost fetishistic attention to detail. The Dress Coat survived the transition from eighteenth-century court dress virtually unscathed. Typified by tails at the back, a horizontally cut front and stiff velvet collar, the only concession to changing styles was the gradual lowering of the waist seam as the century progressed. The Morning or Riding Coat differed from the Dress Coat in its adoption of sloping front edges and was permissible for formal wear during the final twenty years of the century. The Frock Coat probably exemplifies most closely those familiar generalisations concerning male dress as a symbol of respectability and patriarchy from the 1860s onwards. Appearing first in 1816 the coat was derived from the military greatcoat, buttoned from neck to knee and decorated across the chest with frogging. By 1850 it had been accepted as formal wear and achieved its loose, straight, undecorated appearance in the 1860s. At the close of the century, a renewed tightness associated the Frock Coat with the heightened elegance of city swells and dandies. The Paletot, introduced from the 1830s, allowed for a degree of informality. Cut loose and without a waist seam, it could be worn as a casual jacket and denoted a certain bohemianism in matters of taste. Refined by the 1850s into the Lounge Jacket, the Paletot was made to fit more closely through the addition of darts from the underarm and could be worn with matching waistcoat and trousers as an informal ancestor of the modern lounge suit. By the 1880s the Lounge Jacket had diversified to include the black dinner-jacket for semi-formal evening wear, and with the addition of front box pleats, back belt and knickerbockers, the Norfolk Jacket for hunting and rural pursuits. Trousers underwent similar transformations according to fashion change and the demands of occasion. Breeches were generally worn with evening dress until 1830, replaced by tight-fitting Pantaloons throughout the 1840s. Both were characterised by front flap openings, one inside leg seam and buttons or straps at the calf or ankle to achieve the requisite 'neo-classical' tightness. 'Pantaloons, like knee breeches', note Davidoff and Hall, 'showed off men's limbs and sexual parts, making them conscious of the way they stood.'[40] By 1825 trousers were in general use for day wear, cut

tight and in loud plaid textiles to the middle of the century. From 1840, all trousers were made with a central buttoned fly, and the looser tubular cut of the 1860s was developed into a slight flare during the 1870s. Wider variations surfaced periodically, including the balloon-like Cossack trousers of the Napoleonic wars and the peg-tops of the late 1850s.

The adoption of all of these styles by a variety of consumers besides the young, the rich and the cosmopolitan, together with equally rapid changes in styles of shirt, necktie, shoes and hair do not lend much weight to explanations which prioritise the self-denying aspects of nineteenth-century manliness. Nevertheless, recent research in the social and cultural formation of masculinity has stressed the pressure which models of ideal manhood placed on Victorian men, and which may have countered a less complicated relationship with the acquisition and display of fashionable dress. Graham Dawson has suggested ways in which ideal role models, communicated through the fictions of popular literature, painting and film can have a very concrete effect on the material choices and attitudes that men take up and vice versa, proposing a relationship between masculinity and its models that is much more self-fulfilling and much less 'imposed from without' than feminine equivalents:

> Masculine identities are lived out in the flesh, but fashioned in the imagination . . . an imagined identity is something that has been 'made up' in the positive sense of active creation but has real effects in the world of everyday relationships, which it invests with meaning and makes intelligible in specific ways. It organises a form that a masculine self can assume in the world (its bodily appearance and dress, its conduct and mode of relating) as well as its values and aspirations, its tastes and desires.[41]

The two ideological models that underpinned nineteenth-century attitudes to masculinity, if not to culture generally, where the historically-based concepts of Platonism and chivalry. Lord Acton, writing in 1859, claimed that 'two great principles divide the world and contend for mastery, antiquity and the Middle Ages. These are the two great civilizations that have preceded us, the two elements of which ours is composed . . . This is the great dualism that runs through our society.' Through recourse to the justifying power of historical precedent, concepts as diverse as the supremacy of 'pure' male friendships over heterosexual marriage, the spiritual beauty of the exercised male body, ideals of chivalric gentlemanly behaviour protecting female frailty, muscular Christian exhortations to celibacy and self-denial

and crusading concepts of military might and imperialist paternalism, could become embedded in official definitions of British 'manliness' through such institutions as the public school, the Church, the army, and the club. The power that such concepts held in maintaining the status quo both undermined and supported attitudes towards men and dress, pathologising an 'unseemly' personal interest in appearances as evidence of the invert or 'homosexual' (especially after the Wilde trials of 1895, the newspaper reports of which branded on the public consciousness the links between 'perversion' and sartorial excess) whilst celebrating a culture of shared power and an emphasis on the male physique, through the uniforms and 'kits' of organised sports such as cricket and football. Bruce Haley records the contradictory messages that such attitudes could throw up:

> An 1864 article in the popular sporting journal *Baily's* titled 'Mens Sana in Corpore Sano', argued that 'the sinews of a country like England cannot depend on its aristocracy. A good wholesomely cultivated mind and body, taught to endure, disciplined to obedience, self-restraint, and the sterner duties of chivalry, should be the distinguishing marks of our middle-class youth.' The article objected not only to such sartorial affectations as the turndown collar and the Zouave breeches pocket, but to any sort of adopted style or manner. A man's bearing should be a natural expression of his own mind and body, and a programme designed to train both of these would impart 'a cheerful, active, confident tone, an upright carriage, and a graceful ease, instead of that lounging, semi-swaggering, confoundedly lackadaisical manner which they have adopted in compliment . . . to the real swell, and the man of fashion.[42]

However, as in the reactionary accounts criticising a feminine embracement of modernity in fashion, the lectures of clerics and headmasters should not be read as a literal reflection of the actual consumption habits and aspirations of all nineteenth-century men. There is enough evidence, though much of it has not been properly digested, to suggest a thriving, though complicated, contemporary engagement with notions of masculine fashion. To that, at least, we owe the survival of traditional standards of elegance and cut that typify nostalgic advertising and touristic notions of 'English' masculine attire, alongside the darker, more repressive assocations suggested by phrases such as 'Victorian values', which have translated into the undifferentiated grey and black of mainstream male dress.

The nineteenth century perhaps sits uncomfortably between the innovative expansion in retailing and manufac-

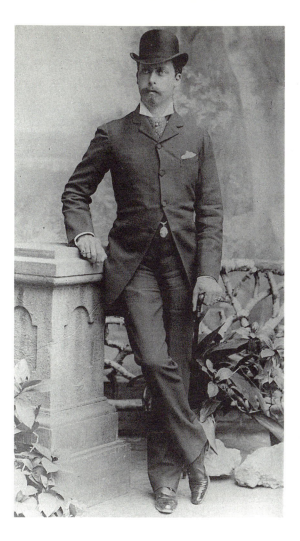

65] By the 1880s, theatrical and music-hall models, improvements in the tailoring trade, and an explosion of magazines aimed at the urban young man, allowed for more sophisticated patterns of clothing.

turing witnessed by the eighteenth century, and a perceived 'democratisation' and mass communication of fashion in the twentieth century. Recent historical research has almost succeeded in pulling the carpet from under the Victorian period's feet, claiming what were formerly recognised as its characteristic and formative, economic and cultural features for earlier and later periods. To deny the period its atmosphere of energy, of robust expansion and arrogant gains is obviously unfair and unrepresentative. But at the same time the century undoubtedly bore witness to a stultifying preoccupation with mythical past values and moral certainties. It is little wonder, then, that nineteenth-century fashion is identified most closely with a sense of contradiction, an uneasy bonding of old and new, though as this chapter has pointed out, and as Grant McCracken suggests, contradiction formed a powerful

motive force for new ideas of consumption and design that approximate well to a central debate around the definition of 'modernity':

> The transformation that had begun in the sixteenth century and expanded in the eighteenth century was, by the nineteenth century, a permanent social fact. Profound changes in consumption had created further changes in society and these in turn had created further changes in consumption. By the nineteenth century, consumption and society were inextricably linked in a continual process of change. There was, then, no 'consumer boom' in the nineteenth century because there was now a permanent and continual dynamic relationship between social and consumer changes which together drove a perpetual transformation of the West. . . . Consumption now bred constant social change. This social change bred constant reforms in consumption. The dialectical relationship between these two forces created an engine that helped drive the 'great transformation' into the nineteenth and twentieth centuries. This engine now consistently violated one of the fundamental laws of thermodynamics. It needed no source of energy external to itself. It had created its own dynamic, one that might break down but would never wear out.[43]

Notes

1 Calhoun, *Modern Women and what is said of them*, New York, 1868.

2 E. Lynton, *The Saturday Review*, 14 March 1868.

3 C. Willett Cunnington, *English Women's Clothing in the Nineteenth Century*, London, 1937, p. 51.

4 *The New Monthly Belle Assemblee*, July 1858.

5 *The World of Fashion*, October 1844.

6 *The New Monthly Belle Assemblee*, March 1856.

7 Willett Cunnington, *English Women's Clothing*, p. 131.

8 *The New Monthly Belle Assemblee*, September/October 1858.

9 E. Wilson and L. Taylor, *Through the Looking Glass*, London, 1989, p. 35.

10 *The English Woman's Domestic Magazine*, April 1862.

11 *The World of Fashion*, March 1866.

12 *The English Woman's Domestic Magazine*, July 1868.

13 Willet Cunnington, *English Women's Clothing*, p. 325.

14 S. M. Newton, *Health, Art and Reason: Dress Reformers of the Nineteenth Century*, London, 1974.

15 D. de Marly, *Worth, Father of Haute Couture*, London, 1980, p. 76.

16 A. Gernsheim, *Victorian and Edwardian Fashion: A Photographic Survey*, New York, 1981, p. 45.

17 *International Exhibition 1862. Reports by the Juries on the subjects in the 36 classes into which the exhibition was divided. Class XXXII.* London, 1862.

18 *The English Woman's Domestic Magazine*, July 1868.

19 H. Mayhew, *The Shops and Companies of London and The Trades and Manufactories of Great Britain*, London, 1865.

20 Mayhew, *The Shops and Companies of London*.

21 W. M. Gardner, *The British Coal Tar Industry, Its Origin, Development and Decline*, London, 1915. M. R. Fox, *Dye Makers of Great Britain 1856–1976: A History of Chemists, Companies, Products and Changes*, London, 1987.

22 Fox, *Dye Makers*, p. 95.

23 H. Clark, 'The Design and Designing of Lancashire Printed Calicoes during the first half of the Nineteenth Century', *Textile History*, 15, 1, 1984, pp. 101–18.

24 *International Exhibition 1862. Reports by the Juries on the subjects in the 36 classes into which the exhibition was divided. Class II*. London, 1862.

25 A. H. Taine, trans. W. F. Rae, *Notes on England 1860–1870*, London, 1872.

26 R. Schwartz Cowan, 'The Consumption Junction: A Proposal for Research Strategies in the Sociology of Technology' in W. Bijker, T. Hughes and T. Pinch, eds, *The Social Construction of Technological Systems*, Cambridge, Mass., 1987, p. 261.

27 L. Davidoff and C. Hall, *Family Fortunes: Men and Women of the English Middle Class 1780–1850*, London, 1987, p. 187.

28 D. Gorham, *The Victorian Girl and the Feminine Ideal*, London, 1982.

29 Davidoff and Hall, *Family Fortunes*, p. 414.

30 *The Saturday Review*, August 1865.

31 D. Davis, *A History of Shopping*, London, 1966, p. 290.

32 W. Hamish Fraser, *The Coming of the Mass Market 1850–1914*, London, 1981, pp. 128–33.

33 A. Adburgham, *Shops and Shopping 1800–1914*, London, 1964, p. 167.

34 E. S. Abelson, *When Ladies go a Thieving: Middle Class Shoplifters in the Victorian Department Store*, Oxford, 1989, p. 35.

35 M. Miller, *The Bon Marché: Bourgeois Culture and the Department Store 1869–1920*, London, 1981, p. 185.

36 Abelson, *When Ladies go a Thieving*, p. 21.

37 *Myra's Journal of Dress and Fashion*, April 1877.

38 T. Richards, *The Commodity Culture of Victorian England: Advertising and Spectacle 1851–1914*, London, 1991, p. 206.

39 S. Levitt, *Victorians Unbuttoned: Registered Designs for Clothing, their Makers and Wearers, 1839–1900*, London, 1986, p. 91.

40 Davidoff and Hall, *Family Fortunes*, p. 412.

41 G. Dawson, 'The Blond Bedouin' in J. Tosh and M. Roper, eds, *Manful Assertions*, London, 1991, p. 118.

42 B. Haley, *The Healthy Body and Victorian Culture*, London, 1978, p. 206.

43 G. McCracken, *Culture and Consumption: New Approaches to the Symbolic Character of Consumer Goods and Activities*, Indianapolis, 1990, pp. 22–7.

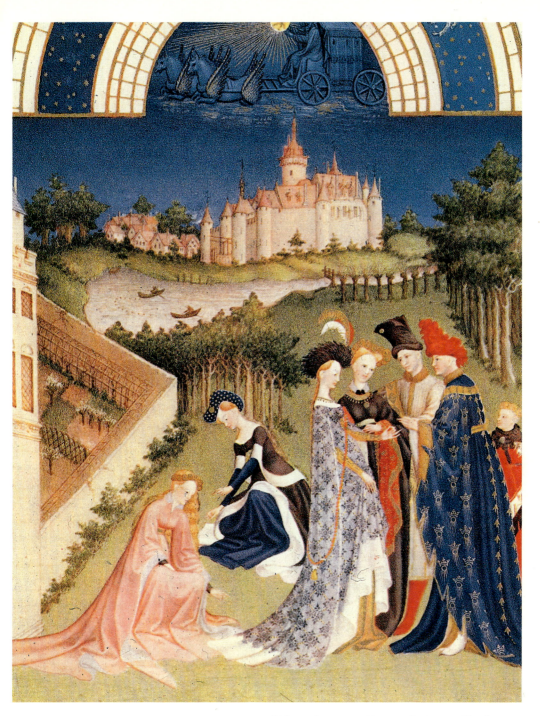

Perhaps the most sophisticated evocation of fifteenth-century Burgundian court life, the illuminations depict in great detail highly decorated houppelandes for men and women with complicated turban constructions as headwear. Here the richness of the clothing is intended to correspond directly with temporal power and innate gentility.

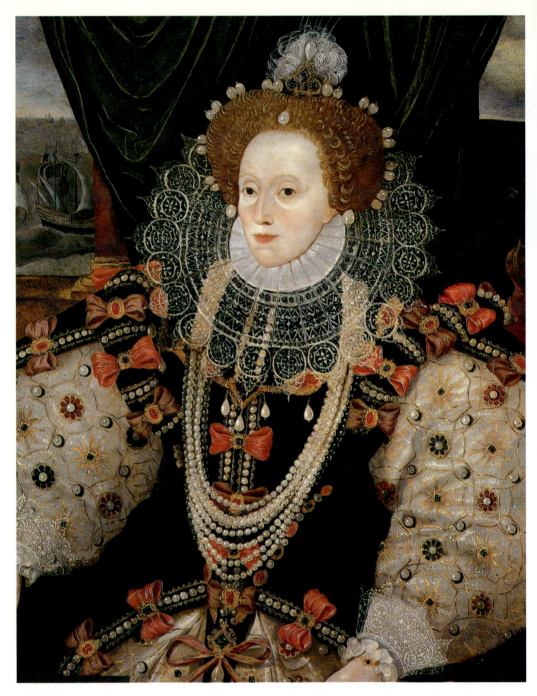

In an image painted to commemorate the routing of the Spanish Armada, Elizabeth I is depicted as a symbol of imperial might. Though dressed in the contemporary French style with its stuffed and rounded forms, each element is loaded with meaning from the inherited jewels that make visible the rights of succession to the pendant pearl at Elizabeth's crotch calling attention to the famed virginity of Glorianna.

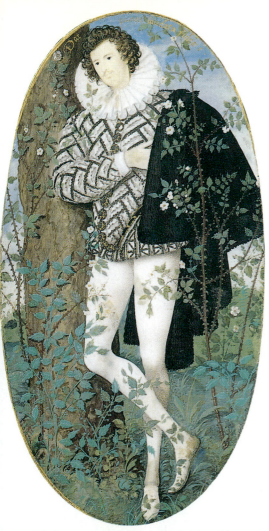

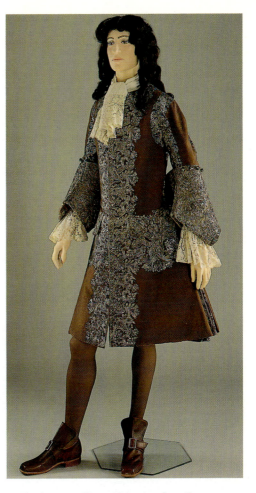

This image encapsulates the fashionable affectation of melancholy, predominant amongst young men at the court of the ageing Elizabeth I. The black and white palette of the sitter's costume announces an allegiance to the Queen, whilst the individual garments follow the effeminate Italianate line popular in the late 1580s and '90s.

The huge cuffs reaching to the elbow are typical of the 1720s and show the jacket at a transitional stage, between the heaviness of the late seventeenth century and the more fitted, tailored appearance of the eighteenth. The sombre appearance of the coat is more than set off by the brilliance of the embroidered vest. The full dark wig appears rather old-fashioned for the date of the clothing.

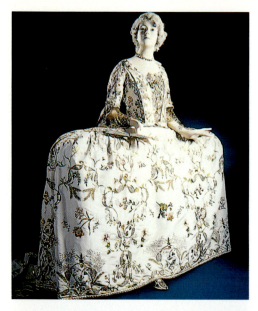

left] The formal embroidered mantua, with skirts held out over panniers, was at its most extravagant in terms of width during the 1740s. In deference to unchanging court etiquette such skirts remained an essential component of official state dress into the 1780s. The flat expanse at the front offered ample opportunity for the display of the embroiderer's art and the garments necessarily commanded a high price. In terms of expense and ostentation court dress became an apt symbol of feminine fecklessness and aristocratic excess for caricaturists and social commentators.

below] A downmarket Vauxhall, this London pleasure garden attracted the aspiring middling sort who are depicted here in a

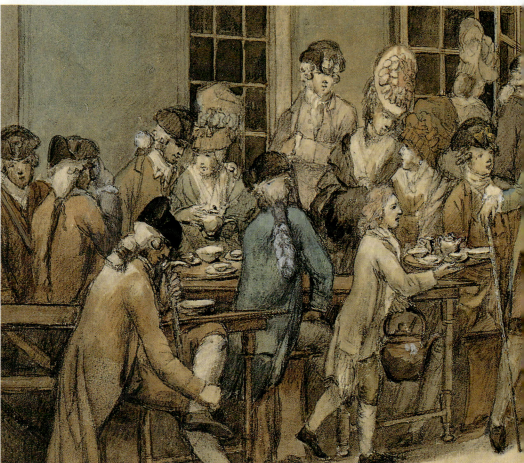

variety of 'loud' fashions. The tall hairstyles
and polonnaise dresses of the women are
typical of the 1770s, whilst many of their
escorts adopt the gestures and garments of
the 'fop'. Renowned as a meeting place for
prostitutes and rascals it is difficult to
differentiate the respectable from the
demi-monde.

right] Prior to the so-called 'Great Masculine
Renunciation' of the 1850s, the dress
adopted by men about town in cities such as
London, Paris, Berlin and New York owed
much to the flattering tailoring, tasteful
colour combinations and general sense of
romanticism introduced as the epitome of
English style by Brummel in the early
decades of the century.

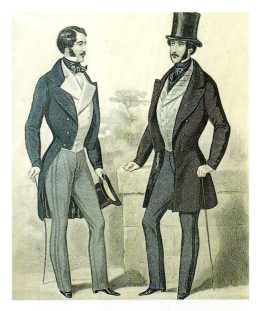

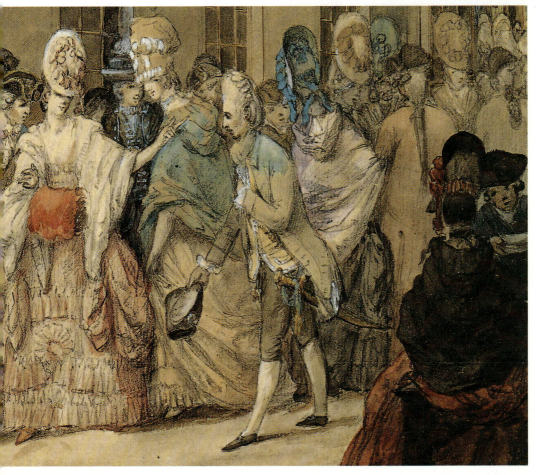

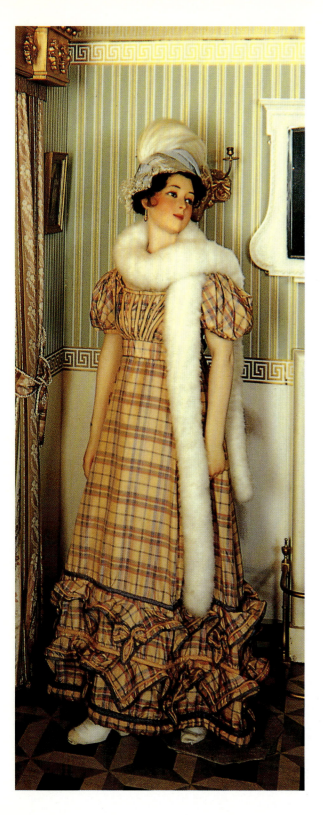

The angular and over-ornamented line of the 1820s has superseded the more consciously historical neo-classical drapes of the previous decade. Surface patterning, pleats and frills add interest to a fairly basic cut, and although this is a fairly expensive example, bright plaid stripes and checks were becoming increasingly popular with poorer consumers of cotton goods.

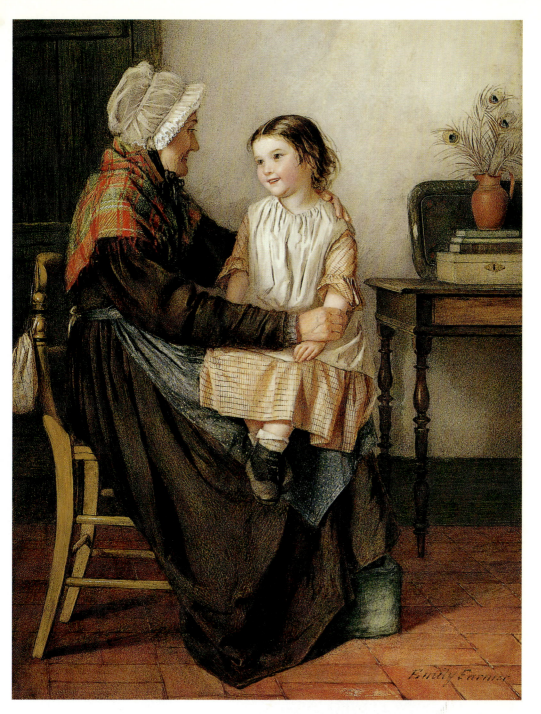

A growing interest in 'forgotten' crafts and nostalgic representations of an idyllic rural past and present gained much credibility from mid-century onwards. The impact of such approaches can be felt in the products of both the Arts and Crafts movement and the Dress Reform movement. In this more middle-brow genre painting there is an interest in recording both traditional patterns of dress and the essence of a 'pure' and 'decorative' feminity.

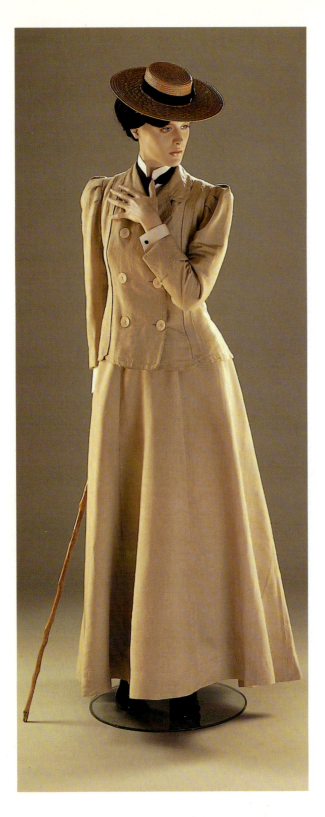

The technique of men's tailoring had been applied to elements of female dress from the 1860s onwards. By the turn of the century this 'masculine' style of dressing carried several connotations from a growing physical freedom encouraged by sports such as cycling and tennis and promoted by rational dress organisations, through the intellectual independence espoused by Fabianism and the women's suffrage movement, to the satirical and sexually provocative caricatures of *Punch* and Charles Gibson.

6 Early twentieth century: clothing the masses

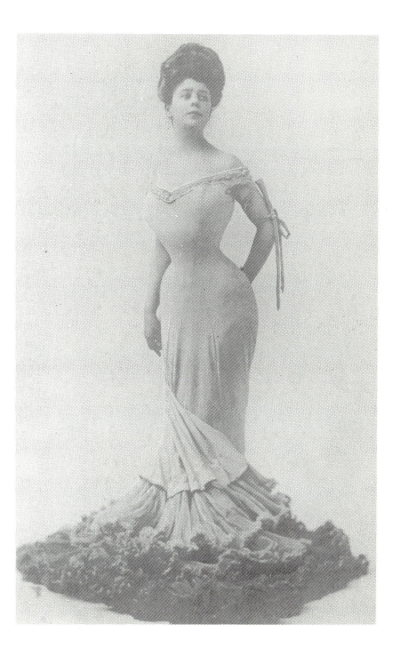

66] The actress Camille Clifford displays the definitive 'S'-shaped curve in a 'frou-frou' dress that fully exposes the fuller, more matronly Edwardian figure.

That which withers in the age of mechanical reproduction is the aura of the work of art . . . One might generalise by saying the technique of reproduction detaches the reproduced object from the domain of tradition. By making many reproductions it substitutes a plurality of copies for a unique existence. And in permitting the reproduction to meet the beholder in his own particular situation, it reactivates the object reproduced. These two processes lead to a tremendous shattering of tradition which is the obverse of the contemporary crisis and renewal of mankind. Both processes are intimately connected with the contemporary mass movements.[1]

The twentieth century has repeatedly been characterised by cultural, social, design and art historians as the age of 'mass'. 'Mass-production', 'mass-consumption' and 'mass-media' have all been quoted as the defining characteristics of Western society since 1900, and from the perspective of fashion history claims have been made that the specific

67] The transition between pre-war notions of 'shimmering' femininity and post-war informality is evident in this war-time theatrical publicity shot.

nature of a mass society has been unavoidably, if problematically, imprinted upon its clothing and its attitudes to dress and identity.[2] Advances in the technology and materials used for clothing production have undoubtedly provided more comfortable, cheaper and attractive items to a larger proportion of the population, whilst the mediums through which fashion change has been communicated have allowed for an equally wide dissemination of fashion information, and broader opportunities for the stimulation of a more homogeneous public imagination. The fashion magazine and the Hollywood film in particular brought fashionable models to a hugely expanded audience from the 1920s onwards, material examples of their 'dream peddling' often made available through the expansion of chain stores and mail order companies. At the same time, paradoxically, a reorganisation of business practices, of marketing and advertising, prioritised particular strands of society as fashion leaders. A cult of 'the designer' revolving around ideals of couture and 'high fashion' or strong subcultural identities ensured the survival of older hierarchies based on notions of quality, style and individuality, as Jennifer Craik comments:

> The new approach to fashion was schizophrenic. On the one hand, fashion was democratised as more people had access to the images and clothing preferred by the trend setters. On the other hand, fashion producers were setting the styles. Other changes were also occurring in the fashion industry. The aristocracy was supplanted as the elite fashion community and role models. Socialites, artists and movie stars offered alternative sources of inspiration. These role models offered desirable images and behaviour that were no longer based on emulating one's superiors. Individualism and modernity prevailed.[3]

However, on the basis of evidence presented in previous chapters, the historian might question how 'new' any of this really was. Technological and marketing revolutions can be claimed and contested for every century from the thirteenth on, and at best, fashion cycles based on notions of emulation can be seen to have held relatively little power in the face of systems of dressing that were highly differentiated in terms of class, age, gender, sexuality and location, anyway. So can we simply replace them with a new construction of 'the fashion leader' based on concepts of publicity and mass communication that replay those discourses of progress which had already underpinned eighteenth- and nineteenth-century notions of fashionability? A more profitable line of investigation, rather than accepting Walter Benjamin's critique of

'mass culture' cited at the beginning of this chapter, might aim to question the conspiracies of control and soulless standardisation implied by reductive explanations of 'mass'. Twentieth-century fashion, rather than producing a sense of undifferentiated sameness, has actually supported fashion changes as frenetic and diverse, as open to the possibilities of individuality, as any other period. The advent of postmodern theory in the 1970s and 1980s, alongside the establishment of cultural studies approaches which legitimised the study of 'popular culture' from the 1960s onwards, has opened up avenues for the exploration of 'difference' within the context of an increasingly automated, filmed, recorded and reported world. Taking into account those recent accounts of the ways in which identities and realities are formed, this chapter will investigate the problematic relationship between mass culture and fashion culture in the twentieth century, looking specifically at the role of magazines and publicity in constructing and reflecting particular roles at distinct historical moments. Initially though, it may be helpful to map the stylistic and material changes in clothing and style that formed a nexus for those wider systems of communication and fashion propaganda over the course of the period.

A century of decadism – fashion style from the twenties to the sixties

The growing sophistication and increasing self-referentiality of fashion publicity in the twentieth century has resulted in the otherwise arbitrary categorisation of fashion change according to the decade in which clothing was produced and worn. Newspapers, magazines and the film industry, all media highly conscious and exploitative of the economic connotations of the passing of time, have tended to construct ideas of *Zeitgeist* as an explanation and means of promotion for current trends. Concurrently with the establishment of more highly-regulated seasonal presentations of couture and ready-to-wear collections by fashion producers, promoters and consumers have been able to anchor fashion products within a concrete notion of the 'now', whilst also drawing on the time-specific qualities of past styles. This regimentation of time has also been useful to fashion historians, providing a useful chronological structure which goes beyond descriptions of decade-specific style, to incorporate wider cultural and social trends associated with specific periods like the 'thirties' or the 'sixties', to elucidate the characteristic sensi-

bility of the time. Indeed, this book has itself used the broader chronological measurements of 'centuries' as a way of structuring information, and often makes reference to the stylistic features of specific decades. This is not a methodological crime as such; chronology has to be dealt with in one way or another. However, the astute historian draws a distinction between 'decadism' as a reflection of market and media demands, and its use as an artificial organisational device, unconnected to historical events. As we have seen, traditions, trends and influences do not necessarily start and end conveniently at years one and ninety-nine. Fashion promotion, however, through its strong adherence to notions of past and present, has often fitted itself comfortably into the constricts of month, season, year and decade; its very transience draws it into the role of cultural clock. In the 'democratised' and 'speeded up' twentieth century this has perhaps constituted its central defining feature, a direct consequence of its place in changing consumption and marketing patterns. To incorporate the idea of the decade, then, in organising a survey of dress from 1920 to 1990, is not quite so historically perverse as its inclusion in earlier chapters, and its use in a more knowing form might actually help to challenge entrenched assumptions.

A discussion of fashion style in the 'twenties' presents an immediate chronological problem. The flat, geometrical 'boyish' forms, so often associated with feminine dress of the decade made no real impact until at least 1926, and then the cropped hair and knee-length skirts were confined to an elite and metropolitan market, or the abstracted illustrations of superior magazines and advertisements. As Valerie Steele has shown, pre-war constructions of a voluptuous femininity had a more lasting impact on the resolution and modelling of post-war women's figures than the supposed sartorial emancipation offered by increased female employment in the armaments factories and service industries associated with World War One or the militant feminism promoted by the suffrage movement.[4] Prior to the war, fashionable style between 1900 and 1914 tended towards a statuesque, heavy-chested grandeur, hips thrown back and accentuated with flared gored skirts, or the alternative pencil-slim 'hobble' skirt associated with the designer Paul Poiret's 'Directoire' line of 1908. The sense of heightened and mature sexuality projected by society women and popular actresses in newspaper photographs and advertising material contrasted with the tailored severity of late Victorian style and suggested the

freshness and freedom espoused by the iconic 'Gibson Girl', a creation of caricature who encapsulated the new economic power wielded by the rich American couture buyer. As Jennifer Craik notes:

> Although the Gibson Girl was encumbered by her tight-waisted bodice and huge billowing skirt which trailed on the ground, she became popular because she embodied new definitions of gender and lifestyle. Her distinctive S-shaped body dominated the iconography of women into the 1900s . . . Her success was due to the conjunction of her image (a relatively unrestricted mode of dressing, active lifestyle and outspoken confidence), with major cultural, political and economic changes in Western societies.[5]

Whilst robust Edwardian models of femininity preceded the effects of war, they also retained and promoted 'traditional' ideals in terms of decoration and a soft, evocative glamour that continued to provide a blueprint for acceptable fashionability well into the 1920s, apparently unaffected by the more pragmatic dictates of the 'home front'. Lucille (Lady Duff Gordon) the couturier summed up the enduring quality that was labelled 'frou-frou' by more dismissive critics: 'For me there was a positive intoxication in taking yards of shimmering silks, laces airy as gossamer and lengths of ribbons, delicate and rainbow-coloured, and fashioning of them garments, so lovely that they might have been worn by some princess in a fairy tale.'[6] Photographs and advertisements for the middle-class market of the immediate post-war years show a similar preoccupation with pale colours, light layered cottons, and lace or broderie anglaise borders, the hair dressed in low chignons, and wide ankle-length skirts partnering loose open-necked blouses. In terms of practicality and comfort, the look was perhaps preferential to the chest-denying tight rubber corseting and sweaty man-made fibres of the later twenties.

By 1927 shingled hair, lips and eyes accentuated by cosmetics, abstract print dresses in new artificial silks such as Rayon which 'was light, warm and cheap, and took bright colours well',[7] exposed calves, and ankle-strapped high heels had become a visual shorthand for 'modern' femininity. The look, inspired by influences as diverse as the 1925 Exposition des Arts Decoratifs in Paris with its generic blend of exotic orientalism, dangerous fine-art derived iconoclasm and pared-down modernist severity, Hollywood vampishness encapsulated by the heightened silent gestures and face paint of Gloria Swanson, Theda Barra and the young Joan

Crawford, and a retrospectively sinister, eugenically informed emphasis on the lithe, tanned and sporting body, found a literal translation through the work of designers such as Coco Chanel. For the average British consumer, however, the impact of modernity on anything more than surface appearances was more limited, and Wilson and Taylor suggest a more circumspect reading of its importance in terms of female emancipation:

> the standard interpretation of the fashions and customs of the 1920s is precisely this: to translate short skirts, cosmetics and cigarette smoking directly into 'freedom' for women. As in the 1960s, the situation was actually more complex and more contradictory. The popular meaning of 'emancipation' for women had shifted away from the ideas of social and political rights that had been so important before 1914. Social emancipation – the freedom to drink, to smoke, even to make love, to dispense for ever with chaperones – served as a substitute for possibly more solid economic freedoms, and was in any case an option only for those few women who *were* socially and economically independent.[8]

In material terms its allure was beyond the reach of many; few even in the 1930s could afford the new clothes in the shops. Mothers, sisters and friends hastily put together copies of their clothes with material bought for a few pence a yard from the market or cheap department stores.[9] Certainly by the thirties, economic depression and political uncertainty diminished the sense of optimism and childishness associated with women's dress in the mid-twenties. Hackneyed comparisons between skirt lengths and negative cultural conditions haunt twentieth-century fashion journalism, and as we have seen, influences and conditions of clothing consumption and production are too diverse to suggest such singular explanations. Nevertheless the fashionable outline at the turn of the decade incorporated new slim skirts and long coats reaching to mid-calf, with backless evening wear trailing on the floor. The desired effect was sinuous, sensual, almost drooping, with softly tinted textiles clinging to the body, aided by the bias-cut perfected in the couture work of Madeleine Vionnet. By the end of the decade, Parisian models had become overshadowed by the marketing and publicity prowess of Hollywood. New film constructions of fashionable femininity prioritised a sense of power and purpose, achieved through a more structured approach to tailoring, padding and accessories. These were displayed in the Adrian and Edith Head costumes designed for the tougher career roles played

by Joan Crawford, Bette Davis and Barbara Stanwyck after 1935. American audiences were able to purchase approximations to the new cinematic look through the outlets of Bernard Waldman's 'Modern Merchandising Bureau' and Cinema Fashions Stores (which numbered 400 by 1937). British customers and retailers, who may have empathised more closely with the dowdier, homespun glamour of Gracie Fields, were also not immune from the influences of the picture house. An early article (4 February 1926) in *Printer's Ink* claimed that:

> Word comes from several countries that swimming pools are being constructed by the wealthier classes, and that foreign makers of bathing suits have been compelled to adapt their design to the California model . . . Not long ago, several large British manufacturers complained that they had been compelled to change the established styles of the shoes they made

68] Comfort and a business-like lack of ostentatious display seem to be the main concerns of the women in this family group.

for their customers in the Far East, and they traced the change directly to the movies from America.

The annexation and growing irrelevance of Parisian Couture, faced with the competition of Los Angeles, was exacerbated in June 1940 when 'the Occupation of Paris . . . brought the whole international fashion system to its knees'.[10] From the outbreak of war in September 1939, British style was initially unaffected, but growing shortages in terms of textiles and labour, together with deteriorating living conditions after the Blitz which began in 1940, relegated issues of appearance to a low priority. The isolation of Paris saw French fashion serving the needs of rich Vichy collaborators and German officers' wives with extravagantly padded and pleated designs. This contrasted with expediences caused by rationing in Britain, as *Picture Post* recorded in 1942:

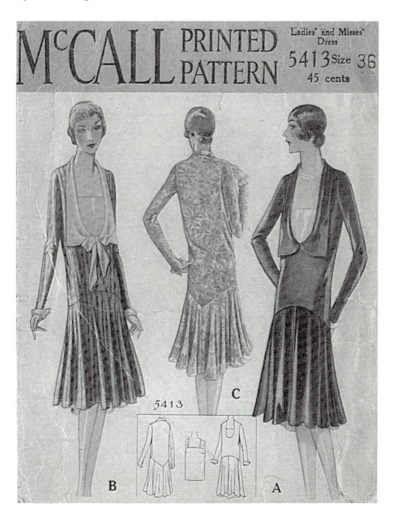

69] The slim-line 'garçon' look became available to a wide market through the promotion of dress patterns in magazines and local dress-making shops.

Among the women who are still dressing up for the evening, we have seen marked signs of clothes rationing. We saw a gay young thing wearing what amounted to a silver lamé tennis dress, because her coupons had not allowed her enough material for sleeves, and a *soignée* woman in an evening dress made out of pink striped mattress ticking.[11]

The growing familiarity of military and civilian uniforms, together with the practical adoption of work wear and trousers, certainly bore some relation to the boxy, tailored appearance of the best suits that many women chose to wear on formal occasions. However, the making of simplistic connections between wartime stringencies and the 'uniformity' or 'militarisation' of female dress ignores the apparent diversity of sartorial approaches according to class, age and location. Readings of female appearance during the forties should incorporate the possibilities offered by invention and imagination. Vaseline, cocoa powder and charcoal could provide gloss, colour and definition to face and legs, and the hat, unregulated by government restrictions, offered the opportunity for highly individual displays. From 1942 strict controls were applied to the production and consumption of clothing that regulated buying through the use of rationing and coupons, followed by the promotion of an official Utility line described by Peter McNeil:

> In May 1942, prominent British designers were invited to contribute models for a Utility Range which conformed to the austerity regulations. Members of the Incorporated Society of London Fashion Designers . . . completed a collection by September. *Vogue* reported positively that the collection included 'some of the most entirely wearable clothes we have ever seen'. The women's garments included a top-coat, suit, afternoon dress, and overall-dress. Most of the designs featured the boxy square shoulder line associated with this period. The amount of fabric allowed for a garment was strictly controlled, resulting in shorter skirts, and a reduction of pleats . . . the Utility garments of wartime Britain were actually worn by the populace, accounting for approximately four-fifths of total production.[12]

The effect of the end of hostilities in 1945 has generally been read in positive terms by fashion historians. Jennifer Craik notes that the experience of war 'revolutionised women's priorities, boosted the mass market and marketing techniques, internationalised cultural influences, and developed realist techniques of reportage'.[13] Within this context, and following the material shortages and restrictions of the Utility scheme, the launch of Christian Dior's 'New Look' in

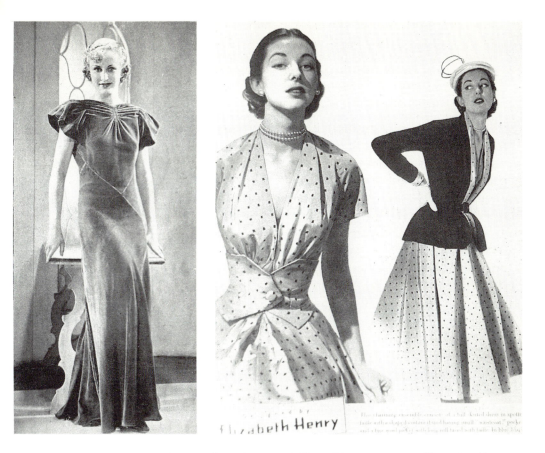

Elizabeth Henry

70] The sinuous drooping line of the mid thirties echoed a new romantic construction of popular femininity which replaced the equally constructed 'flapper' of the previous decade.

71] Long full skirts, nipped-in waists and a severely formal demeanour make up the 'New Look' supposedly 'invented' by Dior in 1947.

1947, with its huge swirling skirts, supported by crinolines or layers of petticoats, nipped-in waist, boned torso and cantilevered bust, sweeping necklines for evening wear and tightly-sleeved jackets for day, has been read both as a natural progression of extravagant French couture trends, uninterrupted by the Occupation, and an 'unbelievable contrast with wartime and post-war austerity'. According to Wilson and Taylor, 'Austerity was the keyword of the later forties; the New Look kicked austerity in the teeth.'[14] Certainly the perception and display of the female body underwent a radical transformation that was anything but uncontroversial. The New Look shape was adopted and disseminated in varying forms at all levels of consumption; yet it was objected to by contemporaries and later critics for its waste of materials and labour, its overt and lascivious sensuality and its entrapment of women as objects of desire and decoration. Angela Partington summarises its contradictory aspects, highlighting the ways in which its components could be utilised by a wide variety of British designers and consumers in different ways, according to class and political sympathies:

There were many professional designers who were outraged by the 'New Look', and who condemned it either as an antithesis to modernism and therefore retrogressive, or as a shameful indulgence in the face of economic restrictions. To an extent, then, its popularity amongst middle-class women, or amongst women generally, can be read as a 'rebellious' or 'subversive' use of fashion, not dissimilar to that usually ascribed to youth sub-cultures. But there were those factions of the design profession who regarded it as a distinct but complementary aspect of modern femininity, which could exist alongside, and enhance, the dutiful housewife look. If women used fashion to resist the dominant ideologies of femininity then, it was through the 'improper' consumption, or appropriation, of the New Look.[15]

This dual reading problematises the received view of women's fashion during the fifties. The promotion of rigid female role models restricted to 'housewife', 'sweetheart', 'siren' by McCarthy-era Hollywood and a new wave of domes-tically-orientated women's magazines is seen to have lent meaning to a variety of popular fashionable lines, from the girlishly innocent dirndl floral print dress, to the rigorously tailored pencil-slim suit that succeeded the voluminous 'New Look' by the late 1950s. Partington suggests an interpretation that takes into account the autonomy of the consumer in cre-ating meaning, rather than the producer, advertiser or retailer, an approach that becomes increasingly relevant with the fragmentation of the market in the succeeding decades:

Popular fashion mixed the glamorous and the practical, fused function and meaning (objectification and identification), by incorporating elements from styles which designers assumed

72] The flamboyant daisy garters and the vampish headscarf connote a new emphasis on leisure and entertainment, more widely available to the lower-middle and working classes, but scorned as 'vulgar' by the intelligentsia.

73] Through a process of ever-quickening dissemination, glamorous couture lines eventually found their way into the family events and special occasions of the suburban classes, where they accrued new meanings and significance.

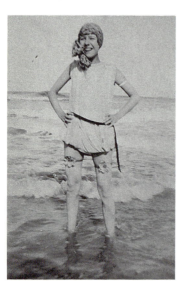

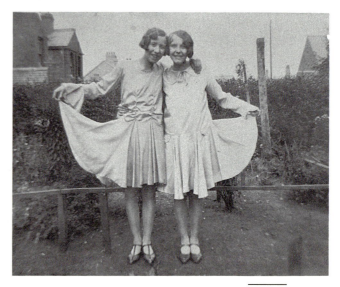

would take their meaning from the clear distinctions between them. This can be read as a challenge to the dichotomy separating 'housewife' (functional woman) and sex object (decorative woman). But it can also be seen as a complete redefinition of the values of the clothes, an insistence on the prerogative to use clothes in meaning-making practices which are dependent on class-specific skills.[16]

By the final years of the decade, overlapping into the early years of the 1960s, those practices had broadened to incorporate skills based on age. The rise of a youth market in postwar Britain has been well documented, although the assumption that youth and fashion were never interlinked before 1945 is a dangerous one. Dick Hebdige, in his influential work on the formation of youth subcultures, has located their rise within the political and economic context of the time, suggesting that age rather than class alone became the primary focus for group identity and consumption patterns:

> despite the confident assurances of both Labour and Conservative politicians that Britain was now entering a new age of unlimited affluence and equal opportunity, that we had 'never had it so good', class refused to disappear. The ways in which class was *lived*, however – the forms in which the experience of class found expression in culture – did change dramatically. The advent of the mass media, changes in the constitution of the family, in the organisation of school and work, shifts in the relative status of work and leisure, all served to fragment and polarise the working-class community. . . . The development of youth culture should be seen as just part of this process of polarisation. Specifically, we can cite the relative increase in the spending power of working-class youth, the creation of a market designed to absorb the resulting surplus, and changes in the education system . . . as factors contributing to the emergence after the War of a generational consciousness amongst the young. This consciousness was still rooted in a generalised experience of class, but it was expressed in ways which were different from, and in some cases openly antithetical to, the traditional forms.[17]

Research into the rise and commodification of youth subcultures has tended to prioritise working-class male movements; the full history of young women's involvement in the consumption of youth identities has yet to be written. Yet evidence for the influence of new marketing strategies, popular music and continental 'lifestyle' design on women's dress from the late 1950s onwards is plentiful. Italian, French and American influences from areas as diverse as modern and traditional jazz, existential philosophy, campus literature,

contemporary dance, folk music and the gamine features of
Audrey Hepburn and Leslie Caron enhanced and encouraged
the adoption of a variety of casual clothing models by young,
predominantly middle-class women. The black polo neck,
duffle-coat, sweater, jeans and pumps, with their unspecific
gender signals and easy continental glamour marked a
deliberate break with the perceived dreariness and formality
of adult dressing.

An increasing emphasis on the youth market has fre-
quently been quoted as the driving force behind design
during the sixties. In Paris the rise of a new younger genera-
tion of designers in the middle years of the decade, including
Courrèges, Cardin, Ungarro and Yves St Laurent, coupled
with diversification away from Haute Couture towards the
establishment of ready-to-wear collections and designer bou-
tique outlets, produced revolutionary clothing, using
technologically advanced fabrics and strident geometrical
designs that simultaneously suggested the retro-chic of the
twenties and the futuristic connotations of space-age discov-
ery. The cult of the designer and a new attention to fashion
personalities was encouraged by the increased space given to
lifestyle reporting and 'pop' culture in the new newspaper
colour supplements and style magazines, and music-based
television programmes aimed at a younger audience. Much of
the publicity focused on the status of London as a creative
centre; Carnaby Street and the King's Road in particular drew
attention for their innovative shops and contemporary zest,
and London style was associated with specific British design-
ers including Mary Quant, Barbara Hulanicki and Tommy
Roberts, who perhaps provided a more accessible and afford-
able but equally distinctive look for the informed young con-
sumer than their French high-fashion counterparts.

It is undoubtedly difficult to analyse fashionable and
popular dress from the mid-sixties onwards without falling
into the trap of prioritising metropolitan style and replicating
the hype of contemporary journalism and publicity. What is
particularly striking about the late twentieth-century fashion
system is its endless recycling and interpretation of former
styles and movements. Defining strategies of self-referential-
ity and irony have led to collections that feed off all aspects
of fashion production: street style, subcultural movements,
green politics, third-world culture, fine art and craft and
haute couture, so that political and cultural meaning is ulti-
mately lost. The explosion of the fashion system into a frag-
mented and highly diversified market at this point makes the

task of constructing a linear history of style change impossible and perhaps irrelevant. It is certainly an area of study which should form a focus for further research, beyond the parameters of this book. Elizabeth Wilson draws a connection between a massively broadened fashion arena and the rise of particular critical approaches, which provides a suitable moment of conclusion for any study that aims towards a usefully descriptive 'history'' and finally leads this chapter into a closer examination of the ways in which the media have increasingly shaped a twentieth-century model of 'fragmented' fashionability:

> Postmodernism appears in a much more immediate and restricted way to explain some of the features of fashionable styles that dominated the 1970s and 1980s. Frederic Jameson identified pastiche and eclecticism as essentials of postmodern style in a wide range of artefacts and aesthetic productions, and these were certainly features of haute couture and its high-street imitations from the late sixties onwards . . . It would be possible to argue that this pluralism was and is a faint echo of the postmodern 'end of grand narrative' – the idea, advanced by postmodernist philosophers, historians and sociologists, that we can no longer subscribe to the . . . Enlightenment belief in continuous progress . . . For one thing, our culture of global mass media feeds us so much information that a massive cultural eclecticism in the only possible response.[18]

Evidence for modern fashion – the use and misuse of women's magazines

> Alongside other social institutions such as the family, the school, the Church, and other media, women's magazines contribute to the wider cultural processes which define the position of women in a given society at a given point in time. In this exchange with the wider social structure, with processes of social change and social continuity, these journals help to shape both a woman's view of herself and society's view of her . . . but these periodicals are about more than women and womanly things, they are about femininity itself, as a state, a condition, a craft and as an art form which comprise a set of practices and beliefs . . . everyone born female is a candidate for their services and sacraments . . . here is a very potent formula indeed for steering female attitudes, behaviour and buying along a particular female world-view of the desirable, the possible and the purchasable.[19]

Marjorie Ferguson in her work on women's magazines in the late twentieth century identifies their role as central props in the construction and commodification of contemporary

femininity, aptly highlighting their profitable use by manufacturers and advertisers of women's dress, beauty products and accessories. Fashion historians have also viewed women's magazines as a useful source of evidence, a barometer of social, stylistic and economic change. It is arguable that in a century defined by an explosion in communications media that the magazine image, rather than first-hand observation of the clothing itself, has dictated both consumer choice and fashion direction. However, whilst it is true that editorial copy, fashion reports and correspondence columns have been used as central primary sources in mainstream fashion histories since the 1930s, they are often placed without question in juxtaposition with photographs or drawings of original costume, as if one automatically illuminates the other. Similarly there has been a tendency to reproduce

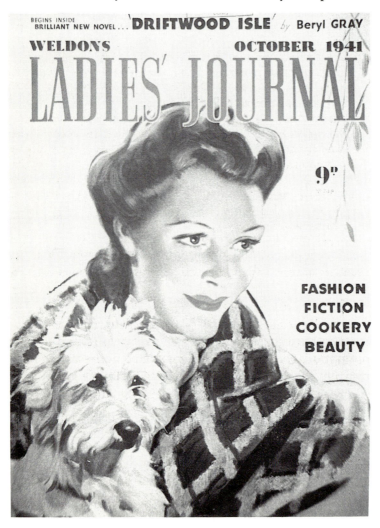

74] This cover expertly projects Hollywood sophistication in terms of poise, make-up and hair, alongside a softer concern with the comforts of domesticity.

fashion plates or journal illustrations as representations of dress as worn, without regard for the literary context or wider iconographical implications of such images.

More recently there has been a rejection of the subjective, uncritically celebratory and elitist fashion histories produced up until the late 1960s, with their unquestioning use of publishing and periodical material. Elizabeth Wilson for example, in her recent attempt to ally fashionable dressing with other mass leisure pursuits, takes the graphic and literary reproduction of dress into a system of mass consumption, and shows that dress historians have been toiling unnecessarily in their efforts to use fashion journalism as evidence for fashion change or cultural conditions. In her account of the role of dress in the formation of status and gender, and its capabilities in terms of dissent and deviance from those roles, Wilson liberates the fashion plate and magazine column from the clutches of a rational, linear dress history:

> Since the late nineteenth century, word and image have increasingly propagated style. Images of desire are constantly in circulation; increasingly it has been the image as well as the artefact that the individual has purchased . . . Fashion is a magical system, and what we see as we leaf through glossy magazines is 'the look'. Like advertising, women's magazines have moved from the didactic to the hallucinatory. Originally their purpose was informational, but what we see today in both popular journalism and advertising is the mirage of a way of being, and what we engage in is no longer only the relatively simple process of direct imitation, but the less conscious one of identification.[20]

The perceived failure of mainstream fashion history in coming to terms with the complexities of material culture generally, and the ideological structures of fashion journalism in particular, has therefore dictated a need to look elsewhere for possible methods of approach to the problems of the relationship between women's magazines and fashion promotion. Focusing on work completed in the area of feminist film theory, it is possible to draw useful methodological parallels from the way in which writers such as Jane Gaines take the 'women's film', an instrument of mass culture from the 1930s to the 1950s deliberately marketed towards a female audience with a self-conscious appeal to areas of so-called 'feminine' interest such as romance, glamour and material wealth, and describe the manner in which this interacts with women's perception of themselves in terms of fashion, consumption, sexuality, maternal and marital duty

and work. There are obvious links here with the positioning of fashion, femininity and women's journals across the twentieth century. Gaines makes the connections explicit:

> There is a significant link between the notion of woman dis-
> played by her dress and woman displayed by other representa-
> tional systems. In addition, one might say that contemporary
> feminists have understood woman's inscription in the codes of
> contemporary representation because they themselves know
> too well what it is to be fitted up for representation. We are
> trained into clothes, and early become practised in presenta-
> tional postures, learning in the age of mechanical reproduction
> to carry the mirror's eye within the mind, as though one might
> at any moment be photographed. And this is a sense a woman
> in Western culture has learned, not only from feeling the con-
> stant surveillance of her public self, but also from studying the
> publicity images of other women, on screen certainly, but also
> in the pages of fashion magazines.[21]

The new dress and film theory revels in the ambiguity of fashion, moving away from earlier reductive, moralistic approaches. A condemnation of fashion, fashion publicity and fashion history implies a dismissal of the women (and men, though the role fashion images play in the construction of twentieth-century masculinities will be discussed later in the chapter) who consume this apparent oppression and ignores 'the strength of the allure, the richness of the fantasy, and the quality of the compensation' which such consump-tion allows. However, to follow recent cultural theory to its illogical limits may pose its own problems when the historian attempts to reconstruct the material reality, the marketing and publishing policies or economic and editorial approaches of women's magazines:

> the more extreme contention of post-modernist theory – the
> idea that the image has swallowed reality whole – obliterates the
> problems endemic to comparisons between images and society.
> If the image now precedes the real, engulfs it and renders it
> obsolete as a point of comparison, do we any more need to show
> how representation is ideological?[22]

The artificiality and hallucinatory nature of fashion journalism and fashion illustration would certainly seem open to similar interpretation. But the post-structuralist approach of Gaines, the argument that the image of feminin-ity is a construction, a product of its society, of culture, economics, politics and technology, relying only on the reality of the moment, allows for a clearing up of this post-modern confusion. The constructed image can be held up for

further scrutiny, the construction made clear and the fashion
journal or film revealed as representational systems, con-
structing the feminine through marketing skills and public-
ity. In this way representation can be shown to rely on current
ideologies, and the 'obliterated' problems of image and
society reinstated for discussion.

Promoting fashionable femininity between the wars, 1918–39

Recent work on dress and the body, formulated from a cul-
tural studies perspective, has therefore been useful in high-
lighting the way that the media form constructions of class,
gender, and sexuality, but this has often been at the expense
of historical specificity. It is equally important to anchor
these broader theoretical concerns within the context of the
more rigorous empirical research that focused case-studies
can provide. As we have seen, Britain between the wars has
often been presented in terms of a sudden democratisation of
fashionability due to advances in clothing technology, a
further expansion of the publicity and advertising machine
to incorporate film, radio and truly mass-circulation period-
icals, and a perceived broadening of employment and educa-
tional opportunities for women and the working class.
However, despite evidence of home-grown expansion, maga-
zine-led fashion marketing in the 1920s and 1930s has gener-
ally been represented in traditional fashion history literature
through a rather narrow recourse to the lavish colour plates
promoted by *Vogue* and other elite American publications. As
a result the reader is often left with a rather simplified and
overly glamourised image of the twenties fashionable female,
swathed in Chanel, sunburnt on the tennis court, reclining
on the liner and answering to the name of 'flapper', a literal
reflection of the advertising expertise of Hollywood and
Harper's Bazaar. Taking on board the problems and contradic-
tions suggested by the new film and fashion histories in
recognising that the use of journalistic material as an unprob-
lematic source for a reconstruction of marketing strategies
and consumer patterns is fraught with difficulties, it may be
more useful to focus on the less exuberant, arguably more
humdrum images that appeared in the lower and middle
market English women's magazines that flourished during
the same period in trying to assess the effect that 'mass
imagery' brought to bear on constructions of fashionable
femininity.

The very ordinariness that these journals embody can in fact be used as evidence to suggest that British editors, illustrators and advertisers were responding to a particular sense of reactionary or 'conservative modernity' that stands in opposition to the more commonly held reading of feminine culture at the time as revolving around ideals of aspirational glamour, the Joan Crawford film and the department store window. The counter-attractions of suburban domesticity offered a more peculiar challenge to fashion producers and promoters than that generally held to be the norm.

As described in the previous chapter, the women's magazine industry had seen massive expansion before the First World War; the transformation of small family firms into large conglomerates by the 1880s together with an unprecedented democratisation of the fashionable image, typified by the wholesale espousal by publications such as *Myra's Journal of Dress and Fashion* of cheap patterns, good colour plates and black and white engravings, and provocative journalism, all made available to the widest possible market without consideration of class, location or profession. Alongside the pioneering publications, more traditional organs such as *The Queen* continued to serve the elite reader with an equally lavish production style. Following the social and economic upheaval resulting from the war years, magazines after 1918 lost some of the carefree prosperity associated with the imagery and reporting of the late nineteenth century. In the most simplified of terms, post-war publications were increasingly forced to respond to the economic situation of a reading market reorganised into the 'New Rich' and the 'New Poor'. The New Rich were characterised as the suburban and entrepreneurial classes, both lower-middle-class white-collar workers and industrial property owners who were benefiting from regular employment and higher wages, and had managed to make money out of the wartime boom in the manufacturing economy. Many of the recipients of an improved lifestyle were women, a limited proportion of whom held on to jobs formerly opened up by war work, the remainder reaping the comforts offered by a more stable, mortgaged 'tudorbethan' lifestyle in areas such as Ruislip and Cockfosters. Robert Graves in his retrospective assessment of the inter-war years, *The Long Weekend* of 1940, commented on the physical effects of feminine prosperity for some: 'The most remarkable outward change of the Twenties was in the looks of women in the towns. The prematurely aged wife was coming to be the exception rather than the rule.'[23] The new

poor, in contrast, were described by *The Queen* in 1920 as constituting a pale reflection on that journal's former affluent readership: 'those classes of education and refinement who have to meet the enormous increases in the cost of the barest necessities with steadily decreasing incomes, often enough on incomes reduced to vanishing point by the loss of husband and father, or heavily encumbered, having the erstwhile breadwinner ill or disabled by wounds'.[24]

Cynthia White, in her seminal work on the history of women's magazines, shows how the journals of the second decade of the twentieth century capitalised on this split in the market, often directing editorials and advertisers towards the increased spending power of the new rich, encouraging an unproblematic embracement of the freedom to be found in unfettered fashion consumption. *Vogue* launched in a British version in 1916 prefaced its first issue with an Americanised call to arms:

> America believes in the higher education of women as does no other country on earth. She knows perfectly well that marriage and motherhood, paramount as they are, are not to be the whole of this girl's life. First, there are the years between college and marriage, often a very considerable period, since the modern girls insist on waiting till they get what they want. Next, a woman of this class doesn't spend the whole twenty-four hours of her day rocking her baby and making a good man happy. Finally, after the baby period is over this girl is going to have fifteen or twenty years of unimpaired vitality when her children don't need and certainly don't want her individual attention. She has been given an abundance of surplus time and energy . . . Do we realise it in England?[25]

In White's words, through 'fashion pages flanked by sumptuous adverts, employing skilful selling devices to tempt the unwary', journals such as *Vogue* and *Eve*, published in 1920, 'transformed the simple desire to be well-dressed into an exorbitantly expensive and time-consuming profession, beyond the reach of all but the most affluent'.[26] Such devices could also, however, appeal to the aspirations of new groups of consumers. J. B. Priestley in his *English Journey* of 1934 lamented the material effects of the new consumerist ethic:

> The third England, I concluded, was the new post-war England, belonging far more to the age itself than to this particular island. America, I supposed, was its real birthplace. This is the England of arterial and by-pass roads, of filling stations and factories that look like exhibition buildings, of giant cinemas and dance halls and cafes, bungalows with tiny garages, cocktail bars, Woolworths, motor coaches, wireless, hiking, factory girls looking

like actresses, greyhound racing and dirt tracks, swimming pools and everything given away for cigarette coupons. If the fog had lifted I knew I should have seen this England all around me at the northern entrance to London, where the smooth wide road passes between miles of semi-detached bungalows, all with their little garages, their wireless sets, their periodicals about film stars, their swimming costumes and tennis rackets and dancing shoes.[27]

Older journals such as *The Lady* remained loyal to their former readership, encouraging ideals of restraint and decorum through economic circumstance that must have appeared peculiarly unattractive to advertisers:

> In these days of increasing expenditure and diminishing income, it behoves us – the new poor – to adapt ourselves to altered circumstances, and to learn how comparatively simple it is to do many things for ourselves that formerly necessitated sending for a workman . . . Having shed the last remnants of our false pride, our terror of 'what the neighbours will think', we can arrange our domestic life on the principle that 'when no one's anybody, then everyone is somebody', a much more comforting state of affairs . . . also of far more use to the country at large and ourselves in particular[28]

Commercial magazine patrons were, however, able to shift or direct their copy towards the demands of a particular readership. In the same year, 1920, for example, a shoe manufacturer was able to claim in *The Lady*:

> Lotus and Delta shoes are not for the 'new rich' at all, either in quality or price. They are not flashy, obtrusive, catch-the-eye shoes, nor are they by any means 'the dearest that can be bought for the money'. The qualities of Lotus and Delta appeal far more to the 'new poor': quiet, good style, comfort, durability and wonderfully reasonable prices.[29]

The implied elitism of such announcements, disassociating ideals of class and 'innate' taste from the 'flashiness' of new money, were not able to sustain the older magazines, and by the mid 1930s the journals market was dominated by titles marketed towards the middle and lower middle classes. The new magazines, including *Good Housekeeping*, *Woman and Home*, *Woman and Beauty*, *Woman's Own* and *Woman*, could be characterised by a uniformity of approach that prioritised domestic duty and suburban pleasures at the expense of glamour and an attentiveness to intimate personal service, evidenced through friendly reassuring editorials and a high degree of reader identification.

This new relationship with the reader was reflected in the

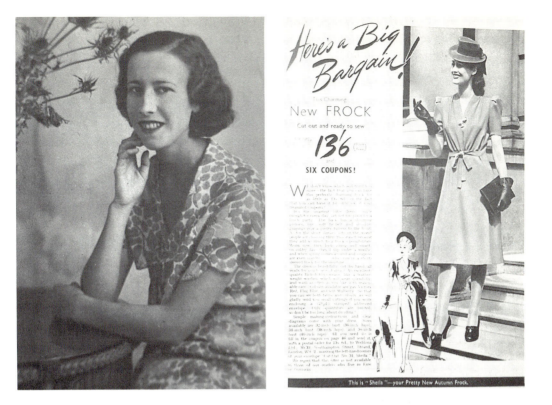

This is "Sheila"—your Pretty New Autumn Frock.

75] The self-assured pose and relaxed but 'feminine' cotton print dress suggest that this is a consumer well versed in the language of fashion promotion and entertainment.

76] Rationing and the stringencies in cut and length later demanded by the utility scheme are both in evidence in this advertisement.

response of advertisers and the management of marketing. Total advertising expenditures increased dramatically in Britain and America after the war and were characterised by a new competitive diversification within the industry. Fashion producers, for example, were now able to utilise radio, film and department store tie-ins as well as the more traditional newspaper and magazine outlets. As a result a number of woman's magazines set up departments with consumer panels and research services that could be offered to interested advertisers; food, cosmetics, home decorating and dressmaking were areas particularly suitable for inclusion in such ventures. Readership circulation data was also attractive to advertisers, increasingly in the expanded form of audience surveys which asked purchasers of the magazines about their economic backgrounds, aspirations and interests. A representative survey completed by *Good Housekeeping* in 1930 found that the 'typical, moderately well-off woman' had an average dress allowance of £65 per year and that 20 per cent of readers used lipstick, 7 per cent rouge, 5 per cent scent and 7.5 per cent used no make-up at all.[30] Through the use of such information advertisers of particular fashion products could direct their goods at the most suitable publication, and the

magazines themselves were able to gauge reader reactions to
presentational, editorial and advertising policy. In this way 'a
continuous circle of mutual influence evolved in which
researchers came to promote themselves to the media, the
media promoted themselves to advertising agencies, agencies
promoted themselves to business, business promoted them-
selves to consumers, and consumers ultimately turned back
to researchers for guidance'.[31]

The publicity of the Amalgamated Press, one of the giants
of periodical publication between the wars in Britain, attests
to the close relationship between the publisher and the adver-
tiser, stating: 'If the advertiser be selling an article of interest
only to women, the Amalgamated Press group of women's
papers, *Home Chat*, *Woman's Weekly*, *Woman's World* and the

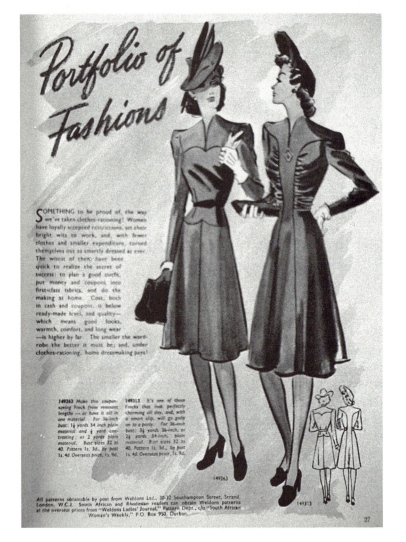

77] A wartime page layout
which successfully combines
a clear diagram of the cut
and structure of the dresses
portrayed with the latest
graphic techniques,
producing an image of
restrained and easy
'glamour'.

group of fashion papers assure to him an exclusive female audience . . . without waste.'[32] The press itself could call into action an impressive array of promotional gimmicks:

> It would be curious if the Amalgamated Press did not believe in advertising. It takes its own medicine to the tune of something like £250,000 a year expended in publicity outside its own journals. This sum, as may be conceived, places the firm among the biggest advertisers in the kingdom and, in the light of results, probably the most successful . . . Inter-advertising between the various journals issued from the Fleetway House is carried to a science. Coloured posters in infinite variety smother the hoardings; two, three and four colour bills are blazoned outside newsagents' shops. Leaflets in infinite variety are distributed from house to house in selected districts, or possibly to football crowds, children coming from school, or to other classes of the public as circumstances may dictate. Indians, Clowns, Cowboys wander in crowded thoroughfares arousing curiosity that is dispelled by an advertisement. The stage and the cinema are called into requisition, 'dummies' distributed for window dressing, free shows organised at holiday time – indeed the list is endless.[33]

In the final analysis though, the Press could attract advertisers by highlighting both its ability to reach a wide market and the personal 'friendly' quality attached to the role of the family or woman's magazine within the individual home:

> Each copy is read sometimes many times. It reaches the home of the millionaire, the professional man, the typist, the artisan and the working woman. It passes from hand to hand throughout the family and sometimes outside . . . the successful traders who have the most experience still persistently make their appeal to the productive home-loving public, with its multitude of wants, through the columns of weekly and monthly journals read thoroughly in their leisure hours by millions of people.[34]

Illustrating fashionability

Through what material means then were images of fashionability, central to the economic concerns of editors and advertisers, produced and consumed? A text like *Modern Fashion Drawing* of 1937 serves as a useful source for viewing the marketing of fashion in women's magazines from the illustrator's viewpoint, whilst offering a perspective perhaps more representative of the general British fashion scene than the illustrations produced in elite transatlantic publications. Aimed at the aspiring graphic artist, the book outlines the structure and organisation of the fashion illustration business between the wars:

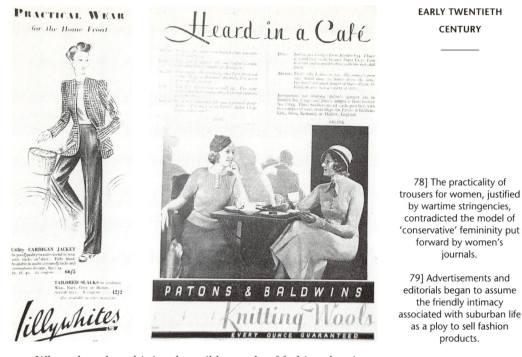

Where then does this inexhaustible supply of fashion drawings come from? Who creates all the original work, and by what channels does it find its way into the pages of press and catalogue which are so much a fact in our lives today? The answer is, principally from the commercial studios, three hundred of which are in London. There a veritable army of artists – mostly well paid, clever young women, many of them known to the great fashion houses of Paris, London and New York – is hard at work meeting the hundreds a day demand . . . how great is that demand today may be realised from the fact that the output of fashion drawings from London's studios alone is roughly four times the amount of other advertising drawings.[35]

The reader was constantly reminded that fashion drawing was above all else a commercial concern:

By all means bring to the work the best that one has, never lowering the standard of art because it is allied to commerce. But at the same time, ideas about art for art's sake must not be allowed to blind one to the essential fact that the purpose of a fashion drawing is to sell something. It may be a journal or magazine which the drawing has to sell . . . or it may be a paper pattern. It may even be prestige one is selling – the prestige of a big store, or the prestige of a studio; or it may just be somebody's hats. But whatever it is the artist must always remember that she is part of the modern organisation for selling things.[36]

In tune with the evidence in middle- and lower-middle-class magazines of a rejection of overt American or Parisian

sophistication in favour of a more pragmatic suburban glamour, the author Dora Shackell advises 'spurning equally the pretty-pretty with the sham modern stuff which is but a blind alley of art. The expression of form in the simplest of terms is one of the greatest qualities of an artist and is particularly necessary in fashion drawing.'[37] A diversification of reader tastes and modes of presentation is also evident in Shackell's delineation of a variety of model types:

> Each house has a sort of tradition or taste, probably based on what they know appeals to their clientele. For example there is the ultra-smart type, in contrast with the distinguished county type and the suburban type . . . Some papers feature the *haute vie* type, smart but not 'smarty'. Others prefer the refined type, yet permit or encourage her to smoke a cigarette so that their readers may feel at home with her; and there is the quite definitely 'cheeky' type. For provincial work a different, less advanced type of figure is required. The provinces like to think themselves rather puritan in these matters, and a cigarette-smoking female in some midland papers would probably create a sensation. The subject-matter must also be somewhat more restrained and decorous.[38]

Modernity or conservatism?

Despite Shackell's disparaging remarks, it was precisely the woman reader from the provinces, the suburbs, the representative of 'Little England', who formed the model consumer for fashion marketers and producers between the wars. It was her consumption preferences that largely defined the appearance of most of the women's magazines, situated at the opposite pole from those representations of glamour that form the bulk of illustrational material for mainstream histories of twentieth-century fashion. There has undoubtedly been a tendency within cultural history generally and fashion history in particular to prioritise the modern, the revolutionary and the metropolitan at the expense of a sense of continuity. The inter-war period is problematic because many writers have placed a growing emphasis on the emergence of a thrusting new mass-cultural movement centred on the city, on film and spectacle, that was particularly attractive to an aspiring working class, especially the young working woman who wanted novelty above all else. Robert Graves identified the phenomenon: 'The American habit of buying cheap mass-produced goods for short use was a novel one to the British . . . If the old-fashioned shop assistants still mumbled 'I can guarantee this – it will last a lifetime' the modern come-

back was "Then for goodness sake show me something else".'[39]

Even if salaries or housekeeping money wouldn't stretch to department store goods, the new forms of mass culture allowed space for escapism and the emotional release of the dream. As Sally Alexander comments in her psychoanalytical reading of the desires and material context of young female working-class consumers in inter-war London:

> advertising and the cinema, playing on fantasy and desire, enabled women to imagine an end to domestic drudgery and chronic want. Images of streamlined kitchens, effective cleaning equipment, cheap and pretty clothes and make-up, on hoardings and cinema screens and in the new women's magazines, added a new dimension to romance – a source of narrative pleasure to women since the eighteenth century at least, the scourge alike of puritan and feminist critics of femininity.[40]

Contemporary commentators threw scorn on the stories and lurid illustrations filling the cheaper working-class magazines for women such as *The Woman's Friend* of 1924 and *Peg's Paper* of 1919. Margaret Eyles, a social reformer writing on the culture of working-class women in her book *The Woman in the Little House* of 1924 wrote:

> The literature most working women read is appalling. Several firms have made an attempt to publish stories true to the life of the people who will read the stories, and I am told that these stories sell quite well, though of course, many women like to read tales of Mayfair, about impossibly beautiful heroines in impossibly wealthy clothes. Such stories are not to be altogether condemned, because they certainly create a new atmosphere in the reader's mind and take the place that poetry took for me and the place that alcohol takes for others – that is, it is just a way of escape from every day's tyranny.[41]

The illustrations and articles of cheaper magazines also indirectly helped the producers and marketers of fashion goods, who advertised on the same pages, in creating a glamorous aura or mask, but they mislead the historian into assuming a scenario of increased fashion consumption that existed only in a very limited sense. Undoubtedly advertisers and editors succeeded in establishing a facade of democratic fashionable consumption, which infuriated reactionaries like J. B. Priestley, who railed at what they saw as its homogenising effects:

> Modern England is rapidly Blackpooling itself. Notice how the very modern things, like the film and wireless and sixpenny stores, are absolutely democratic, making no distinction what-

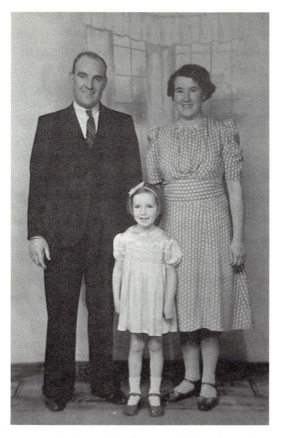

80] Magazine publishers between the wars were quick to capitalise on a new market, opened up by movement towards the suburbs. The simple attractions of home and family to which they aspired are clearly evident in snapshots as this.

ever between their patrons. If you are in a position to accept what they give – and very few people are not in that position – then you get neither more nor less than anybody else gets . . . There is almost every luxury in this world except for the luxury of power or the luxury of privacy . . . Too much of this life is being stamped on from outside, probably by astute financial gentlemen, backed by the press and their publicity services. You feel that too many of the people in this new England are doing not what they like but what they have been told they would like.[42]

However, empirical evidence, alongside approaches suggested by the new literary criticism, suggests that many fashion producers and advertisers chose to take a much more traditional approach. Amy de la Haye, in her work on the dissemination of ready-made fashion in the 1920s, quotes a 1938 survey of British retail trades that showed that small-unit, family-run traditional dress stores held a 51 per cent share of the fashion market as opposed to a miserly 6 per cent share by the supposedly innovatory and 'modern' department stores. Using the example of the Hodson Dress Shop in the West Midlands, de la Haye shows how suburban shops were able to stock economically made mass-produced items

of clothing in limited lines that corresponded closely to the demands of local customers, rather than conforming to city-centre notions of fashionability. Consumers may have paid more for small-shop ready-made fashions than they would have laid out for bargain basement department-store goods or home-sewn items, but personal service and individuality were apparently well worth the extra outlay. It is no coincidence that these small stores were located in those very conservative and inward-looking suburbs that formed the major constituency for the consumption of women's magazines.

Alison Light has repositioned the world of the suburb, and the traditional feminine attitudes that it entailed, at the centre of her discussion of popular culture in England in the twenties and thirties. Deconstructing the novels and reconstituting the readers of Agatha Christie and Daphne du Maurier and the Mrs Miniver columns of Jan Struthers, Light

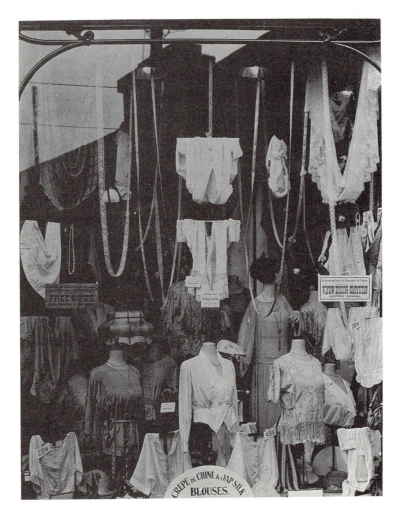

81] The cluttered display of a provincial dress-shop window betrays the reality of many women's consumption choices more clearly than the slick designs of magazine layouts or film fantasies.

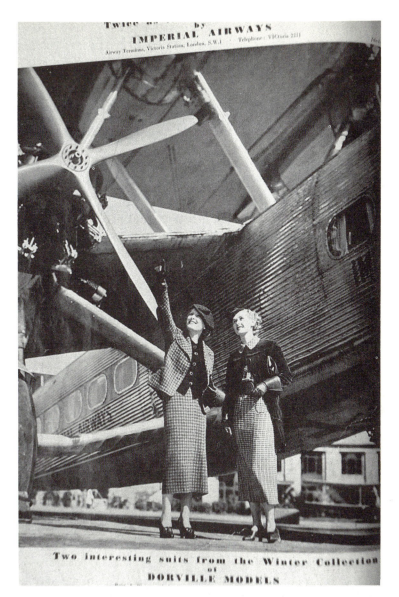

Twice by
IMPERIAL AIRWAYS
Airway Terminus, Victoria Station, London, S.W.1 Telephone : VICtoria 2211

Two interesting suits from the Winter Collection
of
DORVILLE MODELS

82] The spectacle of travel and a notion of the sophisticated high life were used by advertisers, photographers and illustrators to create aspirational images that generally had little direct relevance to the lives of the readers.

evokes a context in which the marketing policies and images of women's magazines can usefully be reread. Writing on Christie's novels she notes those suburban aspirational qualities, important in terms of status, but always carefully concealed:

> Whodunits belong to those 'designs for living' which became available across the social classes between the wars, those new and modern productions of English social life which 'theatricalised' it. Like film and radio and cut-price fashion, the whodunit offered a representation of English behaviour and character which could be copied by anyone who took the trouble to learn the right lines or surround themselves with the

right props. Bearing, posture, appearance and the 'proper' intonation of voice became a matter of careful reproduction, and whilst the image itself might be a conservative one, its reproducibility was modern and was for ever undermining any notion of its authenticity.[43]

The pseudo-art-deco advertisements and constant use of film star affidavits that appeared in the inter-war middle-brow women's magazines, alongside marketing motifs derived from picturesque versions of English history and landscape (a graphic equivalent of suburban 'Tudorbethan' architecture and the ubiquitous 'crinolined ladies' embroidered on to cushion covers and antimacassars) all helped to construct an image of 'modernity' that was in essence centred around notions of domesticity, nostalgia and conservatism. Cynthia White has identified an editorial shift in women's magazines during the mid-thirties back towards a 'traditional' view of femininity that prioritised home and family above personal pleasure and fashionability. This approach stood in ironic contrast to the increasingly sophisticated appearance of the magazines themselves, which included more colour and presented articles in extroverted layouts. In the first issue of *Woman* in 1937, the editor drew attention to the fact that

> In the last ten years there has been a movement, a tendency which the suffrage generation calls backward 'retrogressive' . . . We are trying to do something difficult, to blend our old world with our new . . . [women] are trying to be citizens and women at the same time. Wage earners and sweethearts. But while they work, filling a tremendous place in professional and industrial life, they are still greedy for the pleasures and responsibilities which the sweet stay-at-home, that domestic tyrant, had so well in hand.[44]

Advertisers of fashion products in women's magazines were complicit in that shift, both through the images with which they chose to promote their products and in their economic underpinning of the journals themselves. If there is one important lesson to be gained from the study of fashion promotion and diffusion in women's magazines in any period from the nineteenth century on, it is a realisation of their power not just in selling products, but in suggesting, reflecting and sustaining lifestyles. Mrs Miniver, Jan Struther's blend of fiction and autobiography, whose diary appeared in the columns of *The Times* in the years running up to the Second World War, was nominated the archetypal 'woman's woman' by one magazine in 1945. Though belong-

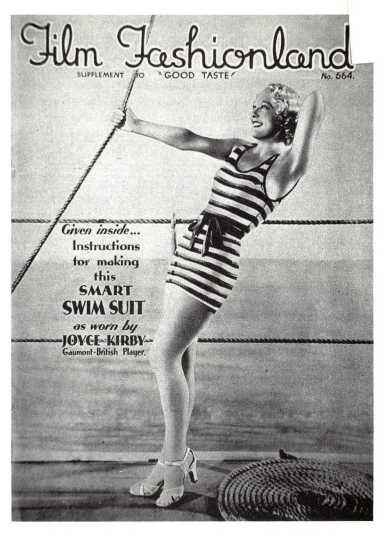

Film Fashionland

SUPPLEMENT to "GOOD TASTE" No. 664.

Given inside...
Instructions
for making
this
SMART
SWIM SUIT
as worn by
JOYCE KIRBY
Gaumont-British Player.

83] The publicity machine of 'Hollywood' offered new models of accessible glamour to a mass audience.

ing to a social class distinct from the suburban masses, she offered them a model of the new consumption resonant with the restraint and 'breeding' aimed at, if not always achieved by the journals themselves. She embodies those complex relationships and inconsistencies that lie at the heart of twentieth-century mass publicity and consumption, and which fashion history would do well to take on board, in the words of Light:

> When she goes shopping it is for luxuries, not necessities, and she brings back not purchases, but experiences. She may visit department stores, but even her spending isn't sordid . . . We never hear her ordering the mutton. No doubt the readers of Mrs Miniver could have the best of both worlds as they strayed from her musings back to the advertisements for new tailor-mades at Debenhams and the latest Deretta fashions.[45]

Marketing masculinity – men and fashionability in the twentieth century

In writing I have become aware how heterosexual men have inherited a language which can define the lives and sexualities of others, but fails us when we have to deal with our own hetero-sexuality and masculine identities. An incident happened when I was thirteen. Two boys approached me at school, they said they were going to ask me an important question. 'Was I', they enquired, 'a heterosexual?' 'No', I said. That was the reply they had expected. Then you must be a queer', was their response. I felt thrown into a panic, because though I hadn't understood what the word meant, I assumed that sexual labels were for sexual deviance. I know that they spent several weeks practising their ploy on a host of confused but predictable schoolboys, who would all vehemently dismiss their allegation. It's an

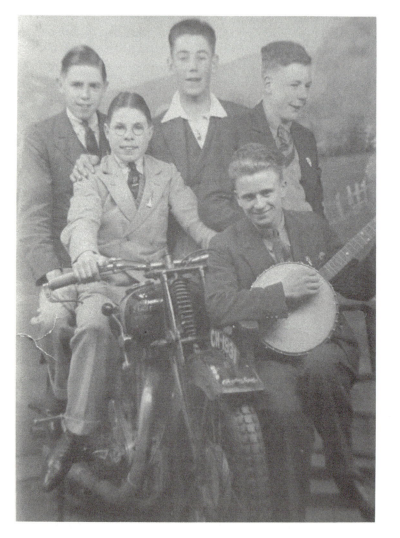

84] Sharp suits, distinctive ties and individualist haircuts undermine the myth that men took no interest in fashion during the interwar years.

85] An advertisement from a mid 1960s physique magazine shows the link between a growing gay scene and the rise of men's 'boutiques' in central London.

incident about naivety, but it also reflects the assumption that 'normal sexuality' is both beyond question and beyond description; women may be sexual beings, homosexuals are, but men are just chaps, the lads. Our language doesn't produce us as sexual subjects or a category in need of a label.[46]

Jonathon Rutherford in his work on the rise of the 'new man' in late twentieth-century journalism, advertising and film, underlines the way in which masculine identity has generally been taken for granted. The positioning of men in roles of power and control within society has negated any need to question or analyse internal motivations, aspirations or uncertainties. That male heterosexuality has become a 'given' around which all other categories are constructed and defined as 'other', implies that self-identifying strategies of display have lost any relevance for the majority of men. Many of Rutherford's terms, such as 'language', 'identities', 'labels' and 'category' pivot around those functions that fashion fulfils in creating and describing a sense of individuality, and these are precisely the codes which mainstream masculinity has been credited with rejecting. Fashion, in such a reading, has become a 'feminised' concern, continuing the discourse of separate spheres set up in the nineteenth century. As Jennifer Craik comments: 'the rhetoric of men's fashion takes the form of a set of denials that include the following propositions: that there is no men's fashion; that men dress for fit and comfort, rather than for style; that women dress men and buy clothes for men; that men who dress up are peculiar (one way or another); that men do not notice clothes; and that most men have not been duped into the endless pursuit of seasonal fads'.[47]

These assumptions have recently been challenged on two fronts. Firstly by the rise of an academic discipline, of which Rutherford is a part, devoted to the analysis and critique of contemporary and historical constructions of masculinity, and secondly by an increasing popular interest, over the last ten years, in the consumption habits, physical image and material culture of young men as a social constituency. The first approach, informed by, and perhaps attempting to answer some of the questions raised by feminist history and cultural studies, has not really directed its attention towards problems of clothing and fashion. The second approach has concerned itself with the illusory world of journalism and advertising, focusing more closely on the problems of appearance and identity. In doing so it has created a myth of the 'new man' that requires the sort of close critical attention that the first approach can provide. In the words of Roland Barthes: 'Myth does not deny things, on the contrary, its function is to talk about them; simply, it purifies them, it makes them innocent, it gives them natural and eternal justification, it gives them clarity which is not that of explanation but that of a statement of fact.'[48] The two approaches together have begun to uncover a wider debate concerning the identities of twentieth-century men, strengthening the visual and descriptive evidence given in recent fashion histories[49] that male consumers have in fact engaged with, and been constructed by, the problems and pleasures associated with a mass fashion culture, in much the same way that women have been described through a variety of cultural strategies. Masculinity is not a 'given', it too is created and manipulated through film, magazines, advertising and, of course, clothing.

Andrew Davies, in his work on working-class culture in the Manchester region between 1900 and 1939, presents a reading of men's dress that contradicts the received view of pre-war northern masculinity as resistant to the supposed 'feminisation' entailed in fashion consumption. Whilst the role of 'breadwinner' was central to the construction of family roles and an ethic of self-denial in terms of personal luxury (a 'masculine virtue', dictated by economic necessity and heightened by fears of poverty and unemployment), the importance of 'keeping up appearances' dictated a close attention to, and approximation of respectability from both sexes. Inventing a veneer of respectable fashionability with a minimum financial outlay left excess money for the equally important leisure pursuit of drinking, which itself provided

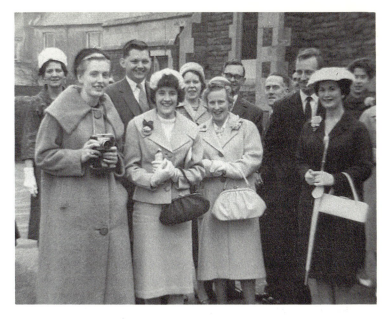

86] A skill in combining elements of formal, street and high fashion styles is evident in this photograph of a working-class Bristol wedding at the end of the 1950s.

an arena for fashionable display. Davies quotes an autobio-graphical description of Salford pub culture just prior to the First World War: 'people were having hard times and small wages, but everybody seemed to be enjoying themselves. At weekends the men dressed up by adding a 6½d dicky in front of their old shirt. This consisted of a stiff shirt with a collar attached and they looked fine, but dared not take their coats off anywhere. It was a muffler through the week.'[50]

Davies also notes the distinctive quality of young male street culture in the 1930s, with its own codes of appearance and behaviour that predated the commercialism of post-war youth style. 'Although young men who were dance-hall regu-lars, sporting fashionable haircuts and clothes, were some-times known as 'jazzers', the term 'corner lads' is much more common as a description of young males during the inter-war period, reflecting the centrality of street activities in youth culture as late as the 1930s. In contrast, the labels attached to young people from the 1950s were more often a reflection of commercial influences, of styles of fashion and music.'[51] The 'monkey parade' or promenade offered the opportunity of wider public display and an excuse for fraternisation with the opposite sex: 'From Hulme, from Ardwick and from Ancoats they come, in the main well-dressed, and frequently sporting a flower in the button-holes of their jackets.'[52] That men's style was as vulnerable to the influences of Hollywood and advertising as women's is attested to by the recollections of a monkey parade participant from the 1920s:

If you could afford it, you had trousers with a twenty-four inch bottom, with an inch turn-up. And if they were anything under twenty-four inches, you didn't want to know them. That was the fashion. You also used to have your hair cut in a special style, what they called a 'jazzer's' haircut. And if you went dancing, that was the recognised rig-out. Bell-bottom trousers with a twenty-four inch bottom, and haircut to match . . . The hat was a stetson. And the one I wore was what they call an 'at-a-boy'. That was like a stetson and you pulled it low down, like a gangster effect. And a black belt, and a short belted overcoat.'[53]

What pre- and post-war descriptions of the fashions adopted by male youth cultures have in common is an emphasis on group identity, and the conspicuous display of disposable income as a sign of belonging to the group. Those who could not afford the requisite clothing, or who lacked

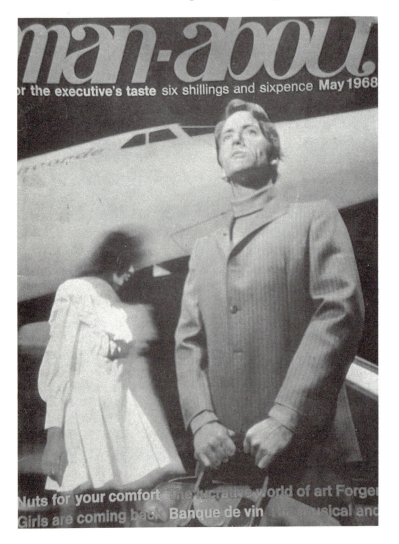

87] Male-orientated publishing ventures from the 1950s onwards anticipate the narcissistic concerns of the 1980s 'new man'. Then, as now, ostentatious fashion consumption was 'heterosexualised' by the inclusion of gratuitous pin-ups and "risqué' editorials.

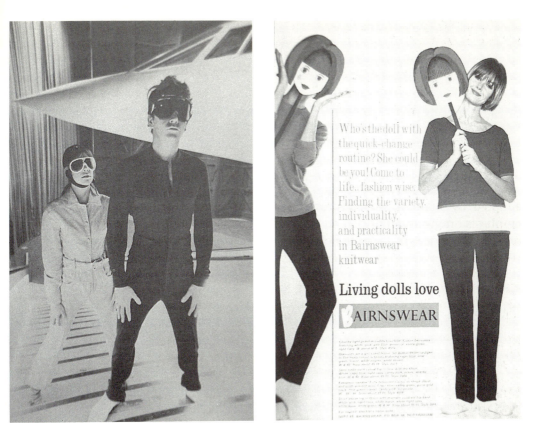

Who's the doll with the quick-change routine? She could be you! Come to life.. fashion wise. Finding the variety, individuality, and practicality in Bairnswear knitwear

Living dolls love

BAIRNSWEAR

88] The modernity suggested by supersonic flight, together with the filmic glamour of space-age science fiction made tangible in the use of new synthetic textiles, offered much inspiration to designers in the late sixties.

89] The bright colours, geometrical designs and pop references of mid-1960s youth culture are utilised in this knitwear advert.

the imagination to approximate style through the accessorisation and alternation of existing items were generally excluded. This differentiates working-class masculine style from the 1930s through to the 1970s from those constructions associated with the dandy in the late nineteenth century and more recent advertising and journalistic projections of the narcissistic 'new man' in the 1980s which tend to prioritise the individual over the group. Rowena Chapman locates the latter within the context of trends in late twentieth-century advertising, publishing ventures, consumerism and sexual politics. In his ideal incarnation the 'new man' repudiated the negative qualities of the old man with his boorish group mentality in favour of a sensitive embracement of domestic roles and personal enhancement:

> So he could be forgiven for preening himself in front of the mirror which he passed by more often. And if the bathroom shelf groaned under the weight of his toiletries, that was a small price to pay for his repudiation of the role of the distant patriarch and old-style parenting. There was something charming in his whole-hearted acceptance of himself as a sexual object, embracing narcissism with open arms, and just a touch of after-

shave. He was the postmodern dandy worrying about the cut of his strides and fretting about the knots in his shoelaces. And he fitted perfectly into an advertising market which was increasingly concerned with lifestyle marketing rather than individual products.'[54]

Sean Nixon, in his work on recent male consumption patterns, takes the sensibilities associated with the 'new man' myth and locates them within the concrete world of the man's clothes shop and the style magazine, showing how constructions originating within advertising and retail strategies have had a quantifiable effect on the way that metropolitan men look at themselves and others in terms of pleasure and self-identity. There is nothing new in a male desire to consume. The neo-Edwardian dress codes of guardsmen and young aristocrats from the late 1940s into the 1950s, with their emphasis on 'classic' English tailoring combined with ostentatious colour combinations, necessitated the patronage of both traditional Savile Row outfitters and newer Chelsea boutiques. The rise of Carnaby Street from the late 1950s provided both a growing gay subculture and the specific demands of suburban and provincial mods with a cheaper 'beat' look incorporating Italian styling and cut, with loud 'pop' inspired motifs and patterns. Similar examples of retailers cashing in and supplying particular goods to successive 'spectacular' and predominantly male subcultural movements continue through to the King's Road concentration of punk emporia in the mid-1970s. But as Nixon points out, 'Representing a break with some of the spectacular forms of subcultural style pre-punk, such as the mods, which tended to produce a more fixed and coherent identity against the classless addresses of the marketplace, 1980s styles played up the ambivalent possibilities of the signifiers of dress.'[55] In the interiors of shops ranging from Next to Harvey Nichols, the fashion spreads of *The Face*, *Arena* and *GQ* and the collections of iconoclastic designers such as Jean-Paul Gaultier, Vivienne Westwood and Body Map, the new male consumer was offered a market-place far more fragmented, supposedly more open to individual interpretation, than its earlier incarnations:

As a general assertion . . . we can suggest that the mags, through their fashion spreads, do offer imaginary identifications and pleasures in looking for men – (narcissistic) identifications with the pleasures displayed in the representations, and pleasures in looking at the representation. At the level of the image, within these exchanges of looks, masculinity is consciously put

together through the assemblages of clothes and haircut; attention is focused on the production of a particular 'look'. Beyond this is the incitement to participate in rituals of adornment; the putting together of an appearance.[56]

This brings us back to Elizabeth Wilson's definitions of postmodern style quoted at the beginning of the chapter, to a notion of fashionability based on concepts of bricollage and assemblage, the pulling together of different fashion signifiers to form a whole that blurs those distinctions of class, age, nationality, gender and sexuality that clothing was always apparently so good at defining and which form the central core of this book. Ultimately though, as Frank Mort illustrates in his essay on cosmopolitan male style in the late 1980s, beneath the sartorial confusion, older forms of inequality are still displayed: 'Looking and listening to the new man we can see at once how partial the changes are. It is too easy to get utopian here. For in the images, as on the ground, many of the traditional codes of masculinity are still in place. The newly sexualised male body can turn out to be nothing more than the old form of male exhibitionism.'[57] In spite of all, clothing and fashion continue to delineate and describe social and cultural concerns in a manner that demands our continued investigation.

Notes

1 W. Benjamin, 'The Work of Art in the Age of Mechanical Reproduction' in H. Arendt, ed., *Illuminations*, London, 1973, p. 233.

2 B. Fine and E. Leopold, *The World of Consumption*, London, 1993, pp. 93–142.

3 J. Craik, *The Face of Fashion: Cultural Studies in Fashion*, London, 1994, p. 74.

4 K. Rolley, 'Fashion, Femininity and the Fight for the Vote', *Art History*, 13, 1, 1990, pp. 47–69.

5 Craik, *The Face of Fashion*, pp. 73–4.

6 N. Rothstein, *Four Hundred Years of Fashion*, London, 1984, p. 80.

7 R. Graves, *The Long Week-End: A Social History of Great Britain 1918–1939*, London, 1940, p. 178.

8 Wilson and Taylor, *Through the Looking Glass*, p. 79.

9 S. Alexander, 'Becoming a woman in London in the 1920s and 1930s in D. Feldman and G. Stedman Jones, eds, *Metropolis London*, London, 1989, p. 263.

10 L. Taylor, 'Paris Couture 1940–1944' in J. Ash and E. Wilson, eds, *Chic Thrills: A Fashion Reader*, London, 1992, p. 127.

11 Wilson and Taylor, *Through the Looking Glass*, p. 110.

12 P. McNeil, 'Put Your Best Face Forward: The Impact of the Second World War on British Dress', *Journal of Design History*, 6, 4, 1993, p. 285.

13 Craik, *The Face of Fashion*, p. 78.

14 Wilson and Taylor, *Through the Looking Glass*, p. 148.

15 A. Partington, 'Popular Fashion and Working Class Affluence' in Ash and Wilson, eds, *Chic Thrills*, p. 158.

16 Partington, 'Popular Fashion', pp. 159–60.

17 D. Hebdige, *Subculture: The Meaning of Style*, London, 1979, p. 74.

18 E. Wilson, 'Fashion and the Postmodern Body' in Ash and Wilson, eds, *Chic Thrills*, p. 6.

19 M. Ferguson, *'Forever Feminine': Women's Magazines and the Cult of Femininity*, London, 1983, pp. 1–2.

20 E. Wilson, *Adorned in Dreams: Fashion and Modernity*, London, 1985, p. 157.

21 J. Gaines, 'Fabricating the Female Body' in J. Gaines and C. Herzog, eds, *Fabrications: Costume and the Female Body*, London, 1990, pp. 3–4.

22 Gaines, 'Fabricating the Female Body', p. 5.

23 R. Graves, *The Long Weekend*, p. 175.

24 *The Queen*, January 1920.

25 C. White, *Women's Magazines 1693–1968*, London, 1970, p. 91.

26 White, *Women's Magazines*, p. 94.

27 J. B. Priestley, *English Journey*, London, 1934, p. 401.

28 *The Lady*, 24 June 1920.

29 White, *Women's Magazines*, p. 95.

30 White, *Women's Magazines*, p. 114.

31 W. Leiss, S. Kline and S. Jhally, *Social Communication in Advertising*, London, 1990, p. 105.

32 G. Dilnot, *The Romance of the Amalgamated Press*, London, 1925, p. 92.

33 Dilnot, *The Romance of the Amalgamated Press*, p. 82.

34 Dilnot, *The Romance of the Amalgamated Press*, pp. 92–3.

35 D. Shackell, *Modern Fashion Drawing*, London, 1937, p. 1.

36 Shackell, *Modern Fashion Drawing*, p. 3.

37 Shackell, *Modern Fashion Drawing*, p. 19

38 Shackell, *Modern Fashion Drawing*, p. 43.

39 Graves, *The Long Weekend*, p. 178.

40 Alexander, 'Becoming a Woman in London in the 1920s and 1930s', p. 247.

41 M. L. Eyles, *The Woman in the Little House*, London, 1922, p. 100.

42 Priestley, *English Journey*, p. 402.

43 A. Light, *Forever England: Femininity, Literature and Conservatism Between the Wars*, London, 1990, pp. 96–7.

44 White, *Women's Magazines*, p. 112.

45 Light, *Forever England*, p 141.

46 J. Rutherford, 'Who's That Man', in R. Chapman and J. Rutherford, eds,

Male Order: Unwrapping Masculinity, London, 1988, p. 22.

47 Craik, *The Face of Fashion*, p. 176.

48 R. Barthes, *Mythologies*, London, 1972, p. 143.

49 F. Chenoune, *A History of Men's Fashion*, Paris, 1993.

50 A. Davies, *Leisure, Gender and Poverty: Working-Class Culture in Salford and Manchester, 1900–1939*, Oxford, 1992, p. 35.

51 Davies, *Leisure, Gender and Poverty*, p. 97.

52 Davies, *Leisure, Gender and Poverty*, p. 102.

53 Davies, *Leisure, Gender and Poverty*, p. 105.

54 R. Chapman, 'The Great Pretender: Variations on the New Man Theme' in Chapman and Rutherford, eds, *Male Order*, p. 228.

55 S. Nixon, 'Have You Got The Look? Masculinities and Shopping Spectacle', in R. Shields, ed., *Lifestyle Shopping: The Subject of Consumption*, London, 1992, pp. 161–2.

56 Nixon, 'Have You Got The Look?', p. 163.

57 F. Mort, 'Boy's Own' in Chapman and Hall, eds, *Male order*, p. 222.

7 Late twentieth century: catwalk and streetstyle

90] The designer 'classic' was a lynchpin of 1980s marketing techniques. Here a designer label, combined with the supposedly 'timeless' and 'functional' nature of denim work-wear, connote 'quality' and 'style'.

The fashion conspiracy is not simply a conspiracy of expensive clothes being marked up around the world, it is a conspiracy of taste and compromise; the prerogative of the international fashion editors in determining how the world dresses, and how their objectivity can be undermined, the despotic vanity of the designers and the ruthlessness of the store buyers . . . Often the conspiracy is a conspiracy of silence. A magazine goes to great lengths to make bad clothes look good, because the designer is advertising heavily in its pages. Major designers exert extraordinary pressure on department stores for more prominent square footage while simultaneously pirating ideas from smaller rivals . . . But this was not a conspiracy I could grasp all at once. Fashion is an infinitely larger and more complex world than it appears from outside. The decade from 1978 has been decisive for fashion, as important as the 1950s were for the motor industry and the 1970s for computers. Designers like Ralph Lauren, Calvin Klein and Giorgio Armani have created from nothing fashion empires on a scale and with a speed that seemed impossible in the mid-1970s . . . designer money has transformed the social status of designers.[1]

Nicholas Coleridge, writing in the final years of a decade which pretentiously labelled itself that of the 'designer', rumbles ominously against the vanity and hollowness of fashion promotion; highlighting a new emphasis on marketing and publicity which many commentators have used to signify a renaissance or revolution in the fashion industry that helped to mould the visual and cultural character of the developed world from the early eighties onwards. His is a rhetoric of condemnation which sounds familiar in its similarity to those anti-consumer diatribes which have been quoted throughout the chapters of this book, and strangely dated, or at least of its date, when compared to the more recent clarion calls for restraint, renunciation and recycling which typify fashion marketing and journalism in more recent years. Whilst many of the features which he quotes as being essentially of the 1980s – the cult of personality, the marketing tie-ins, the reliance on journalism – can be traced back at least to the second half of the eighteenth century and persist into the 1990s, Coleridge does make an important point about the expanding breadth of fashion 'knowledge'. Quoting Fred Hughes of the Andy Warhol Trust, he says: 'What's happened is that the entire Western world – the entire world – is clothes conscious. People are living longer and staying fashion conscious; it's just going to go on and on, getting bigger and bigger and richer and richer.'[2] Undoubtedly, the power of clothing itself to communicate difference in terms of nationality, social status, gender and sexuality has

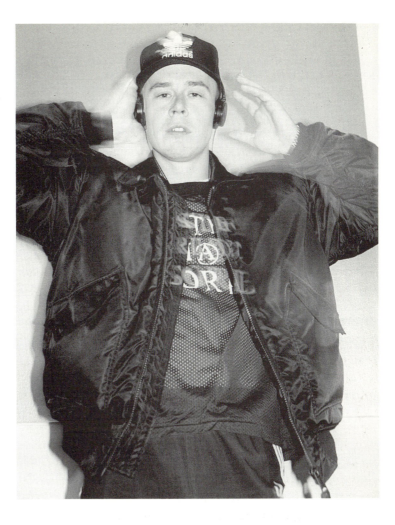

91] Baseball cap, flight jacket, tracksuit trousers and 'destroy' mesh T-shirt evoke the fragmented nature of contemporary street culture.

become muddied in such a context, and what has increasingly emerged after a decade of journalistic hype and overkill is a deliberate focusing on the creativity of individuals – designers, models and elite consumers – as a form of contemporary 'mass' spectacle, together with an eroding or homogenising of the 'individual' cultural and economic significance of their products or purchases. Greil Marcus has pinpointed precisely the centrality and conflicting meanings of Guy Debord's ideas of 'spectacle'[3] to late twentieth-century mass culture, in a reading which is useful for any understanding of the place of fashion within that system:

> The Spectacle as Debord developed the concept through the 1950s and 1960s was . . . a wonderful prison where all of life was staged as a permanent show . . . 'capital accumulated until it becomes an image' . . . Spectacle had become a fashionable critical commonplace by the early 1980s. It was a vague term, devoid

of ideas. It simply meant that the image of a thing superseded the thing itself. Critics used the cliche not to think, or to imagine, but to complain . . . that consumers were being seduced by advertisements instead of choosing rationally among products . . . This was the theatre, but Debord had insisted on the church: the spectacle was not merely advertising, or television, it was a world. 'The spectacle is not a collection of images', he wrote, dismissing in advance the obvious social critiques that would follow his book, 'but a social relationship among people, mediated by images'.[4]

This is primarily a book about history and it is perhaps difficult to place contemporary fashion under the same kind of 'objective' scrutiny as the clothing of the more distant past. However, as we have seen, fashion operates both as an incisive interpreter and mirror of the present, which is what makes it such a fascinating and complicated decoder of historical trends and conditions. Indeed, fashion, by its very nature cyclical and ephemeral, abruptly metamorphoses into historical evidence, but its increasing reliance on subjective structures of meaning, its role as 'spectacle', makes its immediate interpretation a complicated and fraught process. In describing contemporary style, the historian slips swiftly into the world of journalism and celebration. There is, however, an argument for a more detailed examination of the influences and messages reflected and produced by those individuals credited as the 'conspirators' of the late twentieth-century fashion revolution. A specific regard for 'History' and 'Culture' in the work of recent designers, together with the resurgence of the physical object as a fitting focus for art and design history, would seem to make the limited study of contemporary themes a fitting and potentially helpful conclusion to the earlier arguments of this text. It might also emphasise the practical and creative uses to which historical and cultural knowledge can be put, bringing the consideration of practice and theory in fashion design closer together.

The work of individual designers during the 1980s has been subsumed and reconciled by cultural historians and critics with a broader revolution in consumers' relationships with the world and its products that can be traced back to the critiques of consumer society put forward by the Frankfurt School of Social Research, discussed in the previous chapter, through to the explanations of Guy Debord. Iain Chambers, for example, places the 'fashion revolution' in the context of techniques of 'montage' and 'bricolage', which are closely allied to those concepts of the metropolitan experience that have always been essential to processes of fashion change:

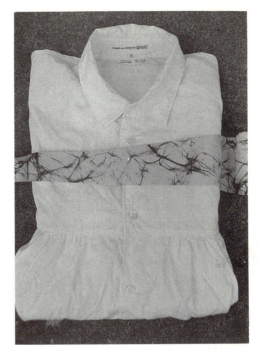

92] The metropolitan club scene of the mid 1980s produced a rash of designs that mixed elements of the primitive and the knowingly camp, resulting in an ultimately androgynous look.

93] Experimentation with construction, texture and pattern blur the distinctions between art and craft in the process and products of fashion design.

The sights and sounds of the urban scene – advertising, music, cinema, television, fashion, magazines, video clips – exist in the rapid circuits of electronic production/reproduction/distribution. They are not unique artefacts but objects and events multiplied a thousand, a million times over. In the rapid interplay of these signs, sense outstrips the referents. It produces an aesthetics of transitory and tactile reception, of immediate participation and expendable criteria. Contemplation and study can follow, but in a medium in which we have all become experts it is not a necessary requirement.[5]

In this way the language of the revived catwalk, the supermodel, and the designer label has become a kind of contemporary Esperanto, immediately accessible across social and geographical boundaries. Fashion change in this context can be reduced to a shorthand for late twentieth-century cultural experience or 'lifestyle'. Tony and Claes Lewenhaupt present a typical 'lifestyle' approach in their glossily attractive book *Crosscurrents*.[6] Produced in the alluring photographic and typographic format familiar to consumers of fashion, food and furniture magazines, the book organises expertly lit and styled key images of designer clothing alongside representations of carefully chosen architectural and interior views. Fashion is made to follow a cool and preordained progression through successive consumer styles, which are then shown to reflect particular economic and social trends. Thus the pared

down high-tech functionalism of the late 1970s, relying on shiny chrome, strong primary colours and the emergence of the ubiquitous matt black, forms a perfect foil for Sonia Rykiel's informal sportswear with its exposed construction and conspicuous function. This in turn is related to an emphasis on workplace efficiency transposed to the domestic and leisure spheres by an underlying fear of unemployment. Katherine Hamnett's clothes are quoted as 'typical of the eighties. Separately they appear simple and not particularly striking, but put together, her combinations take on an unexpected life and audacity . . . they create a new, highly personal and very post-modern whole'.[7] In the same way Japanese designers are credited with introducing a 'sacrifice of everything unnecessary' and an 'appreciation of large clean surfaces' to create 'severely graphic, clearly sexless clothes for a new broad-shouldered businesswoman'. Individual design choices are thus presented as miraculous approximations of the cultural *Zeitgeist* and the idea of the power-dressing businesswoman or the creative yuppie, strengthened through representations in Hollywood and through the shoots of glossy lifestyle magazines is reinforced and further communicated by the deliberate construction of designer personalities and trend-setters.

Deyan Sudjic's monograph on the cult designer Rei Kawakubo of Comme des Garçons provides a similar series of generalisations and simplifications that not only decode, but also help to encode the designer decade with its familiar connotations. Descriptions and explanations of Kawakubo's designs emphasise their formalist connotations, linking the designer with other twentieth-century modernist pioneers and drawing a fetishistic attention to the tactile qualities of clothing itself. Through his text Sudjic enforces a typical attention on the iconic status of the individual and her products, revealing the manner in which elite fashion has been marketed and perceived during the past decade:

> There is an echo of the purism of the pioneering architectural modernists about the way Kawakubo approaches fashion; she likes she has said 'to start from zero', re-examining not just the appearance of clothes but their construction. Kawakubo talks of her admiration for Le Corbusier, and it is not too far fetched to see the influence of his purist modernism in her own abstraction of fashion into the fundamentals of texture, form and colour.[8]

The casual observer might be forgiven for interpreting the output of Comme des Garçons, Issey Miyake or more

recently the collections of European 'deconstructivists' such as Martin Margiela or Anne Demeulemester, as a manifestation of those late twentieth-century debates centring around the distinctions between fine art and craft, suitable for display in the spaces of a gallery, rather than ephemeral commodities designed for retail and wear, ultimately limited in terms of shelf-life to a specific season and collection. But such confusion is a deliberate marketing ploy, and designer fashion has increasingly come to represent both readings. The architect-designed spaces of high fashion shops, the contrived and often conceptual graphic imagery of advertisements, show cards and catalogues, together with the literature and journalism surrounding the catwalk, are intended to suggest a creative seriousness attractive both to potential customers, and as a model for a broader selection of high street retailers from Next to Top Shop. Ironically, Sudjic and Kawakubo both define and deny a target audience particularly susceptible to connotations of 'lifestyle', an audience immediately recognisable through the lampoons, caricatures and fictions of eighties high living. Kawakubo commented in the *New York Times* in 1983 'I do not design with the image of a particular character or body type in mind, it's a way of life I design for', whilst Sudjic enthuses revealingly:

> These are clothes which appeal to those who see themselves as outside the conventional idea of fashion. Worn by New York artists, Swiss architects, London advertising millionaires and the more independent-minded of Los Angeles film people, they make a statement about the wearer without being a label that carries with it a whole fantasy life for the socially insecure . . . Like all high fashion, they contain aspects of luxury, but their origin is not immediately obvious and they are by no means an overt status symbol.[9]

Arguably, to be a status symbol is exactly what designer wear aspires to, both in terms of customer expectations and manufacturers' intentions. At the heart of the contemporary fashion system lies the necessity of creating an image of the bespoke, the individual and the exclusive. The spectacle of high fashion, physically available to the few, though disseminated at an increasingly quickening pace through fashion forecasting and down market approximations, is a gloss, paid for through more pragmatic ventures. John Fairchild, editor of *Women's Wear Daily*, and author of a vitriolic text which encapsulates precisely the glamour and artifice of much fashion publicity, explains:

Even back in my early Paris days, none of the leading designers could support their studios based on couture sales alone, for very, very few women dressed in the couture. Today of course there are even fewer. After all, a very simple suit in the couture can easily cost $10,000, though the designers give all sorts of special prices to people they think are important. French women don't go to the couture very much. Couture's biggest customers are American women and people you've probably never heard of: exceedingly rich Arabs and Germans. Early on the designers started making their serious money with perfumes and accessories . . . It was only with those profits – and the hysterical press coverage they bought – that the top designers could ever afford the luxury of making couture clothes for the very rich.[10]

One of the most interesting aspects of couture and ready-to-wear design is the self-conscious manner in which the 'creative genius' of the couturier draws on references from fashion history, isolating their original meanings and context in stylistic terms, whilst also commenting on contemporary concerns. Christian Lacroix has in the past attested to the self-referential nature of much design work, stating in the March 1988 edition of *Vogue* 'every one of my dresses possesses a detail that can be connected with something historic, something from a past culture. We don't invent anything.'[11] Certainly the rich textures, bustles and boning of his output owe much to eighteenth- and nineteenth-century inspiration, but in terms of meaning don't go much further than decorative pastiche. British designers, however, have attracted a reputation for their subversion of historical and contemporary dress codes. John Galliano, for example, was feted by fashion journalists during the second half of the eighties for his exuberantly constructed, romantic evocation of empire dandyism. Zandra Rhodes achieved particular notoriety from the late 1960s onwards for her interpretations of London bohemian and street styles. Her screen-printed silk chiffon evening dresses of the early seventies incorporate ethnic, oriental and Gipsy motifs in a high fashion appropriation of counter-culture anti-commercialism, whilst her 'Conceptual Chic' collection of 1978 'used the heavy elements of street punk dress – black bondage trousers, leather jacket with chains and safety pins – as starting points for a less oppressive variation for a different market'.[12] The influence of club life and popular music was present again in the 1981 'Elizabethan Collection' which fused first-hand study of historical precedents to eighteenth-century court dress at the Victoria and Albert Museum with the ostentatious glamour of

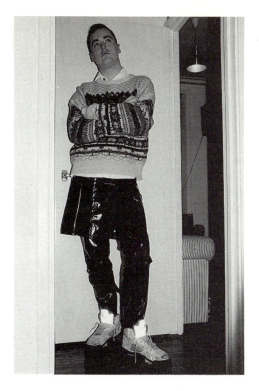

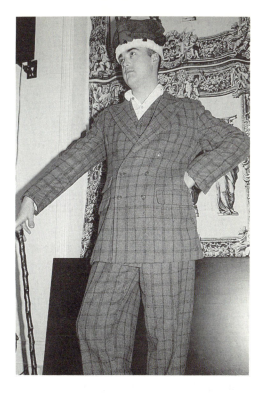

94, 95] Vivienne Westwood jumper and PVC bondage trousers, 1993.

Vivienne Westwood: traditional tweed suit and crown, c.1990.

blitz culture pioneered at a subcultural level by Rusty Egan and Steve Strange. Extravagantly pleated swirls of gold metallic fabrics at shoulders and pannieried hips deliberately suggested the possibilities of disguise and dressing-up central to the concerns of contemporary youth culture.

The work of Vivienne Westwood, however, has been quoted most frequently for its ability to transcend categories of street and catwalk. Whilst Rhodes was able to utilise aspects of popular culture in collections that were ultimately limited to a discrete market, Westwood has continually found herself not simply reacting to current trends, but delineating and defining them at the same time. It is significant that her boutiques, alternatively named SEX, Seditionaries and Worlds End, have attracted a clientele not confined to the conventionally successful or financially secure, the architects, film-makers and media moguls alluded to by Sudjic, but also incorporating those who lead subversive style changes from the cutting edge. It would be simplistic to claim, as many have, that Westwood and her one-time partner Malcolm McClaren were uniquely responsible for the visual construction of punk in the mid-seventies, though much of their work captured and commodified the energy and iconoclastic tendencies of the movement. What forms the most challenging

aspect of Westwood's collections is her ability to deconstruct
and subvert the historical and contemporary 'resonance' of
clothing. The kitchen-sink cardigan, currently accorded the
status of museum object at the Victoria and Albert Museum,
is able to connote both traditional domestic and gendered
categories of sartorial choice, whilst also suggesting the
formal qualities of Japanese clothing, a Dadaist appropriation
of found objects, and a concurrent emphasis on the baggy,
threadbare and body-denying appearance of early eighties
'buffalo' youth styles. In the words of Valerie Mendes, it is

> made in loosely woven, dishcloth cotton, dyed purple. Its sin-
> gular look is completed by three huge burnished metal buttons,
> which are made from 'Vim' scouring powder lids. Each lid is
> attached with coloured cotton thread through the ready
> punched holes and fastens with a loop of thick cotton cord,
> which is knotted and left to unravel at the ends. The cardigan
> has two, square patch pockets constructed from interwoven
> strips of pink, green, yellow and purple dishcloth.[13]

Later collections have made similarly interpretative and chal-
lenging use of fashion history icons from the fig leaf through

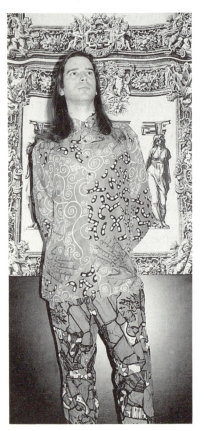

96] English Eccentrics: neo-
classical, jugendstil and
primitive inspired prints,
c.1986.

97] Through reference to
historical methods of cutting
and tailoring, and the skilful
styling of accessories,
designers such as John
Galliano and Christian
Lacroix have been able to
create contemporary
approximations of old-world
glamour.

to the corset and the crinoline, though as Juliet Ash states, ultimately her work evades quantitative description:

> Westwood's work eludes the journalist (attempting synopsoid descriptions of this season's predictions); the fashion historian (extracting linear references to costume developments); the postmodernist critic (delving into all meanings as a reductionist form based on fragmentation, and consciously rejecting the desirability of knowing the world as a whole) the fashion business 'rep' and the buyer (relying on the commercial viability of the 'Sell').[14]

Perhaps ultimately a general inability to read Westwood's work is more indicative of a perceived implosion of the fashion system in the early nineties, rather than an implied failure on Westwood's part to conform to the hierarchies imposed by the market and fashion publishing. The growing importance of 'popular culture' as a source for fashion change and the tendency of young designers who attract the public eye to experiment with received ideas of cut, texture and colour, rather than meet the demands of the average consumer, may do little to strengthen the economic base of the established high fashion industry in a time of recession, despite contrary claims that the new fashion is a rejection of the consumerist ethos and an exploration of the potential of the environment or the formal limits of clothing. It does, however, reinforce the continuing idea of 'spectacle' that has underpinned the engine of fashion change since the 1350s at least, and thankfully offers much scope for the future historian of dress. As Iain Chambers comments:

> Contemporary popular culture may no longer be strictly 'working-class' as the idealistic purists of political formalism would like, but it does emerge from subordinate cultures, from the inventive edges of the consensus, from the previously ignored and suppressed. It gestures through a widening democratization of styles, sounds and images, to an important remaking, to new possibilities, new perspectives, new projects.[15]

Notes

1 N. Coleridge, *The Fashion Conspiracy: A Remarkable Journey through the Empires of Fashion*, London, 1988, pp. 4–5.

2 Coleridge, *The Fashion Conspiracy*, pp. 4–5.

3 G. Debord, *Society of the Spectacle*, Detroit, 1977.

4 G. Marcus, *Lipstick Traces: A Secret History of the Twentieth Century*, London, 1990, pp. 98–104.

5 I. Chambers, *Popular Culture: The Metropolitan Experience*, London, 1986, p. 185.

6 T. and C. Lewenhaupt, *Crosscurrents: Art, Fashion, Design 1890–1989*, New York, 1989.

7 T. and C. Lewenhaupt, *Crosscurrents*, p. 186.

8 D. Sudjic, *Rei Kawakubo and Comme des Garçons*, London, 1990, p. 10.

9 Sudjic, *Rei Kawakubo*, pp. 81–2.

10 J. Fairchild, *Chic Savages*, New York, 1989, pp. 14–15.

11 C. Wilcox and V. Mendes, *Modern Fashion in Detail*, London, 1991, p. 90.

12 Rothstein, *Four Hundred Years of Fashion*, p. 98.

13 Wilcox and Mendes, *Modern Fashion in Detail*, p. 80.

14 J. Ash, 'Philosophy on the Catwalk' in Ash and Wilson, eds, *Chic Thrills*, p. 177.

15 Chambers, *Popular Culture*, p. 61.

Select bibliography

Abelson, E. S., *When Ladies Go A-Thieving: Middle-Class Shop Lifters in the Victorian Department Store*, Oxford University Press, 1989.

Adburgham, A., *Shops and Shopping 1800–1914*, Allen & Unwin, London, 1964.

Anglo, S., *The Courtier's Art: Systematic Immorality in the Renaissance*, University College of Swansea, 1983.

Aries, P., and G. Duby., *A History of Private Life: Revelations of the Medieval World*, Harvard University Press, Cambridge, Mass., 1988.

Arnold, A., *Queen Elizabeth's Wardrobe Unlock'd*, W. S. Manley, Leeds, 1988.

Arnold, J., *A Handbook of Costume*, Macmillan, London, 1973.

Ash, J., and E. Wilson, *Chic Thrills: A Fashion Reader*, Pandora, London, 1992.

Ashelford, J., *Dress in the Age of Elizabeth I*, Batsford, London, 1988.

Barthes, R., *Mythologies*, Jonathan Cape, London, 1972.

Bijker, W., T. Hughes and T. Pinch, *The Social Construction of Technological Systems*, MIT, Cambridge, Mass., 1987.

Bremmer, J. and H. Roodenburg, *A Cultural History of Gesture*, Polity Press, Cambridge, 1991.

Brewer, J. and R. Porter, *Consumption and the World of Goods*, Routledge, London, 1993.

Bridbury, A., *Medieval English Clothmaking: An Economic Survey*, Heinemann, London, 1982.

Buck, A., *Dress in Eighteenth-Century England*, Batsford, London, 1979.

Campbell, C., *The Romantic Ethic and the Spirit of Modern Consumerism*, Blackwell, Oxford, 1987.

Chapman, R. and J. Rutherford, *Male Order: Unwrapping Masculinity*, Lawrence & Wishart, London, 1988.

Chenoune, F., *A History of Men's Fashion*, Flammarion, Paris, 1993.

Clunas, C., *Superfluous Things: Material Culture and Social Status in Early Modern China*, Polity Press, Cambridge, 1991.

Coleman, D. and A. John, *Trade, Government and Economy in Pre-Industrial England*, Weidenfeld & Nicholson, London, 1976.

Colley, L., *Britons: Forging the Nation*, Yale, New Haven, 1992.

Craik, J., *The Face of Fashion: Cultural Studies in Fashion*, Routledge, London, 1994.

Crowfoot, E., F. Pritchard and K. Staniland, *Textiles and Clothing: Medieval Finds from Excavations in London c. 1150–1450*, HMSO, London, 1992.

Cumming, V., *A Visual History of Costume, The Seventeenth Century*, Batsford, London, 1987.

Cunnington, C. W., *English Women's Clothing in the Nineteenth Century*, Faber & Faber, London, 1937.

Davidoff, L. and C. Hall, *Family Fortunes: Men and Women of the English Middle Class 1780–1850*, Hutchinson, London, 1987.

Davies, A., *Leisure, Gender and Poverty: Working-class culture in Salford and Manchester 1900–1939*, Open University Press, Buckingham, 1992.

Davis, D., *A History of Shopping*, Routledge, London, 1966.

Davis, F., *Fashion, Culture and Identity*, University of Chicago Press, 1992.

De Marly, D., *Louis XIV and Versailles*, Batsford, London, 1987.

De Marly, D., *Worth, Father of Haute Couture*, Batsford, London, 1980.

Dubermann, M., M. Vicinus and G. Channery, *Hidden From History: reclaiming the Gay and Lesbian Past*, Penguin, London, 1989.

Dwyer Amussen, S., *An Ordered Society: Gender and Class in Early Modern England*, Blackwell, Oxford, 1988.

Dyer, C., *Standards of Living in the Middle Ages: Social Change in England 1200–1520*, Cambridge University Press, 1989.

Einberg, E., *Manners and Morals: Hogarth and British Painting 1700–1760*, Tate Gallery, London, 1987.

Elias, N., *The Court Society*, Blackwell, Oxford, 1983.

Ennen, E., *The Medieval Woman*, Blackwell, Oxford, 1989.

Evans, C. and M. Thornton, *Women and Fashion: A New Look*, Quartet Books, London, 1989.

Ewen, S., *All-Consuming Images: The Politics of Style in Contemporary Culture*, HarperCollins, New York, 1988.

Feldman, D. and G. Steadman Jones, *Metropolis London*, Routledge, London, 1989.

Ferguson, M., *Forever Feminine: Women's magazines and the cult of femininity*, Gower, London, 1983.

Ferguson, M., M. Quilligan and N. Vickers, *Rewriting the Renaissance: The Discourses of Sexual Difference in Early Modern Europe*, University of Chicago Press, 1986.

Fine, B. and E. Leopold, *The World of Consumption*, Routledge, London, 1993.

Finkelstein, J., *The Fashioned Self*, Polity Press, Cambridge, 1991.

Foucault, M., *The Order of Things: An Archaeology of the Human Sciences*, Routledge, London, 1970.

Fraser, W. H., *The Coming of the Mass Market 1850–1914*, MacMillan, London, 1981.

Friedman, A., *House and Household in Elizabethan England: Wollaton Hall and the Willoughby Family*, University of Chicago Press, 1989.

Gaines, J. and C. Herzog, *Fabrications: Costume and the Female Body*, Routledge, London, 1990.

Gent, L. and N. Llewellyn, *Renaissance Bodies: The Human Figure in English Culture 1540–1660*, Reaktion, London, 1990.

Gernsheim, A., *Victorian and Edwardian Fashion: A Photographic Survey*, Dover, New York, 1981.

Gimpel, J., *The Medieval Machine: The Industrial Revolution of the Middle Ages*, Penguin, New York, 1977.

Ginsburg, M., *An Introduction to Fashion Illustration*, Victoria and Albert Museum, London, 1980.

Gorham, D., *The Victorian Girl and the Feminine Ideal*, Croom Helm, London, 1982.

Graves, R., *The Long Weekend: A Social History of Great Britain 1918–1939*, Faber and Faber, London, 1940.

Greenblatt, S., *Renaissance Self-Fashioning*, Chicago University Press, 1980.

Gurevich, A., *Medieval Popular Culture: Problems of Belief and Perception*, Cambridge University Press, 1988.

Haley, B., *The Healthy Body and Victorian Culture*, Harvard University Press, Cambridge, Mass., 1978.

Harte, N., and K. Ponting, *Cloth and Clothing in Medieval Europe*, Heinemann, London, 1983.

Hebdige, D., *Subculture: The Meaning of Style*, Routledge, London, 1979.

Herihy, D., *Medieval Households*, Harvard University Press, Cambridge, Mass., 1985.

Hollander, A., *Seeing Through Clothes*, Viking, New York, 1975.

Holmes, U., *Medieval Man: His Understanding of Himself, His Society and the World*, North Carolina University Press, 1980.

Kidwell, C. and V. Steele, *Men and Women: Dressing the Part*, Smithsonian Institution Press, Washington, DC, 1989.

Le Goff, J., *Medieval Civilization 400–1500*, Blackwell, Oxford, 1988.

Le Goff, J., *The Medieval World*, Collins and Brown, London, 1990.

Leiss, W., S. Kline and S. Jhally, *Social Communications in Advertising*, Routledge, London, 1990.

Lemire, B., *Fashion's Favourite: The cotton trade and the consumer in Britain 1660–1800*, Oxford University Press, 1991.

Levey, S., *Lace: A History*, Victoria and Albert Museum, London, 1983.

Levitt, S., *Victorians Unbuttoned: Registered designs for clothing, their makers and wearers 1839–1900*, Allen & Unwin, London, 1986.

Light, A., *Forever England: Femininity, Literature and Conservatism Between the Wars*, Routledge, London, 1990.

McCracken, G., *Culture and Consumption: New approaches to the symbolic character of consumer goods and activities*, Indiana University Press, 1990.

Maccubbin, R. and M. Phillips, *The Age of William III and Mary II: Power, Politics and Patronage 1688–1702*, The College of William and Mary, Williamsburg, Virginia, 1989.

McKendrick, N., J. Brewer and J. Plumb, *The Birth of a Consumer Society: The Commercialization of Eighteenth-Century England*, Europa, London, 1982.

McRobbie, A., *Zoot Suits and Second-Hand Dresses*, Macmillan, London, 1989.

Melling, J. and J. Barry, *Culture in History: Production, Consumption and Values in Historical Perspective*, Exeter University Press, 1992.

Mennel, S., *Norbert Elias: Civilization and the Human Self-Image*, Blackwell, Oxford, 1989.

Miller, M., *The Bon Marché: Bourgeois Culture and the Department Store 1869–1920*, Allen & Unwin, London, 1981.

Mui, H. and Mui, L., *Shops and Shopkeeping in Eighteenth-Century England*, Routledge, London, 1989.

Newton, S. M., *Health, Art and Reason: Dress Reformers of the Nineteenth Century*, John Murray, London, 1974.

Newton, S. M., *Fashion in the Age of the Black Prince*, Boydell Press, Woodbridge, 1980.

Porter, R., *English Society in the Eighteenth Century*, Penguin, London, 1982.

Power, E., *Medieval Woman*, Cambridge University Press, 1975.

Priestley, J. B., *English Journey*, Heinemann, London, 1934.

Quaife, G. R., *Wanton Wenches and Wayward Wives: Peasants and Illicit Sex in Early Seventeenth-Century England*, Croom Helm, London, 1979.

Reay, B., *Popular Culture in Seventeenth-Century England*, Croom Helm, London, 1985.

Ribeiro, A., *A Visual History of Costume, The Eighteenth Century*, Batsford, London, 1983.

Richards, T., *The Commodity Culture of Victorian England: Advertising and Spectacle 1851–1914*, Stanford University Press, California, 1991.

Rothstein, N., *Silk Designs of the Eighteenth Century*, Thames and Hudson, London, 1990.

Rothstein, N., *Four Hundred Years of Fashion*, Victoria and Albert Museum, London, 1984.

Rule, J., *Albion's People: English Society 1714–1815*, Longman, London, 1992.

Rule, J., *The Vital century: England's Developing Economy 1714–1815*, Longman, London, 1992.

Samuel, R. and G. Steadman Jones, *Culture, Ideology and Politics*, Routledge, London, 1982.

Schama, S., *The Embarrassment of Riches*, Collins, London, 1987.

Schoeser, M. and C. Rufey, *English and American Textiles from 1790 to the Present*, Thames & Hudson, London, 1989.

Scott, M., *A Visual History of Costume, The Fourteenth and Fifteenth Centuries*, Batsford, London, 1986.

Shahar, S., *The Fourth Estate: A History of Women in the Middle Ages*, Methuen, London, 1983.

Shields, R., *Lifestyle Shopping: The Subject of Consumption*, Routledge, London, 1992.

Smith, D., *Masks of Wedlock: Seventeenth-Century Dutch Marriage Portraiture*, Bowker, London, 1982.

Steele, V., *Fashion and Eroticism: Ideals of Feminine Beauty from the Victorian Era to the Jazz Age*, Oxford University Press, 1985.

Strong, R., *Hans Eworth: A Tudor Artist and his Circle*, Leicester Museums and Art Gallery, 1965.

Strong, R., *The Culture of Elizabeth: Elizabethan Portraiture and Pageantry*, Thames & Hudson, London, 1977.

Strong, R., *The English Icon: ELizabethan and Jacobean Portraiture*, Routledge, London, 1969.

Swanson, H., *Medieval Artisans: An Urban Class in Late Medieval England*, Blackwell, Oxford, 1989.

Thirsk, J., *Economic Policy and Projects: The Development of a Consumer Society in Early Modern England*, Oxford University Press, 1978.

Thrupp, S., *The Merchant Class of Medieval London 1300–1500*, Chicago University Press, 1948.

Tosh, J. and M. Roper, *Manful Assertions*, Routledge, London, 1991.

Uitz, E., *Women in the Medieval Town*, Barrie & Jenkins, London, 1990.

Vigarello, G., *Concepts of Cleanliness: Changing Attitudes in France since the Middle Ages*, Cambridge University Press, 1988.

Wadsworth, A. and J. Mann, *The Cotton Trade and Industrial Lancashire 1600–1780*, Kelly, New York, 1968.

Walker, J., *Design History and the History of Design*, Pluto Press, London, 1989.

Weatherill, L., *Consumer Behaviour and Material Culture in Britain 1660–1760*, Routledge, London, 1988.

White, C., *Women's Magazines 1693–1968*, Michael Joseph, London, 1970.

Williams, C., *Thomas Platter's travels in England 1599*, Jonathan Cape, London, 1937.

Wilson, E., *Adorned in Dreams: Fashion and Modernity*, Virago Press, London, 1985.

Wilson, E. and L. Taylor, *Through the Looking Glass*, BBC, London, 1989.

Woodbridge, L., *Women and the English Renaissance: Literature and the Nature of Womankind*, Harvester Press, Brighton, 1984.

Zylstra Zweens, H., *Of his array telle I no lenger tale: Aspects of Costume, Arms and Armour in Western Europe 1200–1400*, Rodopi, Amsterdam, 1988.

Index